*The Corning Museum of Glass*
*Catalog Series*

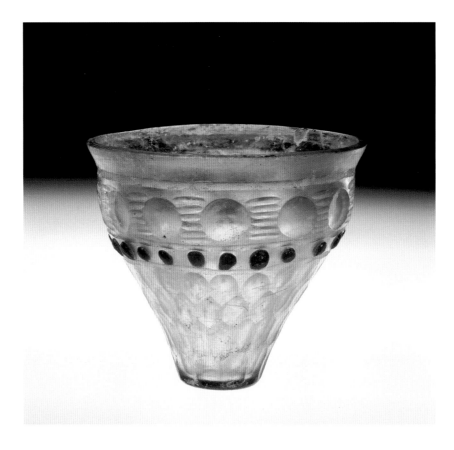

**60.** *Beaker or lamp. Probably 4th to 7th century. H. 9.3 cm, D. 10.7 cm (63.1.21).*

# Sasanian and Post-Sasanian Glass

## in The Corning Museum of Glass

DAVID WHITEHOUSE

with a contribution by Robert H. Brill

THE CORNING MUSEUM OF GLASS
CORNING, NEW YORK

In association with Hudson Hills Press, New York and Manchester

EDITOR: Richard W. Price
DESIGN AND TYPOGRAPHY: Jacolyn S. Saunders
PHOTOGRAPHY: Nicholas L. Williams,
  assisted by Andrew M. Fortune
DRAWINGS: Kim Kelley Wagner, assisted by
  Jill Thomas-Clark

Published by The Corning Museum of Glass
in association with Hudson Hills Press LLC,
74-2 Union Street, Manchester, Vermont 05254

Co-Directors: Randall Perkins and Leslie van Breen
Founding Publisher: Paul Anbinder

Distributed in the United States, its territories and possessions,
and Canada by National Book Network Inc. Distributed in
the United Kingdom, Eire, and Europe by Windsor Books
International.

Standard Book Number 0-87290-158-0
Library of Congress Control Number 2004113484

# CONTENTS

# FOREWORD

This volume contains a catalog of 72 objects in the collection of The Corning Museum of Glass that are believed to be Sasanian or "post-Sasanian" (i.e., made in Sasanian style in the centuries immediately following the fall of the Sasanid dynasty). The uncertainty about their origin derives from the fact that relatively few Sasanian glass vessels have been excavated from controlled archeological contexts. Moreover, only a handful of the vessels that do come from controlled archeological excavations have the facet-cut decoration that characterizes much of the "Sasanian" glass entering public and private collections from the antiquities market. Indeed, the fact that so many of the parallels cited for the objects described in this volume appear in sale catalogs rather than archeological reports underlines the shortage of "hard" evidence from scientific excavations.

The situation described in the preceding paragraph may prompt readers to question the usefulness of yet another publication of Sasanian glass that has no provenance. The justifications of publishing this material, I suggest, are (1) a handful of archeological reports apart, very few publications deal exclusively with Sasanian and post-Sasanian glass; (2) no collection of comparable size and variety has yet been published; and (3) this means that the collection at Corning provides a starting point for anyone who wishes to study the glass made in the Sasanian Empire. If, a

decade from now, the ideas expressed in this volume have been entirely superseded, we will rejoice that its publication may have helped to stimulate new research in an old but insufficiently explored aspect of the history of glass.

Twenty-one of the objects at Corning were collected from miscellaneous sources between 1959 and 1966. An additional 13 objects were part of the collection formed by Jerome Strauss. The glasses from the Strauss Collection were given to the Museum by Mr. Strauss and The Ruth Bryan Strauss Memorial Foundation. Ten vessels were formerly in the collection of Ray Winfield Smith, whose keen interest in the early history of glass and glassmaking led him to acquire fragments as well as complete objects; no fewer than 24 of the 27 appliqués in section E were collected by Smith.

The volume also contains two appendixes. Appendix 1 is a select catalog of fragments collected from three archeological sites in central and southern Iraq in 1967. Appendix 2, by Dr. Robert H. Brill, presents and discusses chemical analyses of Sasanian glass, including objects in the collection at Corning.

DAVID WHITEHOUSE
Executive Director

# ACKNOWLEDGMENTS

Curators of mature collections should approach the task of publishing catalogs with a generous dose of humility. In this case, I am well aware that the richness of Corning's collection of Sasanian glass is due to the energy and acumen of my predecessors as curator of ancient and Islamic glass, Axel von Saldern and Sidney M. Goldstein. They acquired most of the objects, annotated the registrar's records, and to a great extent ensured that Corning's collection of Sasanian glass is as good as—if not better than—many other public collections.

Throughout the preparation of this catalog, I have benefited from conversations with Robert H. Brill, the Museum's research scientist (and the author of Appendix 2 on pages 65–88), and William Gudenrath, resident adviser at The Studio of The Corning Museum of Glass.

I am also indebted to other members of the Museum staff. As with the production of the catalog of Roman glass, special thanks are due to the principal editor, Richard W. Price, and his assistant, Jacolyn S. Saunders, of the Publications Department, and to the photographer, Nicholas L. Williams, and his assistant, Andrew M. Fortune. Over the years, registrars Priscilla B. Price, Jill Thomas-Clark, and Warren M. Bunn II, assisted by Brandy L. Harold, Joseph J. Maio Jr., and other members of the gallery staff, efficiently and safely moved the objects between the galleries, the photographic studio, and my office. Jill Thomas-Clark scheduled the photography and drawing. In the Rakow Research Library, Gail Bardhan answered innumerable questions about the bibliography.

I also wish to acknowledge the assistance of other friends and colleagues who contributed to the text of this volume through conversation, correspondence, and publications. In particular, I am grateful to Mariamaddalena Negro Ponzi, whose publications document glass of the Parthian and Sasanian periods in Iraq, and StJohn Simpson, who showed and discussed with me the Sasanian glass in The British Museum.

# INTRODUCTION

This volume contains a catalog of glass objects that are believed to have been made in the Middle East, in territory controlled by the Sasanid dynasty, between the third and seventh centuries A.D./C.E., and objects of Sasanian type made after the Muslim conquest. The Sasanid dynasty was named after the legendary Sasan, an ancestor of the first Sasanian king, Ardashir (r. 224–241). From his power base in southern Iran, Ardashir overthrew the last of the Parthian kings and proceeded to lay the foundations of an empire that encompassed present-day Iran and much of Iraq, together with parts of Central Asia, the Caucasus, and the Arabian Peninsula. For a brief period during the reign of Khosrow II (591–628), the Sasanians also controlled Syria, the Levant, and Egypt. The Sasanian Empire was destroyed by Muslim armies in a series of campaigns that began in 636 with the battle of al-Qadisiyah in Iraq and ended in 651 with the conquest of Merv in Central Asia (Frye 1983).

## 1. The Study of Sasanian Glass

The study of the glass of the Sasanian Empire began much later than the study of many other categories of Sasanian artifacts, such as coins and silver plate (Vanden Berghe 1993). In the first volume of *A Survey of Persian Art* (Pope 1938), glass is not discussed in the chapters devoted to the art and architecture of the Sasanian period. When the subject does appear in the *Survey*, in a brief overview of pre-Islamic and Islamic glass, it occupies less than a page, and the author, Carl Johan Lamm (1939, p. 2595) was able to cite just one major object (the celebrated dish in the Bibliothèque Nationale, Paris, which has cast glass elements) and fragments from only three excavations: at Susa (Lamm 1931), Ctesiphon (Puttrich-Reignard 1934), and Kish (Harden in Langdon and Harden 1934).

Eighteen years later, in *Glass from the Ancient World* (1957, pp. 189–225), the introduction to the section of the catalog titled "Fifth–Twelfth Century A.D., Excluding Islamic Glass" contains (on pp. 190 and 193) just 10 lines devoted to Sasanian glass. In addition, only five vessels discussed there are identified as Sasanian (nos. 389–392 on p. 199 and no. 453 on p. 225), and one vessel (no. 550 on p. 269; it is our **64**) is identified as "Sassanian or later, about 6th–9th century."

In the next few years, however, the situation changed dramatically. Sasanian glass quickly became a focus of scholarly attention in 1958, when cemeteries of the Parthian and Sasanian periods came to light in Gilan Province, northern Iran, and glass vessels and other grave goods began to appear on the antiquities market in Tehran (Fukai 1973; *idem* 1977, p. 23). These discoveries prompted Tokyo University to mount, in 1960, the first of several archeological expeditions to Gilan, in the course of which Parthian and Sasanian graves containing glass were excavated at Hassanimahale near Dailaman (Sono and Fukai 1968).

The new finds from Iran included cups and bowls with wheel-cut ornament that often consisted of overall "honeycomb" patterns of hollow hexagonal facets. These objects led to a reassessment of a well-known facet-cut bowl in the Shoso-in Treasury at Nara, Japan, which is believed to have been donated to the shrine by Emperor Shomu in A.D. 752. Lamm (1929–30, v. 1, p. 149, no. 5, and v. 2, pl. 53.5) had attributed the bowl in the Shoso-in to the eighth century; but now Shinji Fukai (1960) was able to show that it is Sasanian. Fukai also noted examples of similar bowls not only from Iraq and Iran, but also from the Caucasus and Central Asia. In the same year, Seiichi Masuda (1960a and 1960b) published preliminary accounts of Sasanian glass from Iran.

Shortly afterward, Axel von Saldern (1963) published a groundbreaking paper on Achaemenian and Sasanian cut glass. In his paper, Saldern defined the characteristics of Sasanian cut glass and expressed the hope that the glass of the Sasanian Empire would help to close the gap between the very much better known cut glass of the late Roman and early Islamic periods.

Among the objects illustrated by Saldern are **46**, **51**, **62**, and **64** in this catalog. In a subsequent paper, Saldern (1967) argued that some of the elaborate cut glass in the Treasury of San Marco, Venice, which was brought from Constantinople in 1204 and is often taken to be Byzantine, was made in Iraq or northern Iran between the late sixth and eighth centuries: that is, in late Sasanian or early Islamic times. (The origin of these objects is still a matter of debate.)

The contents of the annual "Recent Important Acquisitions" section of the *Journal of Glass Studies* reflect the new interest in Sasanian glass, and they suggest that the market for it was particularly active in the decade between 1963 and 1972. During this period, 30 Sasanian or supposedly Sasanian objects appeared —more than four times the number of Sasanian glasses in all other volumes of the *Journal* published between 1959 and 2004.

In 1973, Fukai published *Perushia no Garasu* (Persian Glass), in which he summarized the history of glass in Iran from the Bronze Age to the 18th century, but with the emphasis on Parthian and Sasanian glass. The book appeared in English in 1977. Fukai's monograph includes a classification of facet-cut objects and numerous illustrations of Sasanian glasses, many of which were in private collections in Japan.

Despite the pioneering studies of Fukai and Saldern, Sasanian glass has yet to enter the mainstream of glass studies. The 15 volumes of the *Annales* of the International Association for the History of Glass, which contain papers delivered at the association's congresses from 1959 to 2001, include just two contributions on Sasanian material (Meyer 1996, which is extensive, and Price and Worrell 2003, which is very short), and the 46 volumes of the *Journal of Glass Studies* published between 1959 and 2004 do not contain a single article on Sasanian glass. During the same period, however, a number of reports on archeological excavations in Iran and Iraq that contain Sasanian glass objects appeared (see below), most notably Mariamaddalena Negro Ponzi's detailed account of the glass from an old excavation at Tell Mahuz in northern Iraq (Negro Ponzi 1968–9).

One consequence of the comparative neglect of Sasanian glass, coupled with the fact that most "Sasanian" glass vessels in public and private collections are without provenance, is that we are not always confident about distinguishing between what is and what is not Sasanian. A striking example of this uncertainty is a deep green bell beaker that Prudence Oliver Harper (*Royal Hunter* 1978, p. 158, no. 81) and I (*Splendeur des Sassanides* 1993, p. 269, no. 118) identified as Sasanian because a somewhat similar beaker in the National Museum, Tokyo, has, on the base, the molded figure of a rooster in "pure Sasanian style." Smith (1957, pp. 115–116), on the other hand, had identified two somewhat similar objects, apparently found in Tunisia, as made in the eastern part of the Roman Empire, while I later described the Corning beaker as Frankish (Whitehouse 2001, pp. 153–154, no. 670). More generally, scholars have sometimes struggled to distinguish between Sasanian and post-Sasanian metalwork (Fehérvári 1976, p. 25), architecture (Oscar Reuther [1938, p. 493] regarded a building at Sarvistan, southern Iran, as Sasanian, while Lionel Bier [1986, pp. 48–53] argued that it is Islamic), and objects in other media, such as the glass appliqués described on pages 30–40.

## 2. Sasanian Glass from Archeological Excavations in Iran and Iraq

Most Sasanian glasses that appear on the market are said to be from Iran, rather too often allegedly from Amlash (which Negro Ponzi [1987, p. 272] aptly described as a provenance "*de convenance*") or, more vaguely, from Gilan Province, whereas most of the published material from controlled excavations was found in Iraq (for a list of sites in northern Iraq that have yielded glass of the Sasanian period, see Simpson 1996, p. 103). This disparity means that our knowledge of the distribution of specific types of Sasanian glass, which depends on reliably reported find-places, has serious limitations. Nevertheless, it seems useful to review what we know about where certain varieties of Sasanian glass have been found. Additional information appears in the individual catalog entries.

A pressed glass plaque, presumably similar to **1**, was found during excavations in the Sasanian palace at Ctesiphon, 35 kilometers southeast of Baghdad (Puttrich-Reignard 1934, pp. 46–47).

Three rims and necks of plain blown vessels that may have been similar to **2** were excavated at Qasr-i Abu Nasr, six kilometers southeast of Shiraz in southern Iran (Whitcomb 1985, p. 156, z, aa, and cc). At least two complete bottles of this type, acquired from antiquities dealers, are said to be from Iran.

Turning to vessels with mold-blown ornament, dropper flasks similar to **3** have been excavated at several sites in Iraq, including Tell Mahuz, 50 kilometers west of Kirkuk (Negro Ponzi 1968–9, p. 342, no. 46); Kish, 90 kilometers south of Baghdad (Harden in Langdon and Harden 1934, p. 134, nos. 19 and 20); and Abu Skhair, 25 kilometers southwest of Najaf (Negro Ponzi 1972, p. 230, no. 38, with three small feet; cf. pp. 235–237, nos. 55–62).

Several vessels with applied decoration that appear in this catalog have parallels from archeological sites in Iraq. Vessels similar to **6** have been reported from Tell Mahuz (Negro Ponzi 1968–9, p. 358, no. 70, which has the same form but different decoration; it was associated with a coin of Shapur II [r. 309–379]), Kish (Harden in Langdon and Harden 1934, p. 132, nos. 3 and 4, again with a similar form but different ornament), and perhaps Choche (Ctesiphon: Negro Ponzi Mancini 1984, p. 35 and fig. 3, no. 11). **7** has parallels from Choche (*ibid.*, p. 35 and fig. 3, no. 110) and Uruk (Warka), 150 kilometers southeast of Baghdad (Van Ess and Pedde 1992, p. 170, nos. 1272 and 1273). A third parallel was excavated at ed-Dur in the emirate of Umm al-Qaiwain on the west coast of the Oman Peninsula (Lecomte 1993, p. 201 and fig. 14, no. 5, attributed to the third century). A fragmentary bowl resembling **8** was found at Kish (Harden in Langdon and Harden 1934, p. 132, no. 3). A vessel with a similar form but different ornament is reported to be from Joban in Gilan Province, northern Iran (Booth-Clibborn 2001, p. 452). Bowls decorated with prunts, similar to **11**, **12**, and **13**, come from Tell Mahuz (Negro Ponzi 1968–9, p. 336, no. 68), Hassani-mahale in the Dailaman region of northern Iran (Sono and Fukai 1968, pls. 30, 31, and 41.1 = Fukai 1977, pp. 26–27 and figs. 11 and 48–51), and ed-Dur (Lecomte 1993, p. 201 and fig. 14, no. 4).

Among the Sasanian and post-Sasanian appliqués from blown glass vessels, **37**–**44**, which are decorated with human heads, have parallels from three sites in southern Iran: Qasr-i Abu Nasr (Whitcomb 1985, pp. 158–159, fig. 59c); Istakhr, 60 kilometers northeast of Shiraz (Whitcomb 1995, p. 199, fig. 7); and Tall-i Zohak, 140 kilometers southeast of Shiraz (Stein 1936, p. 142, fig. 29.27). An example published by Kröger (1984, pp. 135–136, no. 113) was acquired at Isfahan in central Iran.

Sasanian vessels with cut and polished decoration have a wide distribution in Iraq and Iran, and isolated examples have been found in Yemen (*Yémen* 1997, p. 209), the Caucasus, Central Asia, and the Far East (see below). Cups with overall patterns of hollow facets, similar to **46**–**48**, have been published from at least seven sites in Iraq: Nineveh (Kuyunjik), which is on the east bank of the Tigris opposite Mosul (Simpson 1996, p. 97, fig. 2.1); Ctesiphon (Kühnel and Wachsmut 1933, pp. 29–30, fig. 50); Choche (Negro Ponzi Mancini 1984, p. 33, nos. 36 and 40); and Tell Baruda (Negro Ponzi 1987, p. 272, fig. C) (all of these are very close to one another); Kish (Harden in Langdon and Harden 1934, pp. 131–133, no. 7); Babylon, 80 kilometers south of Baghdad (Lamm 1929–30, v. 1, p. 151,

no. 4, and v. 2, pl. 54, no. 4); and Uruk (Van Ess and Pedde 1992, pp. 167–168, nos. 1240–1246). The find-places in northern Iran include Tureng Tepe, 320 kilometers northeast of Tehran (Boucharlat and Lecomte 1987, p. 173 and pl. 99, no. 9); Shahr-i Qumis, 220 kilometers east of Tehran (Hansman and Stronach 1970, p. 35, fig. 13.10); and sites in Gilan Province (Fukai 1977, pp. 34–37). Among the find-places in adjacent regions are: Sudagilan, Azerbaijan (Fukai 1977, p. 37, fig. 25) and Garni, Armenia (*ibid.*, p. 38, fig. 26). Finally, two fragmentary cups, which may have been similar to **50**, were excavated at Tureng Tepe (Boucharlat and Lecomte 1987, p. 173, pl. 99, no. 6, and pl. 100, no. 14).

Excavated examples of other varieties of cut glass include fragments resembling **50**–**52** from Qasr-i Abu Nasr (Whitcomb 1985, p. 156 and fig. 58k); parallels for **54** and **55** from Kish (Fukai 1977, p. 47, fig. 45 = Harden in Langdon and Harden 1934, p. 132, no. 11); and tubes similar to **66** from Nineveh (Simpson 1996, p. 125, fig. 2, no. 3 = *Masterpieces of Glass* 1968, p. 106, no. 136), Tell Baruda (Negro Ponzi 1987, p. 272, no. 348), and Qasr-i Abu Nasr (Whitcomb 1985, p. 158, fig. 59e, identified as part of a tube in *Royal Hunter* 1978, p. 157).

Finally, a bead closely similar to **72** was excavated at Hassani-mahale (Fukai 1977, p. 27).

Needless to say, we eagerly await the publication of Jens Kröger's report on the Parthian, Sasanian, and early Islamic glass from the excavations at Ctesiphon in 1928–1929 and 1931–1932, which promises to tell us much about the glassware available in one of the principal cities of the Sasanian Empire (Kröger forthcoming).

### 3.  Sasanian Glass from Datable Tombs in China and Japan

At least seven objects at Corning have parallels from datable tombs in China and Japan:

**11**. Tomb of Hua Feng near Beijing, datable to the period of the Western Jin dynasty, 265–316 (Laing 1991, p. 111 = An 1986, p. 174).

**46** and **47**. Tomb of Liu Zong (d. 439) at Chuncheng, Jurong, in Jiangsu Province, China (*China: Dawn* 2004, pp. 61 and 211, no. 117); and tomb of Emperor Ankan (d. 535) in Osaka Prefecture, Japan (Fukai 1977, p. 39 and fig. 30).

**50**–**52**. Tomb of Li Xian (d. 569) and his wife Wu Hui (d. 547) at Guyuan in Ningxa Hui Autonomous Region, China (*China: Dawn* 2004, pp. 61 and 258, no. 158 = *Monks and Merchants* 2001, p. 97, no. 30 = An 1986).

**64**. Tomb of a Buddhist monk (d. 589) at Xi'an in Shaanxi Province, China (*China: Dawn* 2004, p. 324, no. 219 = Joo 2003, p. 171, fig. 2).

## 4.   The Contents of the Catalog

The catalog is divided into eight sections, labeled A–H, usually on the basis of the technique used to form or finish the objects. Section A contains a single object formed by pressing molten glass in a mold. Sections B–D consist of blown vessels: the one in section B is without decoration, in C the decoration was mold-blown, and in D it was applied. Section E presents stamped or pressed appliqués, section F is devoted to blown and cast vessels with facet-cut ornament, section G contains beads, and section H discusses one modern forgery.

## 5.   Catalog Entries

Each entry contains all or most of the following information:

1. Catalog number and name.
2. Date, find-place, previous collections, and accession number.
3. Dimensions.
4. Description.
5. Condition.
6. Comment.
7. Bibliography.

1. *Catalog number and name.* Catalog numbers are arbitrary. Names are either generic (e.g., bowl) or they describe the object (e.g., plaque with *senmurv*).

2. *Date, find-place, previous collections, and accession number. Date:* None of the objects in the catalog comes from a well-documented archeological excavation. The dates, therefore, are suggested on the basis of received opinion or comparison with similar objects that were recovered during archeological excavations, in association with other, datable material. Unless specified otherwise, all dates in the catalog entries are A.D./C.E. *Find-place:* In most cases, places where objects are reported to have been found or acquired are prefaced by the phrase "said to have been found at/acquired in." Place names appear without qualification only when the information is independently corroborated; in such cases, further details are given in the *Comment. Previous collections:* This is a list of previous owners (other than dealers), in chronological order. *Accession number:* The Museum's three-part accession number records, first, the year in which the object was acquired; second, the area of the collection to which it is assigned; and finally, the cumulative number of objects acquired in that area during the year. The accession number 62.1.4, for example, indicates that the object was acquired in 1962, was assigned to the "ancient and Islamic" part of the collection (which includes Sasanian glass), and was the fourth ancient or Islamic item acquired in that year.

3. *Dimensions.* All dimensions are in centimeters (cm). The following abbreviations are used: D. (Diameter), Dim. (Dimension), H. (Height), L. (Length), Max. (Maximum), Th. (Thickness: a single dimension describes a relatively consistent thickness; otherwise, the thickness is given as a range—e.g., 0.4–0.5 cm), and W. (Width).

4. *Description.* Descriptions proceed from the top of the object to the bottom. The glass is described as transparent, translucent, or opaque. The colors are described, arbitrarily, as very pale, pale, light, dark, or very dark. The term "colorless" is reserved for glass that is assumed (or known) to have been intentionally decolorized.

5. *Condition.* Objects that are essentially without damage are described as "intact"; objects that have been damaged and repaired without loss are described as "complete." The condition of other damaged objects is briefly stated, as are the appearance and extent of weathering.

6. *Comment.* The *Comment* may include additional information on the technique, subject matter, and history of the object, or a discussion of comparable material. In many cases, the discussion includes a list of similar objects. The reader should be aware that these lists may contain duplicate entries, especially when the comparanda appear in sale catalogs. Such items may have been offered for sale more than once, or passed from the market to a public or private collection and subsequently been published. Unless an object is distinctive, clear photographs of it appear in the relevant sale catalogs, or its movements are well documented, a second or third appearance may have gone unnoticed.

7. *Bibliography.* This is restricted to publications of the object in question. Publications that describe parallels and related material are cited in the *Comment.*

# CATALOG

# PLAQUE FORMED BY PRESSING

The most common surviving form of Sasanian architectural decoration is stucco (Kröger 1993). Nevertheless, excavations in the palace built by Shapur I (r. 241–272) at Bishapur, southern Iran, revealed the presence of mosaics (Ghirshman 1956), and several Arab historians reported that the walls of the late Sasanian palace at Ctesiphon were decorated with mosaics and glass plaques (Reuther 1929, p. 445). Excavations in the palace revealed one such plaque: a yellowish brown mold-pressed roundel decorated with a guinea fowl (Puttrich-Reignard 1934, pp. 46–47). A fragmentary plaque of deep blue glass, decorated in low relief with the head of a Sasanian king, possibly Shapur II (r. 309–379), was on the market in 1985 (information on file at Corning); its date and present location are unknown.

1. **Plaque with *Senmurv***

Perhaps 6th to 7th century. 64.1.31.
Max. Dim. 8.7 cm, Th. 0.8 cm.
Translucent deep blue. Mold-pressed.

Plaque: apparently oval or elliptical. Upper surface flat; edge rounded; lower surface slightly convex. Upper surface decorated in relief: *senmurv*, facing left, with half-open beak, short horn above beak, and ears pointing back; legs are thrust forward and up, with claws pointing to front; wings curve forward at tips and, on nearer wing, coverts are indicated by dotted scales; tail feathers are also represented by dotted scales.
Incomplete. Dull, pitted, and slightly iridescent, with large areas of gray and brown enamellike weathering.

*1*

COMMENT: Although at first sight the object appears to be circular, it is not. Apparently it was an oval or elliptical plaque, with the width greater than the height. The *senmurv* may be compared with the *senmurv*s that adorn the clothing of the mounted Sasanian king (Khosrow II, r. 580–628) depicted in a bas-relief at Taq-i Bustan, Iran, which was carved about 600 (*Royal Hunter* 1978, p. 121, fig. K, and p. 123, fig. M), and that appear on other late Sasanian and post-Sasanian objects, such as a seventh- or eighth-century silver-gilt dish in The British Museum (*Splendeur des Sassanides* 1993, pp. 220–221, no. 71) and the eighth- or ninth-century caftan from Mochtchevaja Balka in the northern Caucasus (*ibid.*, pp. 275–277, nos. 127 and 128).

The *senmurv* was a mythical creature with the head of a dog, wings, the claws of a lion, the tail of a peacock, and the scales of a fish. It represented the *khvarnah* (glory and good fortune) of the Kayanids, the legendary ancestors of the Sasanians. The presence of *senmurv*s on the royal robes depicted at Taq-i Bustan shows that they were also associated with the *khvarnah* of Sasanian kings (Vanderheyde 1994; Marshak 1998, pp. 84–85).

BIBLIOGRAPHY: "Recent Important Acquisitions," *JGS*, v. 7, 1965, p. 123, no. 13; *Sasanian Silver* 1967, p. 149, no. 72; *Persian Glass* 1972, p. 10, no. 8; *Splendeur des Sassanides* 1993, p. 270, no. 119.

# BLOWN VESSEL WITHOUT DECORATION

It is generally agreed that glassblowing was discovered in the Syro-Palestinian region in the first century B.C., and by the middle of the first century A.D. it had become the most common technique for forming glass vessels throughout the Roman world (Stern 1995, pp. 37–42). Excavations at Seleucia-on-the-Tigris and elsewhere in Iraq have demonstrated that blown glass was being produced locally in the first century A.D. and was used alongside imported Roman objects (Negro Ponzi 2002). When glassblowing had been established in Mesopotamia, it flourished there, and at a date that has not yet been determined, it was introduced on the Iranian plateau.

## 2.  Bottle

3rd to 7th century. Gift of the Wunsch Foundation Inc. 2005.1.1.
H. 9.4 cm, D. (rim) 3.3–3.5 cm, (max.) 13.5 cm.
Translucent deep green, with bubbles up to 1.1 cm long. Blown.

Bottle with oblate spheroid body. Rim everted, with rounded edge, flat top, and narrow mouth, made by folding up and in; neck short, with vertical side; lower wall merges with plain base, which has incomplete annular pontil mark (D. 1.2 cm).

Intact. Dull and extensively pitted, with remains of opaque brown weathering, especially in pits.

**COMMENT:** Bottles of this distinctive type are generally regarded as Sasanian, and several examples have been found in Iran. They include: (1) *Masterpieces of Glass* 1968, p. 105, no. 135 (The British Museum, WA 1961.11-14.1, dark green, "found in Persia" = *British Museum Quarterly*, v. 26, 1962–1963, p. 100; "Recent

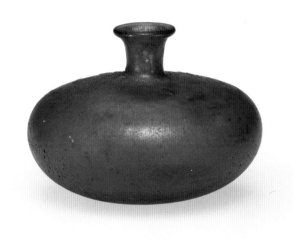

*2*

Important Acquisitions," *JGS*, v. 6, 1964, p. 157, no. 4; Yoshimizu 1992, p. 190, fig. 145); and (2) Fukai 1977, pl. 39 (then in a private collection, Tokyo, green, found in "Gilan province," northern Iran). For the necks of three apparently similar vessels, found during excavations at Qasr-i Abu Nasr, southern Iran, see Whitcomb 1985, p. 156, z, aa, and cc.

Two bottles of this type have been found in China: at Guanlin, Luoyang, in Henan Province (Yoshimizu 1992, p. 190, fig. 144; *China: Dawn* 2004, pp. 324–325, no. 220), and at another site near Luoyang (it is now in the Royal Ontario Museum, Toronto, acc. no. 933.12.3).

Other examples include: (1) Dusenbery 1971, p. 28, no. 53 (formerly in the collection of Wheaton College, Norton, Massachusetts); (2) *Hentrich Collection* 1974,

p. 236, no. 367 (Kunstmuseum Düsseldorf, P 1973-74, green); and (3) Oliver 1980, p. 132, no. 231 (Carnegie Museum of Natural History, Pittsburgh, 23159/2, "natural green"). Dusenbery (1971) noted a bottle of the same type in the Rijksmuseum van Oudheden in Leiden, the Netherlands. Fukai (1977, caption of pl. 39) reported that a similar object was found at Banbhore, Pakistan.

The following objects may be of the same type, although it is difficult to judge from the published drawings: Lamm 1929–30, v. 1, p. 26, and v. 2, pl. 1, 1 and 2 (both green, found together in a collective tomb at Jericho, West Bank, associated with coins of the fourth and fifth centuries).

# C

# VESSELS WITH MOLD-BLOWN ORNAMENT

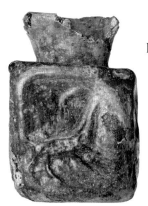

It is probable that the technique of blowing glass in molds that in one operation imparted shape, size, and ornament was discovered (like the technique of glassblowing itself) in the Syro-Palestinian region, in the first or second quarter of the first century A.D. (Stern 1995, pp. 65–66). The use of molds spread quickly in the Roman world. They were introduced in Mesopotamia, too, and first- and second-century mold-blown vessels from a number of sites are sufficiently different from Roman products to suggest that they were made locally. Among the glasses from Mesopotamia in The British Museum, for example, is an imitation of a Roman bottle shaped like a date, which was found at Babylon (Barag 1985, pp. 92 and 94, no. 120), and a somewhat different imitation of a date-shaped bottle was found at Seleucia-on-the-Tigris (Negro Ponzi 2002, pp. 104–105 and 132, fig. 6.8). There is no reason to doubt that, after its introduction in the first century, mold blowing was practiced continuously in Parthia and the Sasanian Empire.

## 3. Dropper Flask

About 3rd to 5th century. Gift of the Hon. and Mrs. Amory Houghton. 56.1.1.
H. (rim) 7.6–8.2 cm, D. (rim) 5.5 cm.
Transparent pale yellowish green. Mold-blown; handles applied.

Dropper flask: spheroid, somewhat lopsided. Rim folded out, down, and up to form broad, somewhat asymmetrical mouth, with seating for lid; neck short, cylindrical, with, at bottom, diaphragm made by folding; base has, at edge, three small, roughly triangular feet made by pinching, and low kick; pontil mark. Wall

has continuous band of vertical mold-blown ribs, which are prominent at top but rapidly become faint, and are scarcely visible at bottom. Two opposed handles, with narrow, roughly circular cross sections, dropped onto wall just above midpoint, drawn up, and reattached to outside of rim; lower, rather thick attachments pinched into two horizontal semicircular lugs; upper attachments pinched into single semicircular lugs, which project out and up.

Incomplete. Handles mostly missing: only attachments survive; one upper attachment lacks lug, and one lower attachment lacks one of two lugs. Partly covered with glossy yellowish brown enamellike weathering; elsewhere, surface is dull, with little iridescence. Earth still adheres to inside of rim.

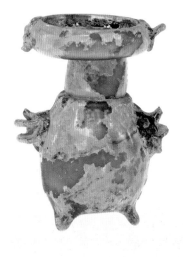

**COMMENT:** Dropper flasks came into use in parts of the eastern Roman Empire, notably Syria, in the third century (Clairmont 1963, p. 41, no. 157, from Dura-Europos, before 256; Stern 1977, pp. 95–100, nos. 27A, B). Most Syrian dropper flasks are globular or pear-shaped, and they frequently have mold-blown decoration that includes overall geometric patterns or applied ornament with "snake-thread" patterns. A second, distinctive group of dropper flasks is found in Iraq, but not in Syria. Most of these Mesopotamian (presumably Sasanian) flasks are spheroid, and they may be decorated with vertical or swept mold-blown ribs or overall geometric patterns, pinched vertical flanges, or spiral trails (but not snake-thread motifs). Find-places of flasks of Mesopotamian type include: (1) Tell Mahuz (Negro Ponzi 1968–9, p. 342, no. 46), (2) Kish (Harden in Langdon and Harden 1934, p. 134, nos. 19 and 20), and (3) Abu Skhair, near Hira (Negro Ponzi 1972, p. 230, no. 38, with three small feet; cf. pp. 235–237, nos. 55–62, which are small spheroid flasks with vertical ribs very similar to the ribs on **3**). For a flask with a diaphragm at the bottom of the neck, a conical body, and a handle, found at Kish, see Harden in Langdon and Harden 1934, p. 136, no. 37.

## 4. Bottle

5th to 7th century. Formerly in the Smith Collection (1394). 66.1.23.
H. 8.3 cm, D. (rim) 4.7 cm, W. (body) 7.1 cm.
Transparent pale yellowish green. Body blown in mold with four vertical sections and separate baseplate.

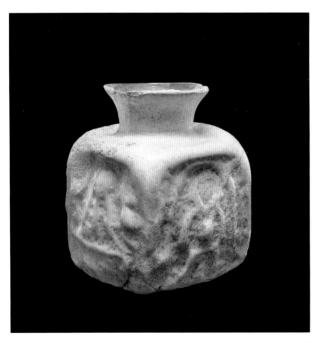

*4*

Bottle with cuboid body. Rim shaped like funnel, with rounded lip; shoulder flat and depressed on one side, with rounded edge; wall vertical; base plain, very slightly concave; circular pontil mark (D. 0.8 cm). Decorated in low relief on all four sides (clockwise): (1) at center, ring-and-dot motif, with open circle adjoining it at top and two narrow projections at bottom, with indistinct element between them, all within large parabolic arch; (2) tripod-like motif with bulbous top, supported on structure with flat top and flanked by two vertical elements; (3) possibly human figure, standing frontally, with unidentified elements to right and left; (4) unidentifiable motifs. Underside of base may also be decorated in low relief; it is uneven, possibly because it bears indistinct molded ornament.

Incomplete. Broken into at least 13 pieces; almost half of rim and small part of lower wall missing. Large part of exterior has opaque pale yellow to pink enamellike weathering; elsewhere, surface is matte and pitted, with traces of weathering.

**COMMENT:** According to R. W. Smith (in *Glass from the Ancient World* 1957; see below), the object "was in Iraq, and may have been found there."

As Smith observed, the decoration is "virtually impossible to interpret," and none of the motifs closely resembles ornament on the various types of mold-blown bottles, pitchers, and jars made in the Syro-Palestinian region (e.g., Stern 1995, pp. 247–269, nos. 169–193; and Whitehouse 2001, pp. 97–109, nos. 590–601). Side 1 has an arch, but this is parabolic and in no way resembles the aediculae on vessels from the Holy Land. Side 3 may have a standing figure, but this is uncertain.

For two mold-blown bottles with a similar form, see Eisen 1927, v. 2, p. 609 and pl. 148d, e.

**BIBLIOGRAPHY:** *Glass from the Ancient World* 1957, p. 209, no. 414.

## 5. Bottle

Perhaps 5th to 7th century. Formerly in the Smith Collection (388). 66.1.22.
H. 6.7 cm, D. (rim) 3.5 cm, W. (body) 4.8 cm.
Translucent bluish green. Body blown in mold with four vertical sections.

Bottle with four sides, somewhat distorted. Rim plain, with rounded lip; neck short and tapering; flat, overhanging shoulder; body has vertical walls; base pushed in at center; pontil scar. Mold-blown decoration on all four sides of body; in each case, running

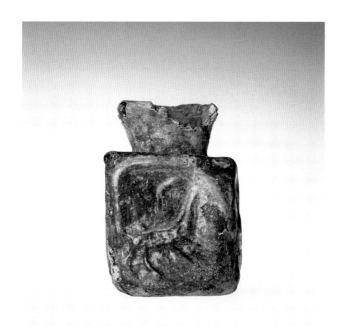

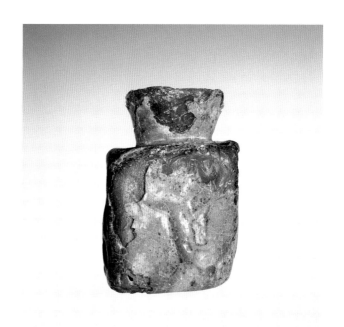

5A

5B

ibex, facing right; on sides (1) and (2), horizontal; on sides (3) and (4), vertical, with head toward top.

Incomplete. One-quarter of rim missing; neck repaired; shoulder restored at one corner. Covered with thick crust of dark green to mid-brown weathering, some of which has flaked off, revealing color of the glass.

**COMMENT:** Presumably, like **4**, this object is Sasanian. The ibexes are reminiscent of stamped ornament on certain Sasanian ceramics (e.g., Simpson 1996, fig. 1, from Nineveh, northern Iraq).

# VESSELS WITH APPLIED ORNAMENT

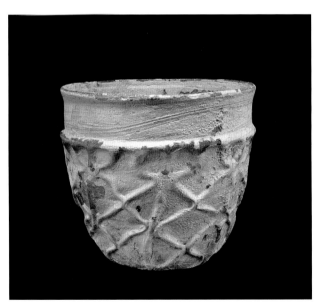

Decoration consisting of applied trails and blobs of glass may not have entered the repertoire of glassmakers located to the east of the Roman frontier until the late second or early third century (Negro Ponzi 2002, pp. 100–101). Late Parthian or early Sasanian applied decoration consisted mainly of rather thick zigzags and spirally wound trails (e.g., a group of small vessels from the Saar cemetery, Bahrain: Nenna 1999, p. 188, nos. 295–300). Somewhat later vessels include bowls with vertical trails that may be nipped to form patterns of diamonds and other motifs (e.g., **6–8**) and vessels decorated with a combination of trails and prunts (e.g., **11–13**).

## 6. Bowl

4th to 6th century. Formerly in the Strauss Collection (S2610). Bequest of Jerome Strauss. 79.1.254.
H. 10.2 cm, D. (rim) 11.0 cm.
Transparent light green. Blown; applied.

Bowl: roughly hemispherical. Rim slightly everted, with rounded lip; base flat and slightly concave; pontil mark. Apart from plain zone below rim, wall is covered with trailed decoration: at top, continuous horizontal rib; below this and extending to bottom of wall, overall lattice pattern consisting of seven vertical trails, each separated from its neighbors by two adjoining zigzag trails that form panel of triangular and diamond-shaped motifs.

Intact. Most of vessel covered both inside and outside with opaque pale honey-colored weathering; this is matte, locally pitted and generally liable to flake, with some patches missing.

COMMENT: Similar objects have been reported from sites in Iraq, such as: (1) Tell Mahuz, 65 kilometers from Kirkuk (Negro Ponzi 1968–9, p. 358, no. 70, which has the same form but not the same decoration, and was associated with a coin of Shapur II [r. 309–379]), (2) Kish (Harden in Langdon and Harden 1934, p. 132, nos. 3 and 4, which have a similar form but different mold-blown ornament), and (3) perhaps Choche (Negro Ponzi Mancini 1984, p. 35 and fig. 3, no. 11).

*6*

## 7. Bowl

About 3rd century. 63.1.10.
H. 10.2 cm, D. 10.9 cm.
Transparent pale olive green, with small bubbles. Blown; applied.

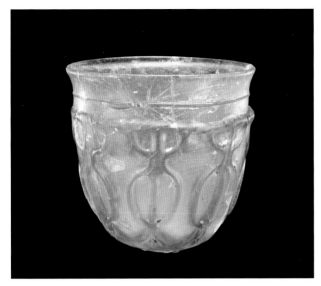

*7*

Bowl: deep, with wall that curves in toward bottom. Molded decoration occupies most of wall and consists of continuous band of ornament: seven groups of three vertical ribs, each group nipped so that central rib remains vertical, but two outer ribs curve inward and touch it in two places; one continuous horizontal rib at top and at bottom of band. Single horizontal trail wound once around wall between rim and upper rib.

Incomplete. Broken, with small losses from rim and wall; restored. Dull, with small patches of iridescent silver weathering.

**COMMENT:** Parallels include fragmentary bowls from Choche (Ctesiphon), central Iraq (Negro Ponzi Mancini 1984, p. 35 and fig. 3, no. 110), Uruk (Warka), southern Iraq (Van Ess and Pedde 1992, p. 170, nos. 1272 and 1273); and ed-Dur, United Arab Emirates (Lecomte 1993, p. 201 and fig. 14, no. 5, attributed to the third century); and a bowl, said to be from Gilan Province, northern Iran, which Fukai (1977, caption to pl. 16) attributed to the first to third centuries A.D.

Similar bowls with pairs of nipped vertical ribs include a fragment excavated at Kish, Iraq (Harden in Langdon and Harden 1934, p. 134, no. 26) and a vessel of unknown provenance in the Cohn Collection at the Los Angeles County Museum of Art ("Recent Important Acquisitions," *JGS*, v. 31, 1989, p. 103, no. 8 = *Cohn Collection* 1980, p. 152, no. 146). *Antiquities and Islamic Works of Art* 2000, p. 11, lot 19, and a beaker in The British Museum, London (WA 1970-2-3,1/135208), also have nipped pairs of ribs without the straight central elements.

**BIBLIOGRAPHY:** *Sasanian Silver* 1967, p. 156, no. 81; *Persian Glass* 1972, p. 10, no. 9; *Splendeur des Sassanides* 1993, p. 268, no. 117.

## 8. Bowl

About 4th century. Formerly in the Strauss Collection (S2471). Bequest of Jerome Strauss. 79.1.240.
H. 10.0 cm, D. 10.7 cm.
Transparent light green; very bubbly. Blown; applied.

Bowl with curving side. Rim plain; upper wall tapers slightly, then bulges before curving in to bottom; base narrow, slightly pushed in; pontil mark. Decoration consists of 21 spiraling ribs that extend from bulge below rim to base.

Intact. Large areas, especially on interior, have cream to pale brown weathering and accretion; where this is missing, surface is slightly iridescent.

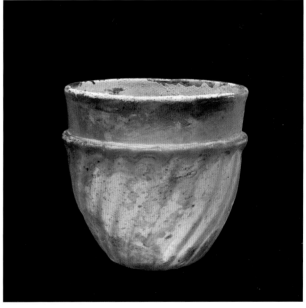

*8*

**COMMENT:** A fragment of a bowl decorated with spiraling ribs was excavated at Kish, southern Iraq (Harden in Langdon and Harden 1934, p. 132, no. 3). A similar but taller example with no known provenance appears in *Antiquities* 1985, n.p., lot 11. A vessel of similar form but with vertical ribs, from Joban in Gilan Province, northern Iran, is in the National Museum of Iran, Tehran (Booth-Clibborn 2001, p. 452). For another vessel with vertical ribs, see **9**.

## 9. Cup

4th to 7th century, or later. Formerly in the Strauss Collection (S2788A). Bequest of Jerome Strauss. 79.1.272.
H. 7.4 cm, D. 8.0 cm.

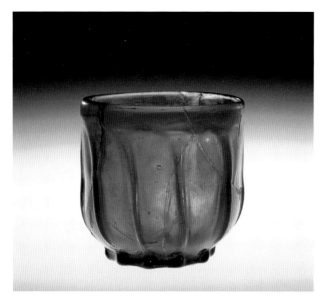

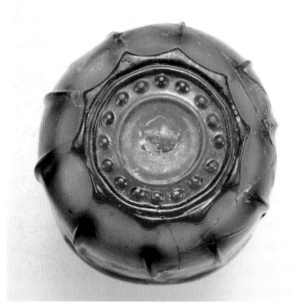

Transparent deep blue. Blown (parison inflated in dip mold).

Cup. Rim very slightly everted, with plain, rounded lip; wall descends vertically, then bulges slightly, and curves in at bottom; base disklike, with 10 sides; pontil mark. Mold-blown decoration: on wall, 10 ribs extending from base to near rim; these are vertical at bottom but bent toward left at top; on underside of base, recessed circular panel containing ring of 16 circular bosses between two concentric circles in relief.

Incomplete. Broken, with three large losses from rim and wall; restored. Dull and abraded in places; very little weathering.

**COMMENT:** The object recalls a mold-blown jug with a handle in the L. A. Mayer Memorial Institute for Islamic Art, Jerusalem (Hasson 1979, pp. 30 and 37, no. 55), which has a series of vertical ribs on the lower wall and two concentric rings of small circular bosses on the underside of the base. Rachel Hasson compared the bosses to the ring of bosses that forms the foot-ring of some Sasanian metal objects (e.g., *ibid.*, pp. 30 and 37, no. 53) and commonly surrounds decorative medallions in various media (e.g., *Splendeur des Sassanides* 1993, pp. 119 [silk textile]; 150, no. 9 [stucco plaque]; and 185–186, nos. 46 and 47 [silver-gilt harness mounts]). Hasson attributed the glass jug to the eighth or ninth century.

## 10. Goblet

About 4th to 6th century. Formerly in the Strauss Collection (S2744). Bequest of Jerome Strauss. 79.1.269.
H. 11.8–12.2 cm, D. (rim) 10.3 cm, (foot) 4.3 cm.
Transparent light green. Blown; applied.

Goblet with plain, rounded rim, slightly thickened on outside. Wall descends vertically before curving in to bottom; short, hollow stem; narrow foot with hemispherical kick; pontil mark. Decoration probably applied before inflation was completed: continuous horizontal trail, 1.6 cm below lip, and 23 more or less vertical trails extending from horizontal trail to foot.
Broken, with minor losses from wall; restored. Dull and pitted, with patches of brownish weathering and iridescence.

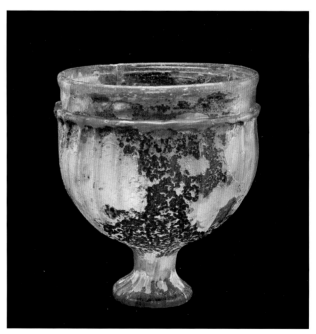

COMMENT: Some of the vertical trails were distorted as the object was twirled on the blowpipe or pontil.

## 11. Bowl

3rd to 4th century. Formerly in the Strauss Collection (S2600). Bequest of Jerome Strauss. 79.1.250.
H. 9.4 cm, D. 10.4 cm.
Transparent pale yellowish green. Blown; applied, and perhaps pinched.

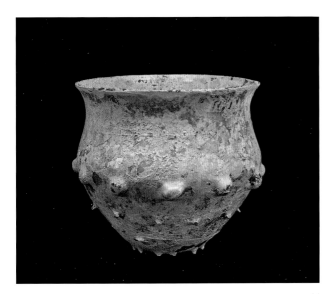

*11*

Bowl: biconical. Rim everted, with plain, rounded lip; wall splays to carination above midpoint and then tapers to bottom; base narrow, pushed in at center; pontil mark, roughly circular (D. about 1.5 cm). Decoration consists of horizontal trails and rows of prunts: at top of wall, very thin trail wound around body in about two revolutions; at carination, 11 prominent rounded prunts; on lower part of wall, 12 very small pointed prunts above very thin trail wound around body in 1⅓ revolutions, and one small isolated prunt; vessel stands on 12 very small pointed prunts at junction of wall and base.

Intact. Much of surface covered with opaque grayish pink weathering, with patches of iridescence.

COMMENT: The large prunts were made by applying blobs of molten glass, which softened the wall at the points of contact and created slight bulges on the inner surface. The small prunts seem to have been made by pinching the parison and pulling the glass away from the wall.

Several similar vessels have been found in archeological contexts in Iraq, Iran, and the United Arab Emirates. The find-places include: (1) Tell Mahuz, 65 kilometers from Kirkuk, northern Iraq (probably third to fourth centuries A.D.: Negro Ponzi 1968–9, p. 336, no. 68); (2) Hassani-mahale in the Dailaman region of northern Iran (dated by the excavators to the first to third centuries: Fukai 1977, pp. 26–27 and 48–50; also Sono and Fukai 1968, pls. 30 and 31); and (3) ed-Dur, Umm al-Qaiwain, United Arab Emirates (third century A.D.: Lecomte 1993, p. 201 and fig. 14, no. 4). Fukai (1977, pl. 15) illustrated a similar vessel in the collection of Saburo Matsumoto, Tokyo, which is said to have been found in Gilan Province, northern Iran.

A similar object was found in the tomb of Hua Fang near Beijing, China, which is datable to the period of the Western Jin dynasty (265–316) (Laing 1991, p. 111, fig. 7 = An 1986, p. 174).

Other examples of the same general type are in the Museum für Kunst und Gewerbe, Hamburg (Saldern 1968, p. 46 and fig. 7); the Victoria and Albert Museum, London (said to be from the Amlash region of northwestern Iran: "Recent Important Acquisitions," *JGS*, v. 11, 1969, p. 112, no. 17); the Museum für Islamische Kunst, Berlin (I. 1/71: Brisch and others 1980, p. 18, no. 3 = *idem* 1971, pp. 41–42, no. 110); the Kunstmuseum Düsseldorf (*Hentrich Collection* 1974, pp. 187–188, nos. 275 and 276); the L. A. Mayer Memorial Institute for Islamic Art, Jerusalem (Hasson 1979, pp. 6 and 35, no. 4); the Los Angeles County Museum of Art (*Cohn Collection* 1980, p. 151, no. 144); the Okayama Orient Museum, Japan (Taniichi 1987, p. 85, no. 82); and The British Museum, London (WA 1964-4-15,2/134374); a similar bowl is shown in *Brilliant Vessels* 2001, p. 16, no. 38. Saldern (in *Cohn Collection* 1980, p. 151) also noted examples from Susa, in the National Museum of Iran, Tehran, and from various Iraqi sites, in the Iraq Museum, Baghdad. See also *Antiquities* 2000b, p. 145, lot 171.

Cf. **13**.

## 12. Bowl

3rd to 4th century. Formerly in the Strauss Collection (S2430). Bequest of Jerome Strauss. 79.1.95.
H. 8.3 cm, D. 9.3 cm.
Transparent pale green. Blown; applied and pinched.

Bowl with everted rim and rounded lip. Wall descends vertically before curving in to bottom; base flat, with roughly circular pontil mark (D. 1.5 cm). At junction of rim and wall, one continuous horizontal trail. Upper wall has band of eight applied bosses, which are roughly square and flattened; lower wall

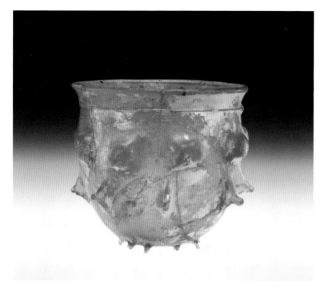

*12*

has band of eight projections, which are tall and narrow, with a triangular profile. At edge of base, 10 small "toes."

Incomplete. Broken, with small losses from rim and wall; restored. Dull, with remains of opaque light brown weathering and some iridescence.

**COMMENT:** This object may be compared with finds from archeological excavations in both Iran and Iraq. A close parallel, but with horizontal trails at the midpoint and on the lower wall as well as at the top of the wall, was found in Tomb VII, which also contained the remains of a "mature female" and other grave goods, at Hassani-mahale, near Dailaman, northern Iran (Sono and Fukai 1968, pp. 13–14 and pl. 41, no. 1; Fukai 1977, pp. 27 and 48–50, and figs. 11 and 49–51). A bowl of roughly the same form, with a band of tall and narrow projections on the lower wall, but without bosses on the upper wall, was found during the excavation of a cemetery at Tell Mahuz, northern Iraq, in 1937 (Negro Ponzi 1968–9, p. 356 and figs. 157 and 161, no. 68). The finds suggested that the cemetery was in use between the late third century and an undetermined date in the fourth century (*ibid.*, pp. 308–309).

Cf. bowls in the Kunstmuseum Düsseldorf (*Hentrich Collection* 1974, p. 188, no. 276, with bosses on the upper wall but no projections lower down); the Middle Eastern Culture Center, Tokyo (*Treasures of the Orient* 1979, pp. 150 and 261, no. 212); the Okayama Orient Museum (Taniichi 1987, pp. 19 and 85, no. 82); and the Museum für Kunst und Gewerbe, Hamburg ("Recent Important Acquisitions," *JGS*, v. 5, 1963, p. 145, no. 17; Saldern 1995, p. 79, no. 13 = *idem* 1963, pp. 46–47, fig. 7); and a bowl shown in *Brilliant Vessels* 2001, p. 16, no. 39.

## 13. Bowl

3rd to 4th century. 62.1.28.
H. 8.2 cm, D. 10.0 cm.
Transparent pale green, with numerous bubbles. Blown; applied.

Bowl: hemispherical. Rim tall and slightly everted, with plain, rounded lip; shoulder narrow and rounded; wall curves down and in; base narrow and slightly concave; pontil mark faint (and partly obscured by paper label). Decoration consists of horizontal trails and rows of prunts: on rim, very thin trail wound around body and almost completely melted into wall; on shoulder, 11 oval prunts; halfway down wall, 11 roughly oval prunts above very thin trail wound twice around circumference; vessel stands on ring of nine very small prunts at junction of wall and base.

Almost complete. Broken and repaired; small losses from lip, which is partly restored. Much of surface is covered with light brown enamellike weathering. Rectangular paper label, inscribed "HM/115/۶۵," gummed to underside of base.

**COMMENT:** See **11**.

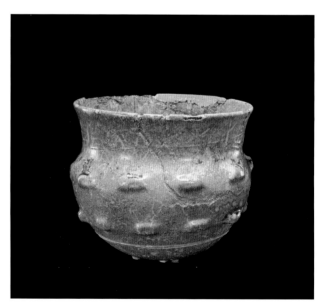

*13*

## 14. Bowl

4th to 6th century, possibly earlier. Formerly in the Strauss Collection (S2226). Bequest of Jerome Strauss. 79.1.221.
H. 5.8 cm, D. 13.7 cm.
Transparent greenish blue, with some bubbles. Blown; applied.

Bowl. Rim plain, with chamfered outer edge; wall curves down and in; base plain and narrow, slightly concave on underside and domed at center of floor; pontil mark. Decorated with 16 more or less vertical trails extending from slightly below rim (where they are very faint) to bottom of wall; alternate pairs of trails nipped in two places, producing chainlike effect.

Complete. Broken into two pieces and repaired, with loss of two small chips. Extensive patches of bluish gray to silver weathering.

COMMENT: Vessels decorated with nipped trails are commonly attributed to the Sasanian period, although Fukai (1977, p. 34 and caption to pl. 35) describes a green vase with this type of ornament (said to have been blown in a dip mold) as Parthian and of the first to third centuries A.D.

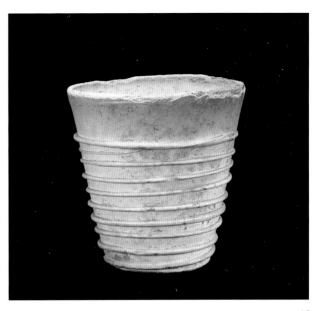

*15*

an, 3rd–6th century" (see below). The character of the glass is certainly compatible with this opinion, and spirally wound trails on walls of drinking vessels are known among Parthian and/or Sasanian vessels from northern Iran (e.g., Fukai 1977, pl. 10).

BIBLIOGRAPHY: "Recent Important Acquisitions," *JGS*, v. 9, 1967, p. 135, no. 14.

## 16. Flute

Perhaps about 3rd century. 70.1.6.
H. 28.4 cm.
Transparent pale green, with transparent pale green and translucent dark green trails. Blown (two gathers); applied.

Flute: cylindrical. Rim plain, with rounded lip; wall straight, tapering slightly, and curving in at bottom; stem short and solid; foot conical and hollow, with rounded edge, made from separate parison. Applied decoration of pale green and dark green trails. Just below rim, one thin horizontal trail wound twice around body; slightly below it, second trail wound once around body. Below this, occupying more than four-fifths of wall, broad band of continuous ornament consisting of four identical groups of vertical trails, each group comprising (from left to right) one flattened and crimped pale green trail, one plain pale green trail, and one flattened and crimped dark green trail; below this band, thin horizontal trail wound once around body.

Incomplete. Broken into many pieces and repaired; small losses restored. Brown to tan-colored enamellike weathering.

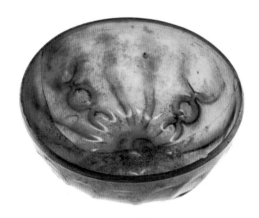

*14*

## 15. Beaker

Perhaps 3rd to 6th century. 66.1.254.
H. 11.9 cm, D. 11.5 cm.
Transparent pale yellowish green. Blown; applied.

Beaker. Rim plain, with rounded lip; wall straight, tapering, and curving in at bottom; base plain, slightly concave on underside; pontil mark. Single, rather thick trail wound spirally $10\frac{2}{3}$ times around wall, beginning 3.5 cm below lip and ending at junction with base.

Virtually intact, but with part of lip lost through weathering. Almost completely covered with ivory-colored weathering, which varies from glossy to matte.

COMMENT: When it was acquired by the Museum, the object was believed to be "probably Sassani-

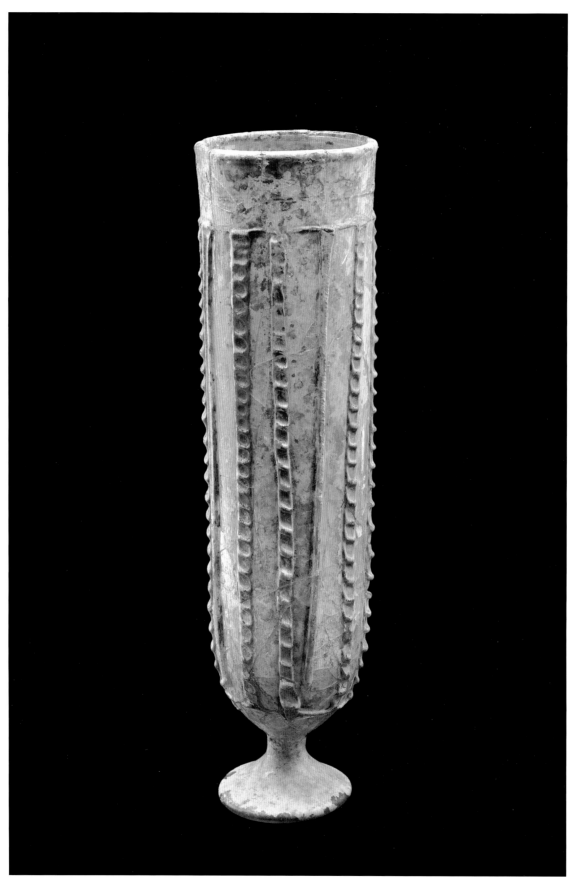

COMMENT: A very close parallel exists in the National Museum of Iran, Tehran (4034: *7000 Jahre persische Kunst* 2001, pp. 294–295, no. 162); indeed, the objects are so similar that one might reasonably conclude that they were made in the same workshop. Only two other Sasanian flutes are known to me: **58** and a vessel with five widely spaced horizontal bands of hollow circular or oval cut facets, which, when it was published by Fukai (1977, pl. 18), was in a private collection in Tokyo.

The form of these objects may be compared with that of flutes made in or near the Roman world, the best known of which are five glasses from Sedeinga, Sudan. The Sedeinga flutes consist of two colorless vessels with wheel-cut decoration, fragments of a light green vessel, and two blue vessels with gilded, enameled, and cold-painted decoration (Leclant 1973; Brill 1991). They were discovered in Tomb 8 in the western cemetery at Sedeinga, which is attributed to the second half of the third century A.D. It is assumed that the flutes were made in Egypt. For another Roman flute, see Whitehouse 1997, p. 251, no. 429.

BIBLIOGRAPHY: "Recent Important Acquisitions," *JGS*, v. 13, 1971, p. 137, no. 19; Charleston 1980, p. 63, no. 23; *idem* 1990, p. 63, no. 23; *Splendeur des Sassanides* 1993, p. 110 and fig. 95; *Guide to the Collections* 2001, p. 44.

## 17. Beaker or Lamp

4th to 6th century. Formerly in the Strauss Collection (S2608). Bequest of Jerome Strauss. 79.1.66.
H. 22.6 cm, D. 8.7 cm.
Transparent yellowish green, with many small bubbles. Blown (probably mold-blown); applied.

Beaker or lamp: conical. Rim plain, with rounded lip; wall straight and tapering; base narrow and slightly concave; pontil mark annular (D. about 2.2 cm). Wall decorated with 20 vertical trails extending from about 2 cm below lip to 1 cm above base; each

*17*

pair of trails was nipped together twice (at about 6 cm and 12–13 cm below lip), and individual trails in each pair were nipped together twice, with nearest trails in adjacent pairs (at about 8 cm and 15 cm below lip), thus creating irregular network of elongated rhomboids.

Incomplete. One small loss from upper wall; long crack extends from lip to lower wall, where it divides. Dull, with extensive remains of very pale brown to silver weathering and, on interior, white accretion.

COMMENT: Although both the form and the decoration are well known among Sasanian glass vessels (cf. *Splendeur des Sassanides* 1993, pp. 259–262, nos. 108–111 [conical vessels], and pp. 267–268, nos. 116 and 117 [nipped vertical trails]), the combination has no known parallel. Fragments of a plain vessel of this form were found during excavations at Kish, Iraq (Harden in Langdon and Harden 1934, p. 132, no. 14).

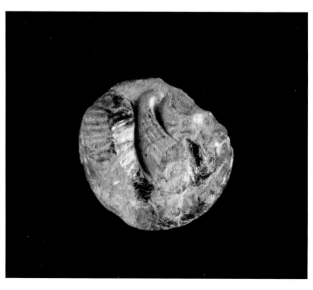

# APPLIQUÉS

V essels with appliqués are the most obvious examples in glass of the continued manufacture of Sasanian-style objects after the Muslim conquest. In two important papers, Kurt Erdmann (1950–1; 1953) published the well-known bowl in the Museum für Islamische Kunst, Berlin. The bowl is decorated with nine appliqués stamped with winged horses accompanied by inscriptions. In his first paper, Erdmann identified the inscriptions as Pahlavi, and he concluded that the bowl is Sasanian. In the second paper, he realized that the inscriptions are Arabic and that the bowl is Islamic.

A selection of appliqués, acquired in Cairo, formed the basis of a chronological and cultural analysis by Paul Balog (1974), who divided them into 12 types and attributed them to four groups:

I. Sasanian.
II. Probably Sasanian.
III. Post-Sasanian early Islamic.
IV. Islamic with no stylistic connection with Persia.

Groups I and II are self-explanatory. Balog considered group III to be early Islamic in date but made in the Sasanian tradition, and group IV to be early Islamic and without Sasanian antecedents. The 28 appliqués in this catalog belong to Balog's groups I–III, or are related to them.

The appliqués are decorated with the following motifs: a *senmurv* facing right (**18**), a winged horse walking to the left (**19–21**), a winged horse walking to the right (**22** and **23**), a horse (with rider) walking to the right (**24**), a horse walking to the right (**25** and **26**), a rooster facing right (**27–32**), a rooster facing left (**33**), a bird facing left (**34**), a ram facing right (**35**), a ram and a guinea fowl facing left (**36**), and human heads en face (**37–44**).

## 18. Appliqué with *Senmurv*

Perhaps 7th to 8th century. Formerly in the Smith Collection (1269-c). 59.1.188.
W. 3.3 cm, Th. (appliqué) 0.4 cm.
Transparent very pale green. Stamped or pressed.

Appliqué: roughly elliptical, with height greater than width; stamped in prominent relief with *senmurv*, facing right. *Senmurv* has mane, short forelegs, right wing extended upward and curling forward at tip, and large tail decorated with herringbone pattern extending upward; below, traces of inscription. Wall (Th. 0.1–0.2 cm) has very small bulb on interior.

Incomplete. Edge severely chipped between one and three o'clock, destroying part of head. Patches of opaque, rather streaky pale brown weathering.

**COMMENT:** The depth of the relief, which implies a certain amount of pressure, and the smallness of the

*18*

bulb, which implies minimal pressure, suggest that the appliqué was pressed into a mold before it was attached to the vessel.

For the *senmurv* and its significance, see **1**.

### 19. Appliqué with Winged Horse

7th to 8th century. Formerly in the Smith Collection (1001). 59.1.184.
D. 3.8 cm, Th. (appliqué) 0.4 cm.
Translucent light grayish brown. Stamped.

Appliqué: approximately circular, decorated in relief with winged horse walking to left, with left wing raised, pointing forward, and right wing extended in front of chest; trappings on head and body; at lower left, trace of curved motif and possibly inscription. Wall has small bulb on interior.

Intact. Dull and extensively pitted, with traces of light brown weathering.

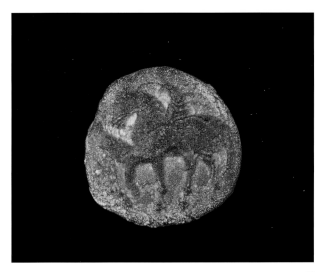

*19*

**COMMENT:** Balog (1974, p. 137) suggested that the winged horse is none other than al-Buraq, the horse on which the prophet Muhammad made his Night Journey from Mecca to Jerusalem and from there ascended to the heavens. **19** is similar to Balog's type 8b of "post-Sasanian early Islamic" appliqués.

For a complete vessel decorated with nine appliqués bearing winged horses, see Erdmann 1950–1, 1953, and 1969, pl. 91. For a single appliqué in The British Museum, presumably from Iraq (it was acquired at the same time as material from Layard's excavations at Nineveh), see Morton 1985, p. 39, no. 553. Frye (1973, p. 100, nos. D.238–243, etc.) published a number of sealings that depict winged horses, found at Qasr-i Abu Nasr, southern Iran.

Cf. **20** and **21**.

**BIBLIOGRAPHY:** *Glass from the Ancient World* 1957, p. 197, no. 388 (one of 16).

### 20. Appliqué with Winged Horse

7th to 8th century. Formerly in the Smith Collection (1184). 59.1.186.
D. 3.5 cm, Th. (appliqué) 0.3–0.6 cm.
Transparent pale yellowish green, with bubbles. Stamped.

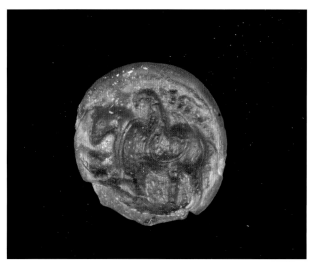

*20*

Appliqué: circular, decorated in high relief with winged horse walking to left, with left wing raised, pointing forward, and right wing extended in front of chest; trappings on shoulder; near upper right margin, short Arabic inscription. Wall has small bulb on interior.

Edges extensively chipped at bottom and on left. Dull and pitted, but with very little weathering.

**COMMENT:** Cf. Balog 1974, pp. 137–138, type 8a.

Cf. **19**.

**BIBLIOGRAPHY:** *Glass from the Ancient World* 1957, p. 197, no. 388 (one of 16).

### 21. Appliqué with Winged Horse

7th to 8th century. Formerly in the Smith Collection (893). 59.1.180.
H. 3.6 cm, W. (max., surviving) 3.6 cm, Th. (appliqué) 0.2–0.5 cm.
Transparent very pale purple. Stamped.

Appliqué: roughly oval, with width greater than height, stamped in relief with winged horse walking

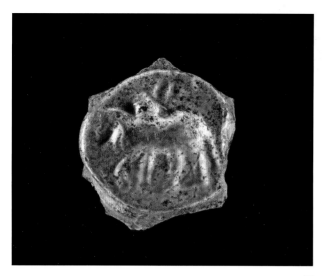

to left. Horse has wings pointing forward, one above and one below its head; one foreleg bent and other legs straight; and long tail. Edge of appliqué is slightly raised. Wall (Th. 0.2 cm) has bulb on interior.

Incomplete, with losses from edge behind tail. Appliqué is covered with iridescent opaque green weathering.

**COMMENT:** The raised edge indicates that the appliqué was stamped after it had been attached to the vessel. It is possible that the object was intended to be colorless and that its very pale purple hue was caused by the addition to the batch of too much manganese dioxide (a decolorizing agent) or by extensive exposure to sunlight, which caused minute crystals of manganese to form in the glass (an effect known as solarization). Cf. **19**.

**BIBLIOGRAPHY:** *Glass from the Ancient World* 1957, p. 197, no. 388 (one of 16).

## 22. Appliqué with Winged Horse

7th to 8th century. Formerly in the Smith Collection (1299). 59.1.179.
W. (max., surviving) 3.3 cm, Th. (appliqué) 0.6 cm.
Transparent pale yellowish green. Stamped.

Appliqué: circular, decorated in relief with winged horse walking to right, with right wing raised and left wing extended in front of chest; triangular plume on head, and trappings on back and rump; at edge, running from raised wing to rump, Arabic inscription. Wall has large bulb on interior.

Chip on lower edge has removed parts of two legs. Dull, with grayish weathering.

**COMMENT:** Cf. **23**.

R. W. Smith noted (in *Glass from the Ancient World* 1957; see below) that "this illuminating object has recently entered our collection through the kindness of Henri Seyrig." Henri Seyrig (1895–1973) was a distinguished French archeologist, numismatist, and ancient historian. In 1929, he became director of antiquities of Syria and Lebanon, and in 1946 he was appointed director of the Institut Français d'Archéologie in Beirut, a position he held until he retired in 1967. Smith acquired a number of objects in Lebanon (e.g., Whitehouse 2001, p. 222, no. 791), and it is possible that **22** was acquired there with Seyrig's assistance.

**BIBLIOGRAPHY:** Erdmann 1953, cc. 136–137 and fig. 1; *Glass from the Ancient World* 1957, p. 197, no. 386.

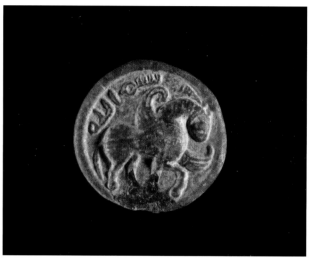

## 23. Appliqué with Winged Horse

7th to 8th century. Formerly in the Smith Collection (1430). 59.1.185.
W. (max., surviving) 3.1 cm, Th. (appliqué) 0.2 cm.
Transparent pale brown. Stamped.

Appliqué: circular, decorated in relief with winged horse walking to right, with right wing raised and left wing extended in front of chest; triangular plume on head, and trappings on back and rump; at edge, running from raised wing to rump, Arabic inscription. Wall has large bulb on interior.

Extensively chipped. Virtually unweathered.

**COMMENT:** Cf. **22**.

**BIBLIOGRAPHY:** *Glass from the Ancient World* 1957, p. 197, no. 388 (one of 16).

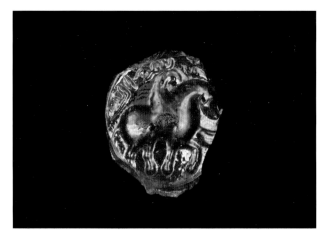

*23*

## 24. Appliqué with Horse and Rider

Perhaps 7th to 8th century. Formerly in the Smith Collection (1358). 59.1.181.
W. (max.) 3.6 cm, Th. (appliqué) 0.2–0.4 cm.
Translucent light yellowish green. Stamped.

Appliqué: oval, with raised border and, in relief, horse with rider, walking to right; details not clear, but rider seems to have disproportionately large head and vestigial body. Stamp was struck off-center, so that raised border exists on right side only. Wall has bulb on interior.
Chipped. Dull and heavily pitted, with traces of pale brown weathering in cavities.

**COMMENT:** This appliqué was acquired by R. W. Smith in Tehran, Iran. It is similar to Balog 1974, pp. 138–139, type 10a.
The horse and rider, usually in pursuit of game, was a favorite theme in Sasanian art (cf. *Royal Hunter* 1978, pp. 38–41, 49–50, and 58–59, nos. 6, 7, 12, and

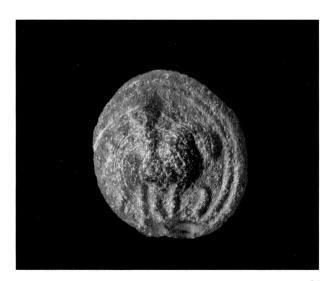

*24*

17; and *Splendeur des Sassanides* 1993, pp. 188–191 and 193–199, nos. 49, 50, and 52–56). This appliqué shows the horse walking, rather than galloping, and in this respect it recalls the animal and rider on a 10th- to 11th-century dish in The Corning Museum of Glass (55.1.139: *Glass of the Sultans* 2001, pp. 196–197, no. 101) and a lead or pewter object from Rayy, which shows a falconer on a walking horse (University of Pennsylvania Museum of Archaeology & Anthropology, Philadelphia, acc. no. 37-11-235).

**BIBLIOGRAPHY:** *Glass from the Ancient World* 1957, p. 197, no. 388 (one of 16).

## 25. Appliqué with Horse

Perhaps 7th to 8th century. Formerly in the Smith Collection (1187). 59.1.182.
D. 4.3 cm, Th. (appliqué) 0.4 cm.
Almost colorless, with yellowish green tinge. Stamped.

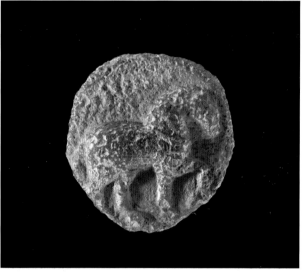

*25*

Appliqué: roughly circular, decorated in prominent relief with horse walking to right; above, traces of one line of Arabic inscription. Wall has bulb on interior.
Edges chipped; otherwise intact. Dull and deeply pitted, with pale green weathering in cavities.

**COMMENT:** A horse, accompanied by a Pahlavi inscription, appears on a sealing from Qasr-i Abu Nasr (Frye 1973, p. 101, no. D300).
Cf. **26**.

**BIBLIOGRAPHY:** *Glass from the Ancient World* 1957, p. 197, no. 388 (one of 16).

## 26. Appliqué with Horse

Perhaps 7th to 8th century. Formerly in the
Smith Collection (1379-1). 59.1.183.
D. 4.3 cm, Th. (appliqué) 0.4–0.6 cm.
Translucent pale brownish yellow. Stamped.

Appliqué: circular, with raised border on right and
at bottom, decorated in high relief with horse walking
to right; collar at base of neck; large bulbous feet. Wall
has bulb on interior.
    Edges chipped at top and top right; worn. Pitted,
with matte pale gray to yellow weathering.

COMMENT: Cf. **25**.

BIBLIOGRAPHY: *Glass from the Ancient World* 1957,
p. 197, no. 388 (one of 16).

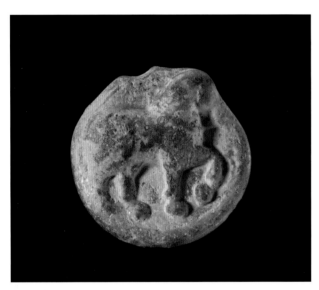

*26*

## 27. Appliqué with Rooster

Perhaps 7th to 8th century. Formerly in the
Smith Collection (1379-4). 59.1.190.
W. 3.7 cm, Th. (appliqué) 0.4 cm.
Translucent light yellowish green. Stamped.

Appliqué: approximately circular, with raised edge
on lower left side, decorated in relief with rooster fac-
ing right, with crest and long, curling tail feathers; trace
of tendrillike foliage held in beak. Wall has bulb on in-
terior.
    Edge chipped at top right. Dull and deeply pitted,
with traces of pale brown weathering.

COMMENT: Although appliqués of this type are
usually considered to have come from bowls, a beaker

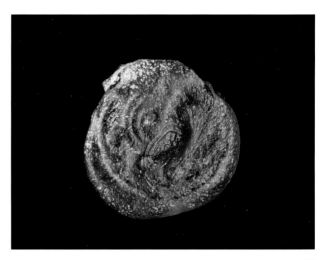

*27*

in the National Museum, Tokyo, has a circular stamp
depicting, under the base, a rooster with a crest and
elaborate tail (Masuda 1960b, p. 24; *Royal Hunter* 1978,
p. 158, fig. 81a). Similar birds also appear on textiles
(Erdmann 1969, pl. 100).
    Cf. **28–32**.

## 28. Appliqué with Rooster

Perhaps 7th to 8th century. Formerly in the
Smith Collection (1379-3). 59.1.192.
W. 3.4 cm x 2.9 cm, Th. (appliqué) 0.3–0.5 cm.
Translucent pale grayish green. Stamped.

Appliqué: oval, stamped in relief with rooster fac-
ing right, with crest and long, curling tail feathers; ten-
drillike foliage hangs from beak. Wall has very small
bulb attached to interior.
    Edge chipped at top right. Dull and extensively
pitted, with specks of pale brown weathering.

COMMENT: Cf. **27** and **29–32**.

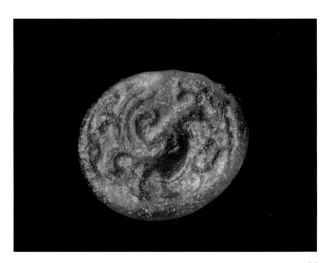

*28*

## 29. Appliqué with Rooster

Perhaps 7th to 8th century. Formerly in the Smith Collection (1269-b). 59.1.189.
D. 3.1 cm, Th. (appliqué) 0.3 cm.
Translucent pale yellowish green. Stamped.

Appliqué: circular, with raised edge, decorated in high relief with rooster facing right, with crest and long, curling tail feathers, holding tendrillike foliage in beak. Wall has small bulb on interior.
Edge chipped; otherwise intact. Pitted, with glossy bluish tan weathering.

COMMENT: This object is similar to Balog 1974, pp. 138–139, type 10a.
Cf. **27**, **28**, and **30–32**.

BIBLIOGRAPHY: *Glass from the Ancient World* 1957, p. 197, no. 388 (one of 16).

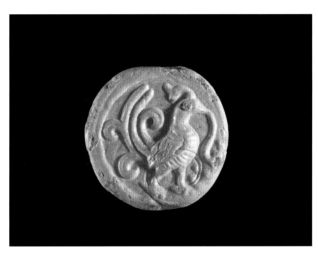

*29*

## 30. Appliqué with Rooster

Perhaps 7th to 8th century. Formerly in the Smith Collection (1305). 59.1.195.
W. 3.0 cm x 2.7 cm, Th. (appliqué) 0.4–0.6 cm.
Translucent olive green, with purple streaks. Stamped.

Appliqué: roughly oval, stamped in relief with rooster facing right, with crest and long, curling tail feathers; tendrillike foliage, which terminates in cluster of seeds or berries, hangs from beak. Wall has large bulb on interior.
Edge has slight chip at bottom. Pitted, with patches of brown weathering.

COMMENT: Cf. **27–29**, **31**, and **32**.

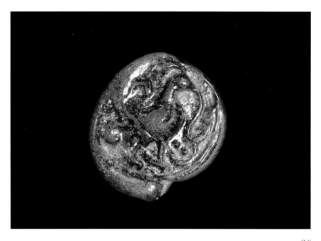

*30*

BIBLIOGRAPHY: *Glass from the Ancient World* 1957, p. 197, no. 388 (one of 16).

## 31. Appliqué with Rooster

Perhaps 7th to 8th century. Formerly in the Smith Collection (1013). 59.1.194.
W. 2.5 cm x 2.0 cm, Th. (appliqué) 0.2–0.4 cm.
Transparent or translucent pale yellowish green. Stamped.

Appliqué: irregular oval, decorated in relief with rooster facing right, with long, curling tail feathers and tendrillike foliage, which terminates in cluster of seeds or berries, hanging from beak; stamp was larger than appliqué, so that part of bird's head (possibly with crest) and feet are missing.
Edge chipped at lower right. Slightly iridescent opaque honey-colored weathering.

COMMENT: Cf. **27–30** and **32**.

BIBLIOGRAPHY: *Glass from the Ancient World* 1957, p. 197, no. 388 (one of 16).

*31*

## 32. Appliqué with Rooster

Perhaps 7th to 8th century. Formerly in the
Smith Collection (1307). 59.1.193.
D. 2.2 cm, Th. (appliqué) 0.3 cm.
Probably translucent pale green. Stamped.

Appliqué: circular, decorated in relief with rooster
facing right, with crest and long, curling tail feathers.
Wall has bulb on interior.
Edge chipped at lower left and lower right. Thick
layer of cream to dark gray weathering; locally pitted.

**COMMENT:** Cf. **27–31**.

*32*

## 33. Appliqué with Rooster

Perhaps 7th to 8th century. Formerly in the
Smith Collection (1379-2). 59.1.191.
W. 3.9 cm, Th. (appliqué) 0.3–0.5 cm.
Transparent yellowish green, with large bubble.
Stamped.

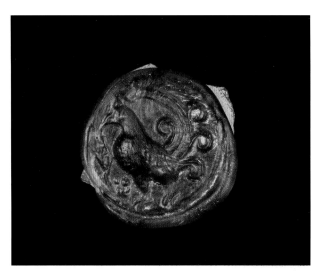

*33*

Appliqué: approximately circular, with raised
edge, especially on lower left side, decorated in high
relief with rooster facing left, with crest and long, curl-
ing tail feathers extending forward to touch crest; ten-
drillike foliage, which terminates in cluster of three
berries, hangs from beak. Wall has bulb on interior.
Intact. Dull, with traces of pale brown weather-
ing.

**COMMENT:** The appliqué resembles the five appli-
qués that decorate the body of a small globular jar in
The Toledo Museum of Art, Toledo, Ohio (1923.2015:
*Glass of the Sultans* 2001, pp. 115–116, no. 34 = Lamm
1929–30, v. 1, p. 63, no. 4, and v. 2, pl. 15, no. 4; and
Erdmann 1950–1, c. 123, fig. 6).

**BIBLIOGRAPHY:** *Glass from the Ancient World* 1957,
p. 197, no. 388 (one of 16).

## 34. Appliqué with Bird

Perhaps 5th to 7th century. Formerly in the
Smith Collection. Gift of Carl Berkowitz and
Derek Content. 76.1.131.
H. (surviving) 3.3 cm, W. 2.5 cm, Th. (appliqué)
0.4 cm.
Transparent pale yellowish brown. Stamped.

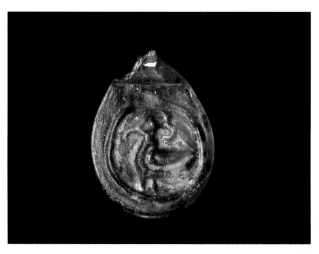

*34*

Appliqué: oval, stamped with incomplete circle
containing bird facing left; stylized crest or scroll pro-
jects from back of head.
Incomplete. Broken at top, perhaps where handle
projected upward. Dull, with some pitting and slight
iridescence.

**COMMENT:** For another bird with a scroll instead
of a crest, see the textile fragment in the Vatican Mu-
seums published by Erdmann (1969, pl. 101).

## 35. Appliqué with Ram

Perhaps 7th to 8th century. Formerly in the Smith Collection (1185). 59.1.187.
D. 3.0 cm, Th. (appliqué) 0.2–0.5 cm.
Translucent pale pinkish gray. Stamped.

Appliqué: oval, decorated in relief with standing ram facing right.

Part of bottom right edge missing, together with animal's feet. Dull and very deeply pitted, with brownish weathering in cavities.

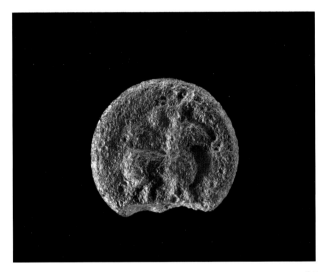

*35*

**COMMENT:** The design is similar to Balog 1974, p. 137, type 6.

The ram is a recurrent motif in Iranian art. For animals with curved horns closely similar to this example, cf. the Sasanian silver plate, allegedly found at Qazvīn, northern Iran, now in The Metropolitan Museum of Art, New York (acc. no. 34.33: *Splendeur des Sassanides* 1993, pp. 188–189, no. 49 = *Royal Hunter* 1978, pp. 40–41, no. 7); and stucco plaques in the Louvre, Paris (AO. 26174: *Splendeur des Sassanides* 1993, p. 147, no. 6); the Field Museum of Natural History, Chicago (228840: *ibid.*, p. 149, no. 8); and the Museum für Islamische Kunst, Berlin (I.2212: *ibid.*, p. 154, no. 12).

**BIBLIOGRAPHY:** *Glass from the Ancient World* 1957, p. 197, no. 388 (one of 16).

## 36. Appliqué with Ram and Guinea Fowl

Perhaps 7th to 8th century. Formerly in the Sangiorgi Collection. 68.1.28.
D. 2.1 cm, Th. (appliqué) 0.3–0.4 cm.
Translucent purple. Stamped.

Appliqué: circular, decorated in relief with standing ram with strongly curved horns, facing left; standing on animal's back, also facing left, guinea fowl with plump body and long, slender neck.

Edge chipped on right. Dull, with some pitting and traces of grayish weathering.

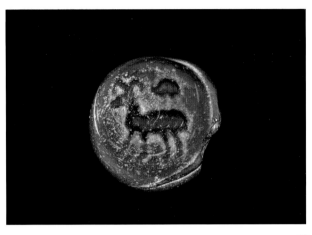

*36*

**COMMENT:** Both the ram and the guinea fowl have close parallels in Sasanian art. For the ram, see **35**. For the guinea fowl, cf. a stucco plaque in The Metropolitan Museum of Art, New York (32.150.13: *Splendeur des Sassanides* 1993, p. 155, no. 13), and a group of silver-gilt harness ornaments in the Museum für Islamische Kunst, Berlin (I.87/63), and the Römisch-Germanisches Zentralmuseum, Mainz (O.39246-7: *ibid.*, pp. 185–186, nos. 46 and 47).

## 37. Appliqué with Human Head

Perhaps 5th to 7th century. 55.1.46.
H. 6.1 cm, W. 2.8 cm.
Transparent pale greenish yellow. Stamped.

Appliqué: roughly oval, with height greater than width, apparently applied over two trails. Appliqué has human head en face, with bifurcated headdress or coiffure, prominent eyebrows, straight nose, mustache, and possibly beard. Below head, trails were flattened, drawn down wall, and turned outward at bottom. Left side of head is framed by one additional trail. Wall appears to be vertical, with relatively small diameter. It has small bulb on interior.

Edge of appliqué is missing between 12 and two o'clock. Partly covered with brown weathering and iridescence.

**COMMENT:** This object is remarkably similar to an appliqué from Qasr-i Abu Nasr, southern Iran, which also has one or more trails drawn down be-

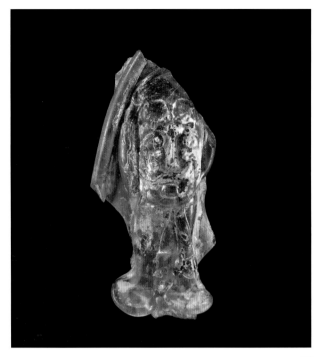

*37*

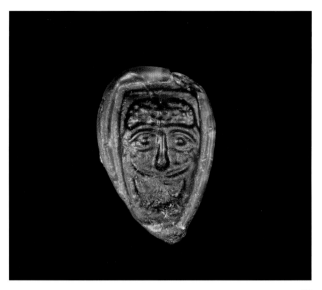

*38*

neath the head (Whitcomb 1985, pp. 158–159, fig. 59c). The trail that frames the head suggests comparison with a vessel in the Hans Cohn Collection. This unique object, which Axel von Saldern (in *Cohn Collection* 1980; see below) rightly described as "very curious," appears to be the lower part of a bottle with a globular body. The body has applied decoration that includes three heads, similar to **37**, each of which is framed by a single horseshoe-shaped trail that begins and ends at the sides of the chin (*Cohn Collection* 1980, p. 178, no. 182, "Near East, perhaps 7th–9th century" = "Recent Important Acquisitions," *JGS*, v. 14, 1972, p. 154, no. 12, "Roman Empire, *ca.* 3rd–4th c. A.D., or possibly later").

Appliqués with heads of this type appear to be Iranian. Similar heads are found on other appliqués from Qasr-i Abu Nasr (Frye 1973, p. 21, fig. 21) and on appliqués from Istakhr (in the Oriental Institute Museum, Chicago: Whitcomb 1995, p. 199, fig. 7) and Tall-i Zohak, near Fasa (Stein 1936, p. 142, fig. 29.27), both of which are in southern Iran. An example published by Kröger (1984, pp. 135–136, no. 113) was acquired at Isfahan in central Iran.

For a similar appliqué in The British Museum, see Morton 1985, p. 163, no. 556.

## 38. Appliqué with Human Head

Perhaps 5th to 7th century. Formerly in the Smith Collection (1313). 59.1.174.
H. 3.7 cm, W. 2.5 cm.
Transparent pale yellowish green. Stamped.

Appliqué: roughly oval, with height greater than width. Appliqué has human head en face, with bifurcated headdress or coiffure, prominent eyebrows, straight nose, mustache, and possibly beard. Wall has prominent bulb on interior.

Edge of appliqué is missing between six and nine o'clock. Traces of pale brown weathering.

**COMMENT:** See **37**.

## 39. Appliqué with Human Head

Perhaps 5th to 7th century. Formerly in the Smith Collection (1002). 59.1.178.
H. 2.9 cm, W. 2.8 cm.
Translucent light purple. Pressed.

Appliqué: roughly circular, decorated in prominent relief with male head with low forehead, curved eyebrows meeting above straight nose, and parted lips;

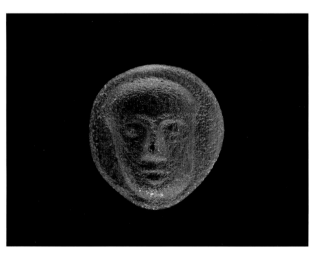

*39*

both head and face are hairless; field is flat, with rounded edge. Surviving part of vessel appears to be vertical, and its horizontal plane has pronounced curve; no bulb on interior.

Appliqué intact. Pitted and almost matte.

COMMENT: The flat field, rounded edge, and absence of a bulb indicate that the appliqué was pressed in a mold before it was attached. At the point of attachment, the vessel probably had a small diameter. This may mean that the appliqué was attached to the neck of a vessel rather than to the body.

See **40**.

BIBLIOGRAPHY: *Glass from the Ancient World* 1957, p. 197, no. 388 (one of 16, illustrated on p. 198).

## 40. Appliqué with Human Head

Perhaps 5th to 7th century. Formerly in the Smith Collection (1188). 59.1.175.
H. 2.9 cm, W. (max.) 2.6 cm.
Transparent yellowish green with purple streaks. Stamped.

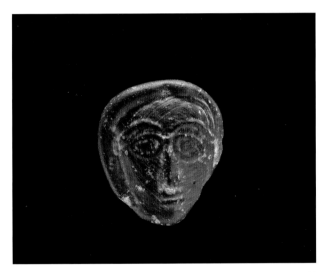

*40*

Appliqué: roughly oval, decorated in relief with male head with broad forehead, curved eyebrows, oval eyes with faint pupils, straight nose, and lips indicated by two short parallel lines; both head and face are hairless; edge of appliqué is slightly raised. Vessel wall (Th. 0.2 cm) has slight bulb on interior.

Appliqué lacks edge between three and six o'clock. Dull and pitted.

COMMENT: R. W. Smith reported (in *Glass from the Ancient World*: see below) that "the object came from Iraqi sources and was possibly found there."

Cf. **39**.

BIBLIOGRAPHY: *Glass from the Ancient World* 1957, p. 197, no. 387.

## 41. Appliqué with Human Head

Perhaps 5th to 7th century. Formerly in the Smith Collection (1269-a). 59.1.176.
D. 3.1 cm, Th. (appliqué) 1.1 cm.
Translucent purple. Stamped.

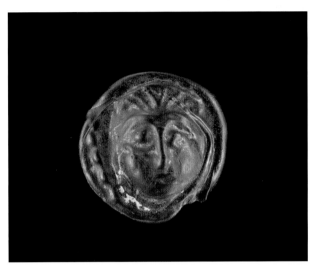

*41*

Appliqué: roughly circular, attached to wall of vessel. Stamped in relief with human head en face, with bifurcated headdress or coiffure, curved eyebrows, oval eyes with large pupils, straight nose, and small mouth; face is hairless; head is framed to proper right by arc of dots, also in relief; edge of appliqué is slightly raised. Wall (Th. 0.1 cm) has bulb on interior.

Appliqué complete except for chip in edge at five o'clock. Traces of weathering.

COMMENT: See **37**.

BIBLIOGRAPHY: *Glass from the Ancient World* 1957, p. 197, no. 388 (one of 16, illustrated on p. 198).

## 42. Appliqué with Human Head

Perhaps 5th to 7th century. 55.1.47.
H. 2.9 cm, W. 2.1 cm.
Transparent light yellowish green. Stamped.

Appliqué: roughly triangular, attached to wall of vessel. Stamped in relief with male head with curly hair (or helmet), prominent eyebrows, well-defined oval eyes with circular pupils, long and straight nose and mus-

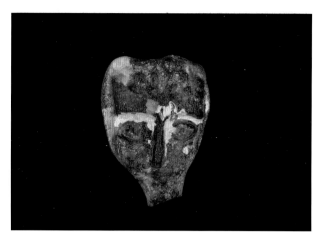

*42*

*43*

tache; details of lower face unclear. Wall (Th. 0.1 cm) has small but prominent bulb on interior.

Appliqué has lost most of edge. Patches of silver weathering; elsewhere, surfaces are pitted, with slight iridescence.

COMMENT: This object was acquired in Iran.
Cf. Stein 1936, p. 142, fig. 29.27 (from Tall-i Zohak, near Fasa, in southern Iran); Frye 1973, p. 21, fig. 21; Kröger 1984, pp. 135–136, no. 113 (acquired in Isfahan, central Iran); and Whitcomb 1985, pp. 158–159, fig. 59c (from Qasr-i Abu Nasr, southern Iran). Whitcomb (1985, p. 155) noted two examples from Istakhr, also in southern Iran (in the Oriental Institute Muscum, Chicago: A22719 and A24743). The known find-places, therefore, suggest that appliqués of this type were made in southern Iran.

The "curls" may represent the studs on a metal helmet: cf. *Splendeur des Sassanides* 1993, pp. 172–176, nos. 30–34. Helmets of this type are attributed to the period between the fifth and seventh centuries.

## 43. Appliqué with Human Head

Perhaps 7th to 8th century. Formerly in the Smith Collection (1371). 59.1.272.
D. 1.8 cm, Th. (appliqué) 0.8 cm.
Translucent blue. Stamped.

Appliqué: circular. Schematic human head, shown frontally, with lentoid eyes beneath very prominent brows; other features indistinct, and partly obscured by spiral "tail" of glass (see below). Prominent oval bulb on inner surface of wall.

Almost complete, but chipped at edge. Dull and pitted, with some grayish weathering.

COMMENT: Evidently a blob of molten glass was applied to the vessel, and when it was cast off the pon-

til, a "tail" was left on the surface. The blob was then stamped, but with insufficient force to obliterate the tail and form a clear impression.

See **44**.

## 44. Appliqué with Human Head

Perhaps 7th to 8th century. Formerly in the Smith Collection (1192). Gift of Carl Berkowitz and Derek Content. 76.1.134.
Max. Dim. 2.9 cm, Th. (appliqué) 1 cm.
Translucent blue. Stamped.

Appliqué: roughly circular. In high relief, schematic human head, shown frontally, with large lentoid eyes but few other features, surrounded by incomplete circle of dots, also in high relief; edge of appliqué is slightly raised. Wall (Th. 0.1 cm) has bulb on interior.

Intact. Dull and pitted, with remains of silvery gray weathering.

COMMENT: The head resembles, but is not identical to, **43**.

*44*

# VESSELS WITH FACET-CUT ORNAMENT

The best-known Sasanian glasses are those that are decorated with overall patterns of ground, cut, and polished hollow facets. For many students of the history of glass (e.g., Saldern 1963; Kröger 1998, pp. 134–135), these objects occupy the middle ground, chronologically and geographically, between the facet-cut glass of the Roman Empire and Islamic facet- and relief-cut glass. Third-century facet-cut glass from Dura-Europos, and from other sites on or near Rome's frontier with the Sasanians, is decorated with patterns of adjoining or adjacent hollow facets (e.g., Clairmont 1963, pp. 60–86). Eighth- to 10th-century Islamic facet-cut glasses, many of which have demonstrable or reputed Iranian provenances, also have patterns of adjoining or adjacent facets. Sasanian facet-cut glass may demonstrate the continuity of glass cutting between the first and last quarters of the first millennium.

This supposed connection between Roman and early Islamic glass cutting may have existed, but it remains to be demonstrated. Typical Sasanian cut glass objects have overall patterns of contiguous more or less hexagonal facets. The patterns sometimes recall the "honeycomb" facets on late first- and early second-century Roman glasses (e.g., Whitehouse 1997, pp. 221–222 and 233–236, nos. 395 and 397–399), but they have little in common with the majority of the third-century fragments from Dura-Europos (Clairmont 1963, pp. 56–86, nos. 235–355).

They also have little in common with Sasanian objects in other media. The few exceptions include two silver vessels and perhaps two hard stone objects. A silver dish in the Cincinnati Art Museum, reputedly found between Qasr-i Shirin and Kermanshah in western Iran, has a medallion containing a bust at the center and eight concentric rings of small convex disks (*Splendeur des Sassanides* 1993, p. 209, no. 63), and a silver plate from Mtskheta, Georgia, has a central medallion and four concentric rings of disks (Harper 1974, pp. 62–63). The two vessels are attributed to the late third or early fourth century A.D. As Prudence Oliver Harper noted (in *Royal Hunter* 1978, p. 32), the overall pattern of disks is not unlike the overall patterns of circular facets on vessels made of glass. The hard stone objects, both of which have allover patterns of adjoining facets, are the rock crystal Eleanor of Aquitaine Vase in the Louvre (MR. 340: Beech 1992, 1993, 2002) and a green jasper vase with 17th-century mounts in the Prado, Madrid (00047: *Tesoro del Delfín* 2002, pp. 112–113, no. 8), both of which have been attributed to the latter part of the Sasanian period.

On the objects in this catalog, the patterns of hollow facets fall into two main categories: (1) patterns of adjoining facets, often arranged in quincunx, that are usually more or less hexagonal except at the top and bottom of the ornament, where the outermost perimeters of the facets tend to be rounded; and (2) patterns of adjacent facets that are usually oval or circular. It is not yet clear whether these categories are of different dates or are contemporaneous and reflect different preferences or qualities of workmanship.

## 45. Bowl

About 4th to 6th century. 65.1.28.
H. 4.1 cm, D. 14.4 cm.
Transparent pale green, with very few small bubbles. Blown; facet-cut.

Bowl: segmental. Rim plain, with flat upper surface finished by grinding and polishing; wall curves

down and in, and merges with rounded base. Decorated on wall with five continuous horizontal rows of 19 crisply cut facets arranged in quincunx, and on base with circular medallion. Rows, from top to bottom: (1) facets are rounded at top and three-sided at bottom, with each pair connected by short horizontal groove; (2) most of facets are six-sided, with each pair separated by small uncut square; (3 and 4) similar to (2); (5) facets have five straight sides, with curved side at bottom. Medallion has, at center, wheel-cut equal-arm cross within square consisting of four straight cuts that almost touch ends of arms of cross and, outside this, two concentric circles separated by continuous band of straight cuts that radiate from center.

Complete. Broken cleanly into two almost equal pieces, and repaired without loss. Remains of mottled light to dark brown weathering, mostly on interior; otherwise, surface appears almost pristine.

COMMENT: The quality of the cutting invites comparison with some of the most crisply facet-cut glass of the Sasanian period, most notably the hemispherical bowl in the Shoso-in Treasury at Nara, Japan (Harada and others 1965, color pl. 1 and black-and-white pls. 15–25). Other, less accomplished objects include **63** (a conical lamp or beaker), and **46** and **49** (two hemispherical cups). The motif of a cross within a square also occurs on a wheel-cut and blobbed bowl, said to be from Gilan Province, northern Iran, which was attributed to the first half of the Sasanian period by Fukai (1977, pp. 50–51, fig. 54 and pl. 8).

## 46. Cup

5th to 6th century. 60.1.3.
H. 8.9 cm, D. (rim) 13 cm, Th. 0.6 cm.
Almost colorless, with yellow tinge; few minute bubbles. Blown; facet-cut.

Cup: hemispherical. Rim beveled; wall curves down and in; base small and concave. Entire outer surface decorated with five continuous horizontal rows of contiguous cut, ground, and polished facets surrounding hollow circular facet at base (in descending order): one row of 19 facets, each with rounded top, vertical sides, and V-shaped bottom; three rows of 19 hexagonal facets, each with smaller facets than those in the row above it; and one row of seven circular facets.

Intact. Rim abraded, and surface partly covered with enamellike weathering and slight iridescence.

COMMENT: According to the vendor, the object was found, allegedly with many more similar bowls and conical beakers, in the neighborhood of Amlash, northwestern Iran (but see page 10).

Hemispherical facet-cut bowls have been found in archeological excavations in Iraq, Iran, and adjacent regions. Among the find-places in Iraq are: Nineveh (Kuyunjik) (Simpson 1996, p. 97, fig. 2.1), Ctesiphon (Kühnel and Wachsmut 1933, pp. 29–30, fig. 50), Choche (Ctesiphon) (Negro Ponzi Mancini 1984, p. 33, nos. 36 and 40), Kish (Harden in Langdon and

Harden 1934, pp. 131–133, no. 7), Babylon (Lamm 1929–30, v. 1, p. 151, no. 4, and v. 2, pl. 54, no. 4), Tell Baruda (Negro Ponzi 1987, p. 272, fig. C), and Uruk (Van Ess and Pedde 1992, pp. 167–168, nos. 1240–1246). The find-places in Iran include Tureng Tepe (Boucharlat and Lecomte 1987, p. 173 and pl. 99, no. 9) and sites in Gilan Province (Fukai 1977, pp. 34–37). Among the find-places in other regions are: Sudagilan, Azerbaijan (Fukai 1977, p. 37, fig. 25); Garni, Armenia (*ibid.*, p. 38, fig. 26); and Rust'avi, Georgia (Č'xatarašvili 1978, p. 90). Fukai (1977, p. 38) also noted finds from "Karl Marx" in Russia and Kumtura in western Xinjiang, China.

**46** is closely similar to the celebrated faceted glass cup in the Shoso-in Treasury at Nara, Japan, which is believed to have been donated to the shrine by Emperor Shomu in A.D. 752 (Laing 1991, p. 118, fig. 25); another example was found in the tomb of Emperor Ankan (r. 531–535) in Osaka Prefecture, also in Japan (Blair 1973, p. 61, pl. 1; Laing 1991, p. 118, fig. 26). In China, a cup of this type was found in the tomb of Liu Zong (d. 439) at Chuncheng, Jurong, in Jiangsu Province (*China: Dawn* 2004, pp. 61 and 211, no. 117).

Other objects of the same general type, none of which has a reliable provenance, include: Lamm 1929–30, v. 1, pp. 148, 149, and 151, and v. 2, pls. 53.1 and 5, and 54.5; Erdmann 1961; *Billups Collection* 1962, p. 18, no. 20 (in the New Orleans Museum of Art); "Recent Important Acquisitions," *JGS*, v. 5, 1963, p. 145, no. 19 (in the Rijksmuseum van Oudheden, Leiden); Saldern 1963, pp. 10–12; *7000 Years of Iranian Art* 1964, p. 93, no. 514 (then in the Foroughi Collection, Tehran); *Masterpieces of Glass* 1968, p. 106, no. 137 (in The British Museum); Saldern 1968, pp. 36–39; *Gläser der Antike* 1974, p. 259, no. 758 (in the Oppenländer Collection); *Hentrich Collection* 1974, pp. 184–185, nos. 271

and 272 (in the Kunstmuseum Düsseldorf); *Antiquities* 1975b, lot 256; Hasson 1979, pp. 12 and 35, no. 17 (in the L. A. Mayer Memorial Institute for Islamic Art, Jerusalem); *Treasures of the Orient* 1979, pp. 150 and 261, nos. 210 and 211); *Cohn Collection* 1980, p. 149, no. 142 (in the Los Angeles County Museum of Art); *Islamic Works of Art* 1980, n.p., lots 246–248; Oliver 1980, p. 138, no. 235 (in the Carnegie Museum of Natural History, Pittsburgh); *Fine Antiquities* 1982, n.p., lot 80; *Antiquities* 1983, p. 54, lot 224; *Antiquities* 1984a, p. 11, lots 27–29; *Antiquities* 1984b, n.p., lots 250–252; *Antiquities* 1985, n.p., lot 10; *Ancient and Islamic Glass* 1986, p. 92, lots 236 and 238; *Ancient Glass* 1986, p. 22, lot 67; Taniichi 1987, pp. 21 and 86, nos. 87 and 88 (in the Okayama Orient Museum); *Antiquities* 1988a, p. 115, lot 193; *Antiquities* 1988b, lots 67 and 68; *Antiquities* 1989, p. 156, lot 313; *Wolkenberg Collection* 1991, p. 21, lot 32; *Islamic Art* 1995, p. 105, lot 258; Saldern 1995, p. 80, no. 14 (= *idem* 1968, pp. 36–46, fig. 4) (in the Museum für Kunst und Gewerbe, Hamburg); *Antiquities* 1996, p. 17, lots 20–22; Fehérvári and others 1996, pp. 82–83; *Antiquities* 1997, lot 24; *Antiquities* 2000a, p. 28, lot 117 (part of group); *Antiquities and Islamic Works of Art* 2000, p. 11, lots 16 and 17; *Antiquities* 2001, p. 113, lot 427 (two examples); Booth-Clibborn 2001, pp. 460–461 (said to be from Gilan Province in northern Iran and now in the National Museum of Iran, Tehran); *Brilliant Vessels* 2001, p. 18, nos. 42–45; Carboni and others 2001, p. 10 (in The Metropolitan Museum of Art, New York); Folsach 2001, p. 205, no. 299 = Leth 1970, p. 8 (in the David Collection, Copenhagen); and *Wolf Collection* 2001, p. 353, no. 200 (= *Verres antiques et de l'Islam* 1985, pp. 219–220, no. 532; no. 533 is similar).

**BIBLIOGRAPHY:** Saldern 1963, pp. 10–11, fig. 6; *Sasanian Silver* 1967, p. 153, no. 77; *Persian Glass* 1972, p. 11, fig. 10; *Royal Hunter* 1978, p. 159, no. 82.

## 47. Cup

3rd to 7th century. Formerly in the Strauss Collection (S2475). Bequest of Jerome Strauss. 79.1.241.
H. 8.3 cm, D. 11.6 cm.
Almost colorless, with brown tinge. Blown; facet-cut.

Cup: hemispherical. Rim plain, with rounded lip; wall curves down and in, and merges with base. Exterior covered with five horizontal rows of contiguous hollow facets surrounding one large central facet on base. Facets are of different shapes: pentagonal with rounded top on uppermost row, hexagonal on next

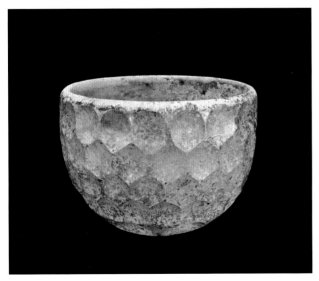

*46*

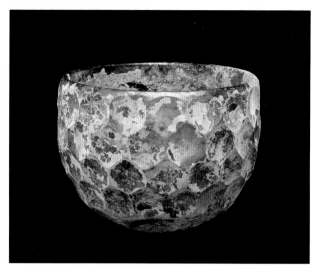

three rows, and circular on bottom row. Central facet is circular.

Intact. Opaque white to gray-brown weathering, and some iridescence.

**COMMENT:** See **46**.

## 48. Cup

4th to 6th century. Formerly in the Strauss Collection (S2149). Bequest of Jerome Strauss. 79.1.219.
H. 7.2–7.7 cm, D. 9.9 cm.
Transparent pale green. Blown; facet-cut.

Cup: hemispherical, slightly lopsided. Rim plain, with rounded lip; wall descends vertically, then curves down and in, merging with rounded base. Decorated on wall with four continuous horizontal rows of shallow facets, which do not touch one another, uppermost

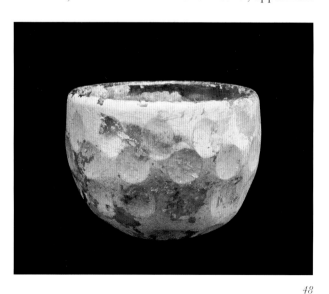

three of which are arranged more or less in quincunx, and on base with one circular facet. Decoration on wall, from top to bottom: (1) 13 oval facets, each slightly taller than it is wide; (2) 13 more or less circular facets; (3) 12 more or less circular facets; and (4) seven circular facets.

Intact. Much of surface is covered with matte to slightly iridescent pale gray to pale brown weathering; where this is missing, surface is almost matte and somewhat pitted.

**COMMENT:** The rows of circular facets that do not touch one another have parallels in both Iraq and greater Iran: see Fukai 1977, p. 37, fig. 23 (= Harden in Langdon and Harden 1934, p. 132, no. 7, from Kish, Iraq) and fig. 25 (from Sudagilan, Azerbaijan). For an example in the Okayama Orient Museum (7-129), see Yoshimizu 1992, v. 1, p. 209, no. 185 (= Taniichi 1987, p. 86, no. 88).
Cf. **49**.

**BIBLIOGRAPHY:** Saldern 1963, p. 10 and fig. 6.

## 49. Cup

5th to 6th century. Formerly in the Smith Collection. 61.1.12.
H. 7.7 cm, D. 10.6 cm.
Transparent pale green. Blown; facet-cut.

Cup: roughly hemispherical. Rim very slightly everted, with lip flattened by grinding; wall descends almost vertically, then curves in to bottom; base narrow and slightly concave. Entire outer surface decorated with three continuous horizontal registers of cut, ground, and polished ornament (from top to bottom): (1) two bands of contiguous hollow facets, with 21 roughly square facets (some of which have rounded tops) in upper band and 21 circular facets in lower band; (2) two parallel grooves; and (3) overall pattern consisting of four bands of 17 hollow facets arranged in quincunx, each band decorated as follows: uppermost band has facets with rounded tops and V-shaped bottoms; two bands at center have hexagonal facets; lowest band has facets with inverted V-shaped tops and rounded bottoms; below this, one band of nine oval facets. Group of grooves on underside of base may be deliberate, but they defy interpretation.

Intact. Dull and pitted, with slight iridescence and patches of brown enamellike weathering on inside and remains of weathering elsewhere.

**COMMENT:** For two fragmentary cups, which may have been similar to this object, excavated at Tu-

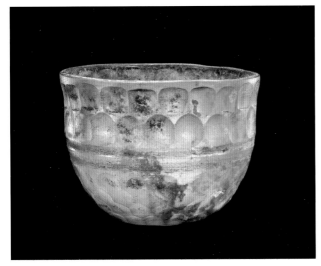

*49*

reng Tepe, northern Iran, see Boucharlat and Lecomte 1987, p. 173, pl. 99, no. 6, and pl. 100, no. 14. The first fragment dates from period VI at Tureng Tepe (Sasanian), and the second fragment was found in a deposit of period VIIA/B (seventh to eighth centuries A.D.).

A similar bowl was found in Tomb 98 (the Great Tomb) at Hwangnam daech'ong, Korea (*Treasures from Korea* 1984, p. 93, no. 84; Lee 1993, pp. 33–35, no. 6 = Laing 1991, p. 115 and fig. 16). The monument consists of two mounds; one is believed to be the tomb of King Soji (d. 499, buried 502), and the other is thought to be the tomb of his wife, who died some time after him.

**BIBLIOGRAPHY:** *Royal Hunter* 1978, p. 155, no. 78; *Splendeur des Sassanides* 1993, p. 263, no. 112.

## 50. Cup

Probably 6th century. 72.1.21.
H. 7.2 cm, D. 8.1 cm.
Transparent light purplish brown. Probably cast, but possibly blown; facet-cut.

Cup: hemispherical. Rim plain, with rounded and very slightly everted lip; wall curves down and in; foot is solid cylinder. Decorated on wall with two continuous horizontal rows of six cylindrical bosses with concave upper surfaces, made by cutting, grinding, and polishing.

Intact, except for extensive chipping on rim, several bosses, and base. Extensively pitted, with brownish weathering in pits.

**COMMENT:** A fragmentary cup of this type was found during archeological excavations at Qasr-i Abu Nasr, southern Iran (Whitcomb 1985, p. 156, fig. 58k).

Similar objects have been found at sites in the Far East. One example was found in the tomb of Li Xian (d. 569) and his wife, Wu Hui (d. 547), at Guyuan in Ningxa Hui Autonomous Region, China (An 1986; *China: Dawn* 2004, pp. 61 and 258, no. 158 = *Monks and Merchants* 2001, p. 97, no. 30); another was discovered at Barchuk in Xinjiang, China (Laing 1991, p. 111 and fig. 8 = *Silk Road* 1988, p. 104, no. 104, and p. 226); and fragments of a third were found in a sixth-to seventh-century context at the Munakata shrine on the Japanese island of Okinoshima, east of northern Kyushu (Laing 1991, p. 118 and fig. 29; Fukai 1977, pp. 44–45).

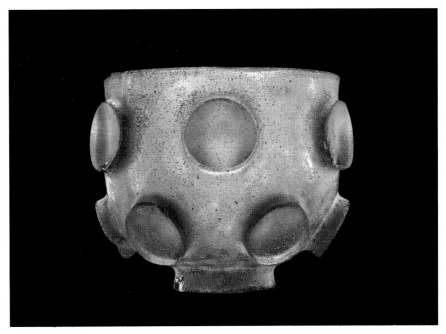

*50*

Other examples of bowls with cylindrical bosses include Taniichi 1987, pp. 86–87, no. 90 (in the Okayama Orient Museum, Japan); *Eredità dell'Islam* 1993, pp. 68–69, no. 4 (in the Museo Nazionale d'Arte Orientale, Rome, inv. no. 2705); *Ancient Glass* 2001, p. 207, no. 176 (in the Miho Museum); and *Brilliant Vessels* 2001, p. 19, no. 47.

Cf. **51** and **52**.

**BIBLIOGRAPHY:** Charleston 1980, p. 67, no. 25; Zerwick 1980, p. 33, fig. 25; Charleston 1990, p. 67, no. 25; Zerwick 1990, p. 33, fig. 26; *Treasures from Corning* 1992, p. 28, no. 19; Yoshimizu 1992, v. 1, p. 289, no. 183; *Splendeur des Sassanides* 1993, p. 265, no. 114; *Guide to the Collections* 2001, p. 45.

## 51. Cup

6th to 7th century. Formerly in the Smith Collection (1543). 61.1.11.
H. 8.0 cm, D. 10.2 cm.
Color unknown. Probably cast, but possibly blown; facet-cut.

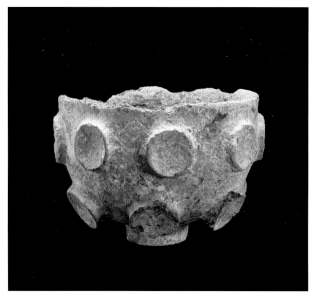

*51*

Cup: hemispherical. Rim probably beveled on inside; wall curves down and in; foot short and cylindrical, with hollow facet on underside. Wall decorated with two continuous horizontal rows of shallow cylindrical bosses; upper row has eight bosses, and lower row has six.

Almost complete. Broken, with small loss, and repaired. Very extensively weathered. Consequently, much of rim and parts of several bosses and foot are missing. Surface is opaque, matte, and very pale brown, with calcareous(?) accretions.

**COMMENT:** See **50** and **52**.

**BIBLIOGRAPHY:** *Persian Glass* 1972, p. 12, no. 13.

## 52. Cup

Probably 6th to 7th century. Formerly in the Strauss Collection (S2560). Bequest of Jerome Strauss. 79.1.64.
H. 6.9 cm, D. 9.8 cm.
Color unknown. Probably cast, but possibly blown; facet-cut.

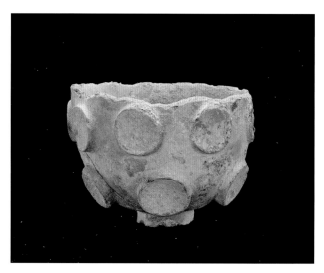

*52*

Cup: hemispherical. Rim probably beveled on inside; wall curves down and in; foot short and cylindrical, with hollow facet on underside. Wall decorated with two continuous horizontal rows of six shallow cylindrical bosses with concave upper surfaces.

Almost complete, but with one small loss in upper wall. Very extensively weathered. Consequently, much of rim and parts of several bosses and foot are missing. Surface is opaque, matte, and pale brown to dark gray, with calcareous(?) accretions.

**COMMENT:** See **50** and **51**.

## 53. Cup

4th to 7th century. Formerly in the Strauss Collection (S2411). Bequest of Jerome Strauss. 79.1.56.
H. 7.2 cm, D. 10.8 cm.
Almost colorless, with green tinge; very few bubbles. Blown; facet-cut.

Cup: conical. Rim slightly everted, with flat top finished by grinding; wall straight, tapering, and curv-

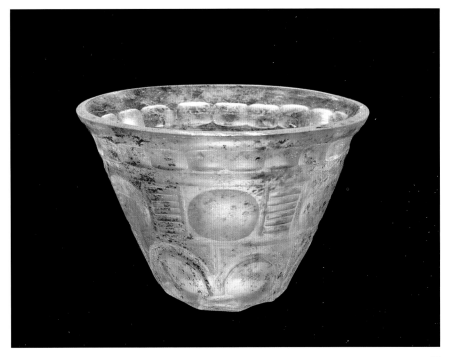

ing in at bottom; base plain, with very small kick. Wall and edge of base decorated by cutting. Wall has three continuous horizontal bands of ornament (from top to bottom): (1) row of 21 contiguous subrectangular facets (L. 1.4 cm, H. 0.8 cm); (2) with continuous horizontal groove above and below, six large subcircular facets (L. 2.4 cm, H. 2.2 cm) alternating with six ladderlike motifs, each with six or seven horizontal cuts between two vertical cuts; and (3) six smaller subcircular facets (L. 1.8 cm, H. 2 cm), each surrounded at top and sides by parabolic cut, with long vertical cut between each pair of parabolas and short horizontal cut at bottom of each pair of parabolas. Edge of base has band of contiguous subrectangular facets.

Intact. Remains of brown weathering or accretion; some iridescence.

**COMMENT:** Bands of subcircular facets framed by parabolic cuts and separated by vertical lines also occur on **62**.

## 54. Bowl

6th to 7th century. Formerly in the Strauss Collection (S2472). Bequest of Jerome Strauss. 79.1.58.
H. 8.9 cm, D. 11.1 cm.
Transparent very pale greenish yellow, with many bubbles. Blown or cast; facet-cut.

Bowl: roughly hemispherical. Rim plain, with rounded lip and slight bevel on inside; wall descends

almost vertically before curving in to bottom; base has stepped profile with two steps and, at center, disk with concave underside; edges of lower step and disk are beveled. Wall is decorated with six large countersunk circular facets with concave surfaces; spaces between four pairs of facets are narrow, and each has, at top and bottom, one small circular facet; spaces between remaining two (opposed) pairs of large facets are wider, and these have, in addition to small facets at top and bottom, broad horizontal cut at midpoint.

Complete. Broken into two pieces and repaired. Deeply pitted, with remains of silvery iridescent weathering.

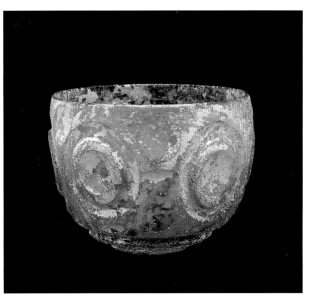

**COMMENT:** A bowl of this type was found during excavations at Kish in central Iraq (University of Pennsylvania Museum of Archaeology & Anthropology, Philadelphia, inv. no. 34-3-2: Fukai 1977, p. 47, fig. 45 = Harden in Langdon and Harden 1934, p. 132, no. 11); the excavators attributed it to the sixth century A.D. Two similar bowls, then in private collections in Tokyo and Osaka, were published by Fukai (1977, p. 46, figs. 42–44 and pls. 12 and 13 = Fukai 1968), who reported that they came from Gilan Province in northern Iran. A fragment of the same type was excavated at the Kami-Gamo shrine in Kyoto, Japan, in 1964 (Laing 1991, p. 118 and fig. 28 = Fukai 1977, p. 47 and figs. 46–48).

Cf. Pope 1938, pl. 1440A; Saldern 1963, pp. 10–11; *2000 Jahre persisches Glas* 1963, no. 22; *Antiquities* 1975a, p. 42, lot 95; *Treasures of the Orient* 1979, p. 261, no. 213 (in the Middle Eastern Culture Center, Tokyo); *Cohn Collection* 1980, p. 150, no. 143 (in the Los Angeles County Museum of Art); *Ancient and Islamic Glass* 1986, p. 92, lot 237; Yoshimizu 1992, v. 1, p. 289, no. 184 (in the Toyama Kinenkan Museum); *Antiquities and Islamic Art* 1998, p. 142, lot 244; *Ancient Glass* 2001, p. 207, no. 175 (in the Miho Museum); and *Brilliant Vessels* 2001, p. 19, no. 46.

## 55. Fragment

About 6th to 7th century. Gift of George D. Macbeth. 62.1.53-27.
Max. Dim. 9 cm.
Probably transparent pale green. Blown; facet-cut.

Fragment of cup or bowl. Lower wall curves down and in to bottom; base (Th. 0.85 cm) is narrow. Lower wall has continuous row of shallow circular facets (D. about 3 cm). Each facet is surrounded by a concentric groove (W. 0.3 cm, D. [est.] about 4.5 cm) and has two

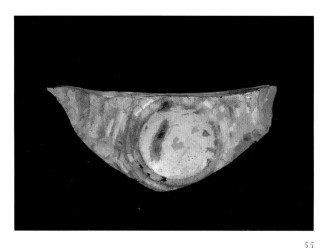

*55*

short horizontal grooves, one above the other, below it. Underside of base has one identical facet and concentric groove.

One fragment, broken on all sides, consisting of most of base and parts of two facets on lower wall. Light gray weathering and some iridescence.

**COMMENT:** Cf. **54**.

## 56. Goblet

Probably 4th to 6th century. Formerly in the Strauss Collection (S2479). Bequest of Jerome Strauss. 79.1.59.
H. 12.8 cm, D. 12.4 cm.
Color unknown. Blown (two gathers); facet-cut.

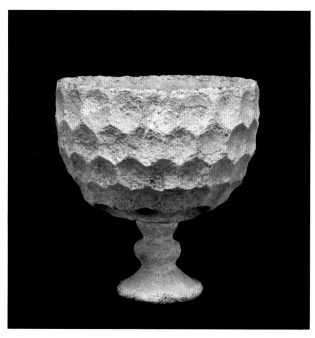

*56*

Goblet with hemispherical bowl. Rim plain, with bevel on inside; wall descends almost vertically before curving down and in; bottom of bowl is flat; stem is solid and tapers to bulbous knop; foot is conical and hollow, with rounded edge; pontil mark (D. about 1.5 cm) fragmentary. Entire wall is decorated with five horizontal bands of contiguous hollow facets, which together make overall honeycomb pattern (from top to bottom): (1) 19 facets resembling regular hexagons, but with rounded tops; (2–4) 19 regular hexagons; and (5) eight large facets, 0.4 cm deep, which resemble regular hexagons, but have rounded bottoms.

Complete. Bowl broken into several pieces, apparently without loss, and repaired. Most of surface is pitted, matte, and various shades of gray; some calcareous(?) accretions.

**COMMENT:** Cf. a goblet in The British Museum, London (WA 1972-5-16,3/135713) and a facet-cut goblet with a straight, tapering wall but a similar stem and foot in the Miho Museum (*Ancient Glass* 2001, p. 208, no. 178).

Some of the "accretions" were applied to the broken edges of the fragments after they had been assembled, evidently in an attempt to conceal the fact that the object was not intact.

**BIBLIOGRAPHY:** "Recent Important Acquisitions," *JGS*, v. 22, 1980, p. 104, no. 8.

## 57. Goblet

About 4th to 6th century. 63.1.4.
H. 10.9 cm, D. 11 cm.
Transparent pale green. Blown; facet-cut.

Goblet with hemispherical bowl. Rim plain; wall descends almost vertically before curving down and in; stem short and hollow; foot conical, with rounded edge made by folding; end of parison pushed up through stem to form dome at center of bowl; pontil mark (D. about 1.6 cm). Wall is decorated with nine horizontal bands of contiguous hollow facets, which together make overall honeycomb pattern (from top to bottom): (1) about 22 facets resembling hexagons, but with rounded tops; (2–7) 21 hexagons; and (8 and 9) 16 hexagons. Height of each hexagon is about two-thirds of its width.

Incomplete. Bowl broken into several pieces, with losses from rim and wall, and restored. Much of sur-

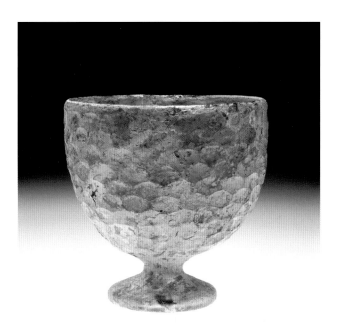

*57*

face has pale grayish brown weathering; where this is missing, glass is pitted and somewhat iridescent.

**COMMENT:** The form of the foot is similar to that of **58** and fragments from archeological sites in Iraq, described on pages 61–62.

## 58. Flute

Perhaps about 3rd century. 2003.1.4.
H. 27.1 cm, D. 11.6 cm.
Transparent yellowish green; many small bubbles. Blown; facet-cut.

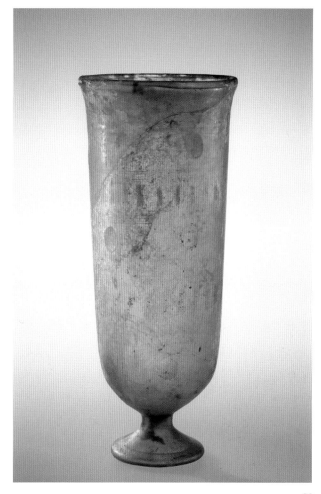

*58*

Flute. Rim slightly everted, with rounded lip; wall straight, tapering slightly, and curving in at bottom; short, hollow stem and conical foot with tubular edge made by folding; center of base pushed up through stem, forming bulb in floor; pontil mark. Upper half of wall has seven continuous horizontal bands of faint wheel-cut decoration (from top to bottom): (1) and (2) narrow bands of horizontal lines; (3) six widely spaced hollow facets, which are oval and taller than they are wide; (4) band of horizontal lines; (5) about

26 short vertical stripes; (6) band of horizontal lines; and (7) six widely spaced horizontal facets, which are taller than they are wide.

Complete. Broken and repaired without loss. Dull, with patches of pale brown weathering.

**COMMENT:** Two other Sasanian flutes have applied ornament (see **16**). The form of these objects may be compared with glasses made in or near the Roman world, the best known of which are five flutes from Sedeinga, Sudan. The Sedeinga flutes consist of two colorless vessels with wheel-cut decoration, fragments of a light green vessel, and two blue vessels with gilded, enameled, and cold-painted decoration (Leclant 1973; Brill 1991). They were discovered in Tomb 8 in the western cemetery at Sedeinga, which is attributed to the third century. For another Roman flute, see Whitehouse 1997, p. 251, no. 429.

**BIBLIOGRAPHY:** *Glasses of Antiquity* 2002, n.p., no. 107.

## 59. Sprinkler

Probably 3rd to 7th century. 68.1.44.
H. 13.6 cm, D. (rim) 7.4 cm, (max.) 10.2 cm.
Almost colorless, with yellowish green tinge; bubbles up to 0.2 cm across. Blown; facet-cut.

Sprinkler with globular body. Rim everted, with rounded lip and uneven horizontal ridge on underside;

*59*

neck cylindrical with, at bottom, diaphragm made by folding. Decorated with hollow facets on shoulder, wall, and base: on shoulder, continuous horizontal band of 17 oval facets, which slant downward from right to left; on wall, four continuous rows of adjoining, more or less circular facets, with 11 facets in top row, 14 facets in second row, 11 facets in third row, and six facets in bottom row; entire base is occupied by one circular facet (D. 3 cm).

Almost complete. Broken and repaired, except for one small loss in shoulder. Slightly iridescent, with traces of dark brown enamellike weathering.

**COMMENT:** The form is reminiscent of Sasanian plain and mold-blown sprinklers from such sites as Tell Mahuz in northern Iraq (Negro Ponzi 1968–9, p. 336, no. 33, and pp. 340–341, nos. 41 and 42). No example of a sprinkler attributed to the early Islamic period appears to have been published, and so the object is assumed to be Sasanian.

## 60. Beaker or Lamp

Probably 4th to 7th century. 63.1.21.
H. 9.3 cm, D. 10.7 cm.
Transparent very pale green, with translucent blue blobs. Mold-blown; applied and facet-cut.

Beaker or lamp: conical. Rim slightly everted, with plain lip, which was knocked off and ground flat; wall bulges and then tapers, curving in at bottom; base plain, with small concavity; no pontil mark. Wall is completely covered with applied and cut, ground, and polished decoration arranged in three continuous horizontal registers (from top to bottom): (1) between rather irregular borders, 13 hollow oval facets alternating with groups of six short horizontal grooves, one above the other; (2) 21 applied blue blobs; and (3) below irregular border, overall pattern consisting of four bands of hollow facets arranged in quincunx, each band decorated as follows: at top, one band with 19 facets with rounded tops and V-shaped bottoms, two bands with 19 more or less hexagonal facets, and, at bottom, 11 irregular facets with rounded bottoms.

Intact. Patches of brown to ivory-colored weathering and faint iridescence; evidently cleaned.

**COMMENT:** This object was acquired in Iran.

Conical beakers or lamps decorated with blue blobs and/or facet-cut decoration are well known in the Sasanian world (cf. *Splendeur des Sassanides* 1993, pp. 110 and 260–262, nos. 109–111 [**60**, **62**, and **61**]). Comparison with the cold-worked ornament on other forms (such as **53**–**55**) establishes beyond doubt that

the facet-cut conical vessels are Sasanian. The Sasanian origin of some conical vessels with blue blobs and simple linear cutting, on the other hand, has yet to be demonstrated; two examples illustrated by Fukai (1977, pls. 21 and 22), reported to have come from northern Iran, are indistinguishable visually from fourth-century Roman products (e.g., Weinberg 1988, pp. 87–93, nos. 404–438, which were made at Jalame, Israel).

**60** may be compared with Fukai 1977, pl. 23 (reported to have been found in Gilan Province, northern Iran), which has facets but no blobs. Examples of the same form, decorated with blue blobs but no facets, include: *Trois millénaires d'art verrier* 1958, p. 87, no. 180 (acquired in Cairo); *Gläser der Antike* 1974, pp. 251–252, no. 731; *Constable-Maxwell Collection* 1979, p. 144, lot 261; and *Kofler-Truniger Collection* 1985, p. 22, lot 25 (= *3000 Jahre Glaskunst* 1981, p. 116, no. 470). Whitehouse 2003, p. 158, no. 1168, which was acquired in Tel Aviv, Israel, has neither facets nor blobs.

A band of hollow circular facets alternating with groups of short horizontal cuts is found on a fragment of a shallow vessel found at Qasr-i Abu Nasr in southern Iran (Whitcomb 1985, pp. 158–159, fig. 59m).

**BIBLIOGRAPHY:** "Recent Important Acquisitions," *JGS*, v. 6, 1964, p. 158, no. 11; *Splendeur des Sassanides* 1993, p. 260, no. 109.

## 61. Beaker or Lamp

Perhaps 4th to 6th century. 66.1.6.
H. 24.8 cm, D. 16.5 cm.
Transparent very pale green, with few small spheroid and elongated bubbles. Mold-blown; facet-cut.

Beaker or lamp: conical. Rim slightly everted, with beveled lip made by grinding and polishing; straight, tapering wall, which curves in at bottom; plain, narrow base. Wall is completely covered with cut, ground, and polished decoration arranged in three continuous horizontal registers (from top to bottom): (1) with border above and below, 20 contiguous hexagons with double outlines consisting of short, rather uneven grooves, each hexagon containing one hollow oval facet; (2) also with border above and below, overall pattern consisting of four bands of 18 hexagons arranged in quincunx, with each band smaller than band above it and each facet resembling those in band below rim; and (3) overall pattern of eight bands of hollow facets arranged in quincunx, each band decorated as follows: at top, one band with 20 facets with rounded tops and V-shaped bottoms, five bands with 20 more or less hexagonal facets, one band with 13 irregular polygonal facets, and, at bottom, nine irregular facets with rounded bottoms.

Complete. Long, branching crack extends from rim to near bottom of wall. Dull, with small patches of grayish brown weathering, especially in facets; evidently cleaned.

**COMMENT:** For a general comment, see **60**.

For this object, cf. *Wolkenberg Collection* 1991, p. 23, lot 30, a smaller vessel (H. 12.1 cm) with three bands of similar wheel-cut ornament: (1) and (2) contiguous hexagonal facets, the latter with double outlines, and (3) an overall pattern consisting of bands of hexagonal facets arranged in quincunx.

**BIBLIOGRAPHY:** "Recent Important Acquisitions," *JGS*, v. 9, 1967, p. 135, no. 15; *Sasanian Silver* 1967, p. 154, no. 78; *Persian Glass* 1972, p. 11, no. 12; *Splendeur des Sassanides* 1993, p. 262, no. 111.

## 62. Beaker or Lamp

Perhaps 4th to 5th century. 59.1.580.
H. 18.7 cm, D. (rim) 8.4 cm, (base) 2.2 cm.
Almost colorless, but with green tinge; many very small bubbles. Mold-blown; facet-cut.

Beaker or lamp: conical. Rim plain, knocked off, and rounded by grinding; wall straight, tapering, then curving in at bottom; base plain, narrow, and finished

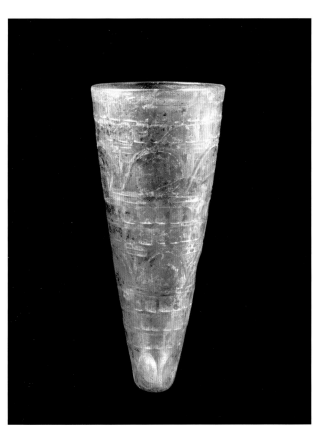

by grinding. Wall is completely covered with cut, ground, and polished decoration arranged in six continuous horizontal registers (from top to bottom): (1) two bands of hollow square facets, with 24 facets in upper band and 25 facets in lower band; (2) one band of five contiguous, semicircular, archlike cuts, resting on pairs of horizontal cuts, one above the other, and with one T-shaped group of cuts in each spandrel; inside each archlike cut, one large, hollow circular facet; (3) two bands of hollow square facets, with 21 facets in upper band and 18 facets in lower band; (4) same as (2); (5) three bands of hollow square facets, with 17 facets in top band, 15 facets in middle band, and 14 facets in bottom band; and (6) one band of six hollow oval facets.

Complete, but with several internal cracks. Dull, with patches of brown weathering and faint iridescence; evidently cleaned.

**COMMENT:** This object is said to be from Amlash, northwestern Iran. Amlash, however, like Nishapur and Susa, was a "provenance" much favored by dealers in Iranian antiquities, and the report should be regarded with skepticism (see page 10).

Cf. a facet-cut beaker or lamp in The British Museum (*Masterpieces of Glass* 1968, p. 106, no. 138 = Pinder-Wilson 1963, pl. 15a: "said to have been found in Persia").

For a comment on conical vessels in general, see **60**.

**BIBLIOGRAPHY:** Saldern 1963, p. 8; *Sasanian Silver* 1967, p. 154, no. 80; *Royal Hunter* 1978, p. 156, no. 79; *Splendeur des Sassanides* 1993, p. 261, no. 110.

## 63. Beaker or Lamp

About 4th century. 62.1.9.
H. 22.4 cm, D. 9.2 cm.
Transparent pale yellowish green. Mold-blown; facet-cut.

Beaker or lamp: conical. Rim plain, with rounded lip; wall tapers, then curves in at bottom; base plain. Decorated on wall with five continuous horizontal bands of vertical oval facets, each row below continuous band of faint wheel-cut lines, and with one large circular facet on underside of base. From top to bottom: (1) wheel-cut lines begin 0.5 cm and end 1.5 cm below rim; beneath them, one row of 35 narrow facets; (2) wheel-cut lines begin 4.1 cm and end 5.0 cm below rim; beneath them, three rather uneven rows of 31 narrow facets, arranged in quincunx; (3) wheel-cut lines begin 9.8 cm and end 10.8 cm below rim;

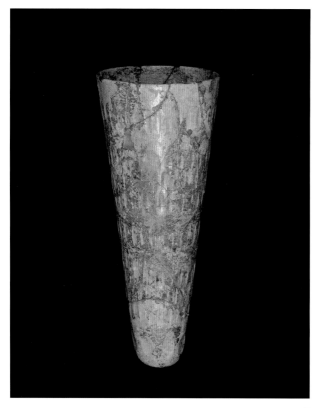

*63*

beneath them, one band of 27 narrow oval facets; (4) wheel-cut lines begin 12.8 cm and end 13.7 cm below rim; beneath them, three uneven bands of 21 narrow oval facets, arranged in quincunx; and (5) wheel-cut lines begin 18.8 cm and end 19.4 cm below rim; beneath them, one band of eight relatively broad facets.

Incomplete. Broken into numerous fragments, with several small losses from wall; restored. Remains of opaque ivory to pale brown weathering.

**COMMENT:** For a general comment, see **60**.

The widely spaced oval facets may be compared with the facets on **46** and **49**.

**BIBLIOGRAPHY:** *Sasanian Silver* 1967, p. 154, no. 79.

## 64. Bottle

About 6th century. Formerly in the Smith Collection (1179). 59.1.435.
H. 7 cm, D. (rim) 1.4 cm, W. (max.) 5.7 cm.
Transparent pale green. Blown; facet-cut.

Bottle: globular. Rim plain, with flat top finished by grinding; neck short and tapering; shoulder has pronounced "step" at edge; base consists of disk (D. 2.7 cm) with vertical edge and slightly concave underside. Wall is decorated with two horizontal rows of bosses

with flat surfaces and vertical sides: at top, four equidistant isosceles triangles, each with rounded, downward-pointing apex and surface embellished with V-shaped groove; at greatest diameter, below spaces between each pair of triangles, four disks (D. 2.1–2.3 cm).

Intact, except for abraded crescent-shaped depression on underside of base. Partly covered with matte light brown weathering; where this is missing, surface is pitted and iridescent.

**COMMENT:** According to R. W. Smith (in *Glass from the Ancient World* 1957: see below), the object is from Iraq and was probably found there. The abraded area on the base has no trace of weathering, and it may be the result of removing a sample for chemical analysis.

One very close parallel is known to exist: a bottle found in the tomb of a Buddhist monk (d. 589) at Xi'an in Shaanxi Province, China (*China: Dawn* 2004, p. 324, no. 219 = Joo 2003, p. 171, fig. 2). A molar flask in The Metropolitan Museum of Art (1985.316: Jenkins 1986, pp. 24 and 56, no. 23), which is attributed to the ninth century, has similar triangular bosses on the shoulder.

**BIBLIOGRAPHY:** *Glass from the Ancient World* 1957, p. 269, no. 550; Saldern 1963, p. 13 and fig. 12.

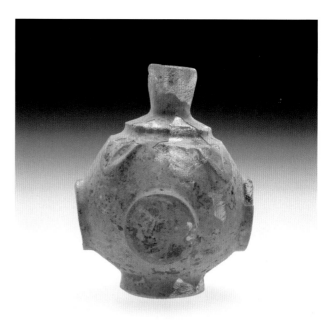

*64*

## 65. Bottle

Perhaps 4th to 6th century. 62.1.4.
H. 20.2 cm.
Transparent pale yellowish brown, with few small bubbles. Blown; facet-cut.

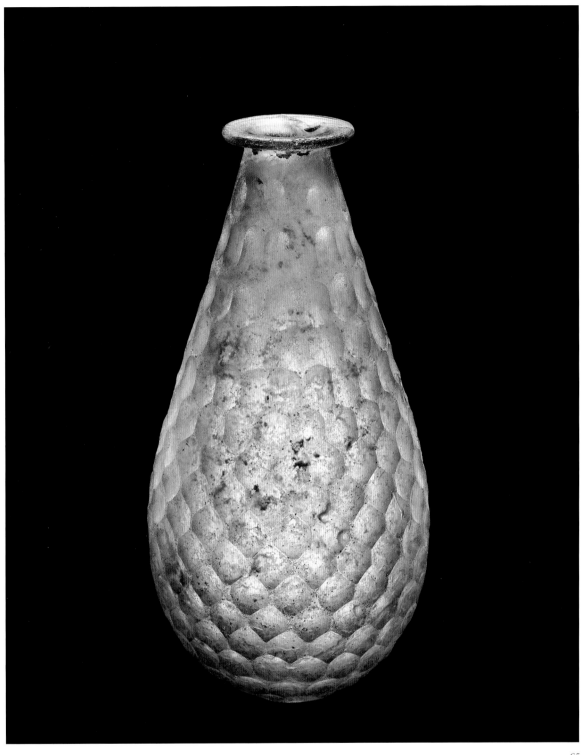

Bottle: pear-shaped. Rim is horizontal flange with rounded lip; wall splays and then curves down and in; very narrow base consisting of hollow circular facet. Wall is completely covered with overall pattern of 16 horizontal bands of contiguous hollow facets arranged as follows (from top to bottom): two rows of tall, rather narrow oval facets; two rows of roughly oval facets, some of which have sections of straight edge and tend toward hexagons; 10 rows of hexagons arranged in quincunx; one row of roughly circular facets, some of which have sections of straight edge and tend toward hexagons; and one row of large circular facets. At center of base, small circular perforation.

Incomplete. Small loss from rim restored. Pitted, with slight iridescence.

**COMMENT:** Fukai (1977, p. 54, pl. 30, fig. 59) published a somewhat smaller and less carefully cut bottle

of this type, which is said to have been found in a Sasanian tomb in Gilan Province, northern Iran. This, too, has a small perforation in the base, apparently made after the object had been finished. The perforations in these two objects are similar to the circular perforations made by R. W. Smith in order to collect samples for spectrographic analysis (Sayre and Smith 1961; Sayre 1963; Smith 1963; Sayre 1964; Smith 1964). The bottle from Gilan, however, was evidently perforated in antiquity.

Other examples of the form include "Recent Important Acquisitions," *JGS*, v. 10, 1968, p. 182, no. 16 (= *2000 Jahre persisches Glas* 1963, no. 18: in the David Collection, Copenhagen, acc. no. 12/1964); Hasson 1979, pp. 28–29 and 37, no. 49 (in the L. A. Mayer Memorial Institute for Islamic Art, Jerusalem, acc. no. G 33); *Islamic Works of Art* 1980, n.p., lot 243; *Ancient Glass* 1986, p. 22, lot 68 (neck restored); *Antiquities* 2000a, p. 30, lot 127 (with a hole in the bottom); and a bottle in The British Museum (WA 1973-4-14,1/ 135854).

For a silver-gilt vessel with the same shape, but decorated with heart-shaped motifs, see Hasson 1979, pp. 28–29 and 37, no. 50 (in the L. A. Mayer Memorial Institute for Islamic Art, Jerusalem, acc. no. M 80). The object is believed to have been made in Iran in the seventh to eighth centuries.

**BIBLIOGRAPHY:** "Recent Important Acquisitions," *JGS*, v. 5, 1963, p. 145, no. 18; *Persian Glass* 1972, p. 11, no. 11; Charleston 1980, p. 64, no. 24; Dolez 1988, p. 55, no. 6; Charleston 1990, p. 64, no. 24; Brewerton 1991, p. 55; *Treasures from Corning* 1992, p. 28, no. 18; Yoshimizu 1992, v. 1, pp. 289–290, no. 186; *Splendeur des Sassanides* 1993, p. 257, no. 105.

## 66. Tube

3rd to 6th or 7th century. Formerly in the Smith Collection. 66.1.19.
L. 33.1 cm, D. 2.8 cm.
Transparent green. Mold-blown; facet-cut.

Tube. Rim plain, rounded by grinding and polishing; wall vertical, curving in slightly at bottom; base flattened by grinding. Cut, ground, and polished decoration beginning 9.3 cm below rim and ending 1.4 cm above base: 17 continuous horizontal bands of facets, arranged (except for lowest band) in quincunx, with seven facets in each band. Facets in bands 2 to 16 are either diamond-shaped or hexagonal, those in uppermost band are rounded at top and V-shaped at bottom, and those in lowest band are oval.

Intact. Dull and extensively pitted, with traces of silvery gray weathering.

**COMMENT:** Cylindrical vessels with facet-cut decoration, usually of deep green glass, are not uncommon, and a few examples preserve their original silver or copper alloy caps. The function of these objects is uncertain. One suggestion is that they were used to protect documents, which were tightly rolled and inserted into the narrow tube, or to contain writing implements such as brushes or pens (*Royal Hunter* 1978, p. 157). The internal diameter, however, is so small that it would have been difficult to extract a rolled document without damaging the tube.

Among the tubular vessels of known provenance are a fragmentary specimen in The British Museum, which was found at Nineveh (Kuyunjik), northern Iraq (*Masterpieces of Glass* 1968, p. 106, no. 136; Simpson

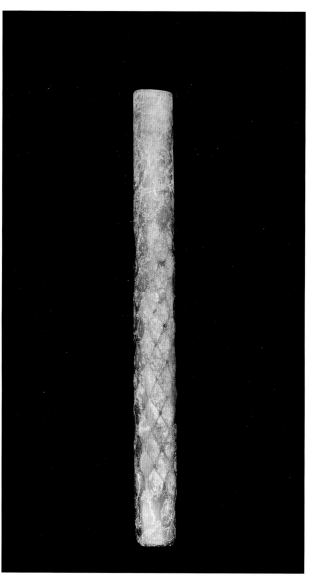

*66*

1996, p. 125, fig. 2, no. 3); a fragment from Tell Baruda (Ctesiphon), central Iraq (Negro Ponzi 1987, p. 272, no. 348); and a fragment in The Metropolitan Museum of Art, New York, which was found at Qasr-i Abu Nasr, southern Iran (Whitcomb 1985, p. 158, fig. 59e, identified as part of a tube in *Royal Hunter* 1978, p. 157).

Other examples include a tube (L. 33.5 cm) in the Middle Eastern Culture Center, Tokyo (*Treasures of the Orient* 1979, p. 261, no. 206); a tube (L. 31 cm) in the David Collection, Copenhagen (5/1971: Leth 1975, p. 11); a tube (L. 30.5 cm) in the Museum für Islamische Kunst, Berlin (*Splendeur des Sassanides* 1993, p. 258, no. 107); a tube (L. 33 cm) that was on the market in London in 1986 (*Antiquities* 1986, p. 9, lot 63); a tube (L. 26.5 cm) shown in *Brilliant Vessels* 2001, p. 7, no. 5; and a fragmentary tube in the Oppenländer Collection (*Gläser der Antike* 1974, p. 259, no. 760).

For similar tubes, but without facets, see Oliver 1980, p. 137, no. 234 ("natural green" glass, L. 27.5 cm, in the Carnegie Museum of Natural History, Pittsburgh); and *Islamic Art* 2004, p. 14, lot 233 (green, L. 24.5 cm).

**BIBLIOGRAPHY:** *Royal Hunter* 1978, p. 157, no. 80; *Splendeur des Sassanides* 1993, p. 258, no. 107.

## 67. Tube

About 7th century. Formerly in the Smith Collection (1050). 59.1.488.
L. (surviving) 15.3 cm, D. (base) 3.2 cm, W. (across facets) 3.6 cm.
Transparent deep green. Blown, perhaps in mold; facet-cut.

Tube: cylindrical. Wall descends vertically, then splays at bottom; base plain, with beveled edge. Wall is decorated with four horizontal rows of relief-cut facets arranged in quincunx; each row contains three facets, and each facet is oval, being slightly taller than it is wide, about 0.35 cm deep, and with convex upper surface. Underside of base is ground and polished.

Incomplete. Upper part missing (ineptly restored with plastic). Dull and pitted, with remains of slightly iridescent, reddish brown to buff weathering. On underside of base, white paper label (1.5 cm square) with serrated edges and printed and handwritten inscriptions: "Paris 1961 [printed in black ink] / Com. 8 / C. 887 [handwritten in black ink]."

**COMMENT:** According to the Museum's records, this object was obtained by Ray Winfield Smith in

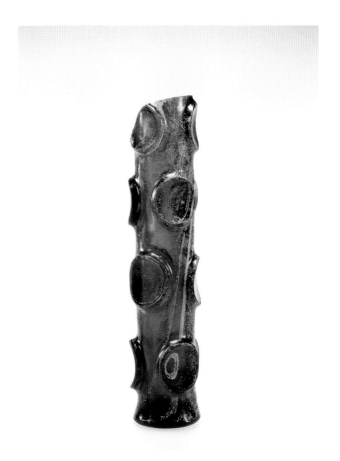

Iran, and it was said to have been found in the Azerbaijan region.

The object has the same form as a group of vessels with oval or diamond-shaped facets. Examples with known find-places include: (1) Whitcomb 1985, pp. 155 and 158–159, fig. 59e (from Qasr-i Abu Nasr, southern Iran); (2) Negro Ponzi 1987, p. 272, fig. 6 (from Tell Baruda [Veh Ardashir], Iraq); and (3) Simpson 1996, pp. 96–97 and fig. 2.3 (= *Masterpieces of Glass* 1968, p. 106, no. 136, from Nineveh [Kuyunjik], northern Iraq). Other examples include: *Gläser der Antike* 1974, p. 259, no. 760; *Davids Samling: Islamisk Kunst* 1975, p. 11, no. 5/1971; *Treasures of the Orient* 1979, p. 148, no. 206; Oliver 1980, p. 137, no. 234; and *Splendeur des Sassanides* 1993, p. 258, nos. 106 and 107.

The relief-cut facets of **67** resemble the facets on a number of late Sasanian or early Islamic vessels, including (1) *Treasures of the Orient* 1979, p. 148, no. 207 (a small flask); and (2) Taniichi 1987, p. 87, no. 91 (= *Constable-Maxwell Collection* 1979, pp. 188–189, lot 328: a shallow bowl).

For the supposed function of these long, narrow tubes, see **66**.

**BIBLIOGRAPHY:** *Glass from the Ancient World* 1957, p. 283, no. 599.

# BEADS

Among the objects collected by R. W. Smith and donated to The Corning Museum of Glass by Carl Berkowitz and Derek Content are a group of four beads (**68–71**), which Smith evidently considered to be a group and of Sasanian origin. This attribution is not unlikely, but given the wide distribution in Europe, the Middle East, and elsewhere of beads enclosing gold or white metal foil, it cannot be treated as a certainty (Boon 1977). **72**, a rather more elaborate bead, came from the same source, and we may claim for it an Iranian origin with much greater confidence. All five beads are made of colorless or almost colorless glass and enclose gold foil. The technique of producing such beads was described by Boon (*ibid.*, p. 193) as follows: "The bead was made from sections of tube, generally colourless, covered in the foil and then dipped into molten glass for protection and added brilliancy. Sections of the composite tube were then placed on a wire, and pinched at intervals to make the segment."

## 68. Bead

Probably 3rd to 7th century. Formerly in the Smith Collection (230-12). Gift of Carl Berkowitz and Derek Content. 76.1.93A.
L. 0.7 cm, D. 1.1 cm.
Almost colorless, with gold-foil inclusion. Drawn.

Bead: roughly cylindrical, with bulging side, flat ends, and circular perforation (D. 0.5 cm). Decorated with gold foil sandwiched between two fused layers of glass.
Intact. Dull, with pale grayish weathering.

## 69. Bead

Probably 3rd to 7th century. Formerly in the Smith Collection. Gift of Carl Berkowitz and Derek Content. 76.1.93B.
L. 0.9 cm, D. 0.5 cm.

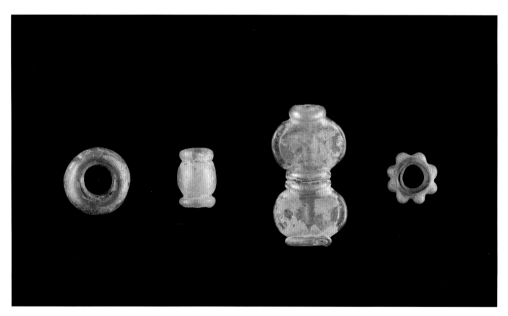

*68–71*

Almost colorless, with gold-foil inclusion.
Drawn.

Bead: roughly cylindrical, with bulging side, prominent "collars" at ends, and circular perforation (D. 0.3 cm). Decorated with gold foil sandwiched between two fused layers of glass.
Intact. Dull, with pale grayish weathering.

## 70. Bead

Probably 3rd to 7th century. Formerly in the Smith Collection (230-9). Gift of Carl Berkowitz and Derek Content. 76.1.93C.
L. 2.2 cm, D. 1.2 cm.
Colorless, with gold-foil inclusion. Drawn.

Bead: segmented. Two segments, both with a flattened oval form, a "collar" at each end, and a circular perforation (D. 0.15 cm). Decorated with gold foil sandwiched between two fused layers of glass.
Intact. Dull, with pale grayish weathering.

## 71. Bead

Probably 3rd to 7th century. Formerly in the Smith Collection (230-18). Gift of Carl Berkowitz and Derek Content. 76.1.93D.
L. 0.4 cm, D. 0.9 cm.
Almost colorless, with gold-foil inclusion.
Drawn; crimped.

Bead: annular, with flat ends and circular perforation (D. 0.35 cm). Decorated with eight small knobs and gold foil sandwiched between two fused layers of glass.
Intact. Dull, with pale grayish weathering.

## 72. Bead

1st to 3rd century or later. Formerly in the Smith Collection (203). Gift of Carl Berkowitz and Derek Content. 76.1.94.
L. 1.9 cm, W. 0.6 cm, Th. 0.4 cm.
Almost colorless. Pressed; gilded.

Bead: rectangular in cross section, with two wide and two narrow sides, and longitudinal perforation. Wider sides are decorated in relief: one side has standing female figure shown frontally, perhaps naked and perhaps with unidentified object beside and above left shoulder; other side has 12 small protrusions arranged in two parallel rows of six. All four sides are gilded, but ends are not.

Intact.

**COMMENT:** The female figure recalls the dancing figures on Sasanian metal objects, such as the silver-gilt vases illustrated in *Splendeur des Sassanides* 1993, pp. 234–239, nos. 85–88. On one of these vases (p. 239, no. 88, in the Louvre: OA.426), a dancer holds a branch that terminates in a mass of leaves and flowers or fruits; it occupies the same position as the unidentified object on **72**.

An almost identical bead was excavated in Tomb IV at Hassani-mahale near Dailaman in Gilan Province, northern Iran. The other finds from this tomb suggested to the excavators that the burial took place between the first and third centuries (Fukai 1977, p. 27).

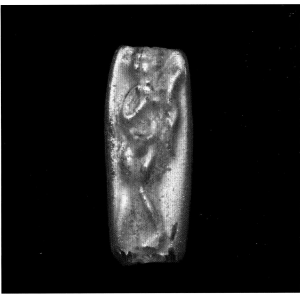

*72A*

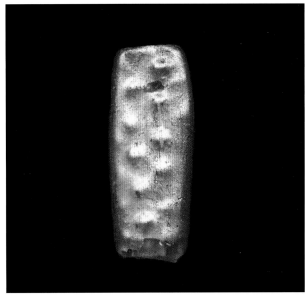

*72B*

# H

# FORGERY

### 73. Plaque

20th century. Formerly in the Smith Collection.
Gift of Ray Winfield Smith. 73.1.8.
H. 5.5 cm, W. (max.) 5.1 cm.
Transparent greenish blue, with bubbles.
Stamped.

Plaque: roughly circular disk. Obverse: thin border of circular bosses (missing from right side); head and shoulders of male, seen full-face, crowned, with long hair, flamboyant mustache, and beard; dressed in garment, with two horizontal rows of bosses, under robe or coat, with lapels, and broad collar; on either side of head, imitation of Pahlavi inscription. Reverse: smooth.

Intact; as new.

**COMMENT:** This is an obvious impostor. Despite a superficial likeness to an image of a Sasanian ruler, such as the silver, parcel-gilt head, perhaps of Shapur II (r. 309–379), in The Metropolitan Museum of Art,

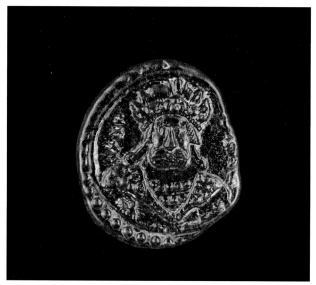

*73*

New York (*Splendeur des Sassanides* 1993, p. 165, no. 23), the object is utterly unconvincing. The crown is unlike any Sasanian crown, the garments are implausible, and the inscription is meaningless.

# Appendix 1

# Fragments from Archeological Sites in Iraq

In 1966, Prof. Henry T. Wright submitted for chemical analysis fragments of Sasanian glass collected from the surface of three adjacent sites at Tulul Umm Ghemimi, 35 kilometers west of An Nasiriyah (45°53′ E, 31°7′ N) in southeastern Iraq (Wright 1981, pp. 335 and 340–341, sites EP-63–65). The following year, Dr. Robert H. Brill collected fragments of glass and related materials from the surface of two other sites in central and southern Iraq, and he brought the fragments to Corning for further study. The two sites are Tell Umm Jirin, 12 kilometers northeast of Tel Aqrab (at about 44°56′ E, 33°26′ N); and Umm Jezaziyat, 58 kilometers southeast of Ad Diwaniyah (45°33′ E, 31°42′ N) (Adams 1965, p. 146, site 263; *idem* 1981, pp. 211 and 288–289). Dr. Brill also collected additional material at Tulul Umm Ghemimi. For additional information on all three sites, see pages 66–67.

The finds from these sites include fragments of glass vessels, chunks of raw glass, and pieces of brick coated with glass—evidently the remains of furnaces. The sites, therefore, were glass factories, and we assume that the fragmentary vessels were either made on the spot or imported as cullet. A single fragment of facet-cut glass from Jezaziyat, for example, may have arrived as cullet (see below). A fragment of a tightly twisted glass bangle with a circular cross section (cf. Spaer 2001, p. 201, nos. 462–465) from the same site is not a known Sasanian type, and it may have been dropped at the site by a later visitor.

Many of the fragments are small, and only the most informative were selected for description and illustration (Fig. 1).

## Tell Umm Jirin

### 1. Cup

H. 3.6 cm, D. (est.) about 10 cm.
Transparent light green; many small and two large bubbles. Blown.

Cup: cylindrical. Rim plain, with rounded lip; upper wall vertical.

**Comment:** The rim is somewhat distorted, and the intended diameter may have been slightly smaller than 10 cm.

### 2. Cup

H. 3.4 cm, D. (est.) 8 cm.
Transparent green; bubbly. Blown.

Cup. Rim plain, with rounded lip; upper wall curves down and in.

### 3. Cup or Bowl

H. 2.5 cm, D. (est.) 12 cm.
Transparent pale green. Blown.

Cup or bowl: cylindrical. Rim rounded and thickened on inside; upper wall is vertical.

## Jezaziyat

### 4. Cup

Max. Dim. 4.9 cm.
Colorless. Blown; facet-cut.

Cup: hemispherical. Fragment from lower wall. Parts of two horizontal rows of hexagonal facets and of one larger circular or oval facet survive.

**Comment:** Sample 1272 (see page 77) was taken from this fragment.

### 5. Bowl(?)

H. 2.9 cm, D. (base, est.) 9 cm.
Transparent very pale brown. Blown.

Bowl(?). Fragment from floor and foot. Vessel has flat floor and hollow truncated conical foot with rounded edge made by folding.

**COMMENT:** Sample 1274 (see page 77) was taken from this fragment.

### 6. Bowl(?)

H. 0.7 cm, D. (base, est.) 6.5 cm.
Almost colorless, but with greenish tint. Mold-blown.

Bowl(?). Fragment from wall and base. Bottom of wall curves down and in; base is flat and thicker at center than at edge. Underside of base has mold-blown decoration in low relief: rosette, originally with eight petals, in circular medallion with double border.

**COMMENT:** Although no datable parallel has been found, this fragment is assumed to be Sasanian because this is believed to be the date of the site. Sample 1279 (see page 77) was taken from the fragment.

### 7. Tumbler

Max. Dim. 4.5 cm, D. (base, est.) 4 cm.
Transparent pale brownish mauve. Blown, perhaps in mold.

Tumbler. Fragment from lower wall, which is straight and tapering before curving in at bottom, and flat base.

**COMMENT:** Sample 1276 (see page 77) was taken from this fragment.

### 8. Goblet

H. 2.6 cm, D. (base, est.) 4 cm.
Almost colorless, but with yellowish green tint. Blown.

Goblet. Fragment from stem and base. Stem is hollow, and base is shaped like shallow cone, with rounded edge formed by folding and central part pushed into stem.

**COMMENT:** Sample 1271 (see page 77) was taken from this fragment.

### 9. Goblet(?)

H. 2.8 cm, D. (base, est.) 7 cm.
Transparent pale brownish mauve. Blown.

Goblet(?). Fragment with bottom of stem (but see below) and part of foot. Foot is shaped like hollow cone, with rounded edge made by folding and center pushed into hollow stem.

**COMMENT:** Too little survives to indicate whether the object was a goblet with a hollow stem, similar to **10**, or a vessel with a very narrow floor.

### 10. Beaker or Lamp

H. 3.3 cm, D. (base) 1.4 cm.
Transparent green. Probably blown in dip mold.

Beaker or lamp: probably conical. Fragment with lower wall and base. Wall tapers; base is plain and narrow; pontil mark circular (D. 1.2 cm).

*Fig. 1. Fragments from archeological sites in Iraq (1:1).*

*Fig. 1 (cont.). Fragments from archeological sites in Iraq (1:1).*

# APPENDIX 2

# CHEMICAL ANALYSES OF SOME SASANIAN GLASSES FROM IRAQ

## Robert H. Brill

The world knows a lot about Islamic glass, but relatively little about Sasanian glass. This appendix is an attempt to establish a starting point from which a more thorough study of the chemical aspects of Sasanian glass technology might evolve.

Over the years, The Corning Museum of Glass has carried out chemical analyses of about 75 examples of Sasanian glasses. Only three of these analyses are of accessioned objects in the Museum's collection. The others were performed either on fragments submitted from excavations or on unaccessioned surface fragments collected in the 1960s at three sites in central and southern Iraq.

The excavated fragments came from Ctesiphon and Choche. Those from Ctesiphon were submitted for analysis by Jens Kröger of the Museum für Islamische Kunst in 1984 and 1985, while those from Choche had been submitted by Mariamaddalena Negro Ponzi on September 1, 1967. A third group, from Tulul Umm Ghemimi, consisted of surface finds collected by Henry T. Wright, who submitted them to the Museum for analysis on November 8, 1966. All of these fragments had been exported from Iraq under government permits. Brief sample descriptions of the fragments are listed near the end of this appendix.

Additional surface finds were collected by this author at two sites in Iraq. They were collected at Umm Jezaziyat on May 8, 1967, and at Tell Umm Jirin on May 5, 1967. These two sites had been identified previously as glass-related locations by Robert McC. Adams, who directed me to them. Adams had listed one of the sites in his comprehensive survey of archeological sites in the Diyala River Plain (Adams 1965). The fragments collected at these two sites were also exported under government permits.

The findings discussed here are not to be thought of as representative of Sasanian glasses as a whole. Except for the three objects in the Museum's collection, all of the glasses discussed here were found in a region measuring about 250 kilometers from north to south. However, considering that they include some 65 fragments from five different locations within that region, their chemical compositions may well be thought of as representative of glasses in use in that region during Sasanian or early Islamic times. Moreover, because abundant evidence of glassmaking was seen at three of these sites in 1967, it is plausible that much of the glass found at all five of the sites could have been made somewhere nearby.

Quantitative chemical analyses for major and minor oxides were performed by atomic absorption (AA) or by inductively coupled plasma spectroscopy (ICP). Semiquantitative optical emission spectrographic (OES) analyses were used to estimate the levels of trace oxides. Silica was estimated by difference from 100.00 percent. (These silica values therefore include chloride and sulfate, as well as phosphorus, except for those samples for which $P_2O_5$ was determined separately.) Most of the analyses were run by Dr. Brandt A. Rising and his co-workers at Umpire and Control Services Inc. in West Babylon, New York, although a few were run more recently by Dr. Rising at the UCS Section of Ledoux & Company in Tenafly, New Jersey. Two of the objects for which only minute samples were available (nos. 1296 and 3086) were analyzed with an electron microprobe by Philip M. Fenn of Corning Incorporated in June 1990. The Museum's reference glasses A, B, C, and D were used for all of the analytical procedures (Brill 1999, v. 2, pp. 529–544).

The data for some of the analyses reported here (Tables 1–6) were published previously, but without interpretation (Brill 1999, v. 1, pp. 82–83, and v. 2, pp. 152–160). In accordance with our usual practice, each table includes reduced compositions that report seven major and minor oxides normalized to 100.00 percent.

Mean compositions for the samples from each of the five archeological sites are reported in Table 7.

## The Archeological Sites

*Ctesiphon*

Ctesiphon is a major site located about 25 kilometers southeast of Baghdad on the eastern bank of the Tigris. It is the location of a large and famous sixth-century brick arch. The glass fragments analyzed from Ctesiphon were submitted by Jens Kröger, who dated them, for the most part, simply as "Sasanian" or "Early Islamic." With the exception of two examples noted in the descriptions, the 16 fragments are either moderately or heavily weathered. Because the dating was not specified precisely, the fragments were treated as a single group of samples in the calculations and graphs that follow.

*Choche*

Choche is located two or three kilometers from Ctesiphon. The 12 fragments of glass in this group were submitted for analysis by Mariamaddalena Negro Ponzi, who dated them from the third to early fifth centuries. The glasses are moderately to heavily weathered, with only one exception (Negro Ponzi Mancini 1984). These fragments, too, were considered as a single group in the calculations and graphs that follow. The analyses were published previously (Brill 1968, pp. 50–51).

*Tell Umm Jirin*

Tell Umm Jirin is a small tell located about 12 kilometers northeast of Tel Aqrab. (The site's approximate coordinates are 44°56′ E, 33°26′ N.) It is site number 263 in Adams's survey (Adams 1965, p. 146 and section 2B). The crescent-shaped tell rises about 2.5 meters above the level of the plain, and it measures about 200 meters in length. Adams accurately described the site as containing "great quantities of molten glass refuse."

The glasses seen at this site, as well as those from the two sites that follow, were mainly aqua, green, colorless, or slightly purplish. The purplish glasses are believed to have been solarized by centuries of intermittent exposure to strong desert sunlight.

*Umm Jezaziyat*

Jezaziyat is a group of low tells lying in the Diyala River Plain, about 58 kilometers southeast of Ad Diwaniyah. (The site's approximate coordinates are 45°33′ E, 31°42′ N.) Professor Adams has published the site and the glass finds, which he identified as Sasanian and early Islamic on the basis of ceramic finds

(Adams 1981, pp. 211 and 288–289, fig. 45). He described the finds as glass slag, furnace-lining fragments, and glass kilns.

In 1967, the tells appeared from a distance to be dark-colored mounds, owing to the presence of thousands of pieces of various types of glass-coated debris, along with fragments of glass vessels. From nearer by, the debris looked as if it was mainly chunks of cullet of various sizes, but still closer examination showed that relatively few pieces were glassy throughout. Instead, the majority of the individual pieces were found to be pottery sherds, pieces of refractory, or pieces of "burnt" structural materials—mostly with green glass adhering to their surfaces. Larger pieces were seen that measured 30 centimeters or more in greatest dimension. Some of these were penetrated by fingers of once molten glass and were coated with glass rundown. It was clear that the larger pieces were structural remains of ancient furnaces or working surfaces of some sort. Collectively, the material was unmistakably debris from some pyrotechnological operations, probably operations involving glassmaking.

There was one conspicuously different piece of debris. It was a sizable rectangular piece of hard, flat stone that was probably not native to the area. Because it had one smooth, blackened surface, we wondered if it could have been imported and once used as a marver.

At the particular location visited in 1967, one type of evidence for glassworking was lacking. Although pieces of furnace debris were abundant, few, if any, pieces of distorted glass wasters or glass trailings were seen. In contrast, large quantities of vessel fragments were found to the south of one of the mounds. The fragments analyzed in this study came from that location.

*Tulul Umm Ghemimi*

Tulul Umm Ghemimi is the third location visited in 1967. It had been brought to the author's attention by Henry T. Wright, who had visited the area previously. (He was then working on behalf of the Lower Iraq Survey of the Oriental Institute of the University of Chicago.) Wright collected some surface finds that he sent to the author late in 1966 for examination and chemical analysis. The samples consisted of glass from three possibly contemporaneous locations, all situated within about 400 meters of one another. Wright had designated them EP-63, EP-64, and EP-65. In particular, he said, EP-63 was an Achaemenid/Seleucid mound. Nearby was the smaller mound EP-64, where much glass was found. However, Wright concluded that the glass workshop was most closely related to a larger fort, EP-65, where there were Sasanian ceram-

ics. The glass workshop also had two features described as "plastered basins."

These tells were located about 35 kilometers from An Nasiriyah and about four kilometers east-southeast of Bat-Ha (approximate coordinates 45°53′ E, 31°7′ N). They are about two kilometers south of the Euphrates in what was then an open area with remains of ancient waterways. The glass-related surface finds closely resembled those seen at the other two sites. Professor Wright has since published the site (Wright 1981, pp. 335 and 340–341).

## Discussion of Results

*Archeological Samples*

By far, the majority of the glasses discussed here were found to be soda limes with relatively high levels of potassium and magnesium oxides ($K_2O$ and $MgO$). This is to be expected because such compositions were the norm for glasses melted in the inland regions of the Near East for many centuries both before and following the Sasanian period. Sasanian glasses can thus be regarded as one stage of a longstanding technological tradition for that part of the world. The use of ashes of certain desert plants, probably along with quartzite pebbles, accounts well for that type of composition. It is known from the cuneiform glassmaking tablets (Brill 1970; *idem* 1972) that these two batch materials were used for melting the earliest Babylonian and Assyrian glasses (about 1500–1200 B.C.) (Brill and Shirahata 1997; Brill 1999, v. 1, pp. 41–42, and v. 2, pp. 40–41), and the same formulation was probably used for melting the somewhat later glasses found at Hasanlu (Brill 1999, v. 1, pp. 43–44, and v. 2, pp. 43–44), Nimrud (*ibid.*, v. 1, pp. 45–46, and v. 2, pp. 47–49), and elsewhere throughout the region. The tradition was apparently carried on through a "dark age" of sorts, and then was continued during Parthian, Sasanian, and Islamic times. Reckoning from its very beginnings, the plant-ash soda tradition would have spanned some 2,800 years of glassmaking history. In fact, it was still being used in Herat in 1977 (*Glassmakers of Herat* 1979). Strictly speaking, although we are quite certain about the use of plant ashes, we do not know that pebbles remained the source of silica throughout this entire period, so we will refer to such glasses here as "plant-ash soda glasses" or simply as "plant-ash glasses."

While it is easy to recognize the plant-ash composition of Sasanian glasses as a forerunner of Islamic glass technology, it is not as easy to identify the predecessors of Sasanian glasses in the region. The immediate predecessors would have been made toward the close of the "dark age" referred to above—if there was such a thing. Our own corpus of analytical samples does not include many examples of glasses described as "Parthian," although they have been mentioned in the literature. (See, for example, Negro Ponzi 2002.) Most of the glasses we have analyzed that were contemporaneous with Parthian and somewhat earlier glasses have turned out to be natron-based glasses. They are believed to have come from the Levant and represent an entirely different glassmaking tradition. They are more closely related to Hellenistic glasses having more westerly origins than they are to Sasanian glasses.

Among the 75 samples analyzed, only two natron-based glasses were found. One came from Choche, and the other came from Ctesiphon. Evidently, these two glasses had been imported into the region—most likely from the Levant or possibly from farther west. These two objects may have been made somewhat earlier than their companion pieces. The Ctesiphon fragment (no. 5360) is noticeably less weathered than the rest of the glasses from the same site. This is consistent with what we have observed from other studies, namely, that natron-based glasses are often more resistant to weathering than plant-ash soda glasses. It is also noteworthy that most of the excavated glasses have thick weathering crusts of enamellike weathering or the stony appearance that is so typical of heavily weathered Sasanian faceted bowls. We associate this stony appearance with the unusually high magnesium contents of the glasses, and we believe that the magnesium was introduced with plant ashes (Brill 1999, v. 1, pp. 212–216, and v. 2, pp. 482–484). In contrast, the surface fragments from the three survey sites are also heavily weathered, but they have lost most of their weathering products through the erosive action of wind-borne sand.

We routinely plot four graphs to interpret analytical data. Figures 1–4 show those four plots for the five groups of archeological samples. The data spread out rather broadly. While all of the glasses conform to a plant-ash soda formulation, there is considerable variability within each of the seven major and minor oxides. The variability is somewhat greater than what we had anticipated, but it is not unreasonably so for glasses made at different times in different places.

When drawing the confidence-limit ellipses on some of these graphs, four samples were omitted either because they are natron-based glasses or because they appeared to be stray samples in regard to one or more oxides. The samples omitted were nos. 1252 (from Choche), 1260 (from Tell Umm Jirin), 5360 (from Ctesiphon), and 7631 (from Tulul Umm Ghemimi).

Not enough attention has been paid in the literature to the factors that contributed to variability in ancient glass compositions. The variability must have re-

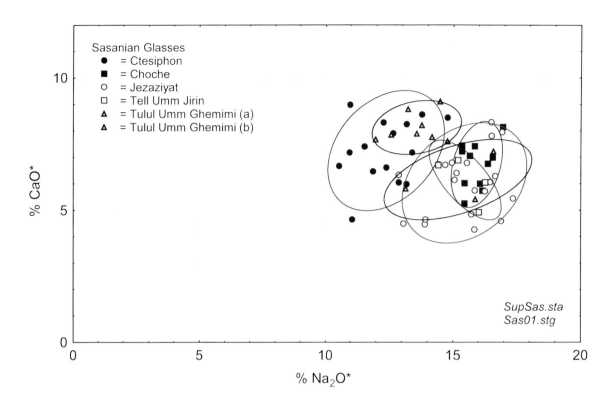

*Fig. 1. CaO\* vs. Na₂O\* plot for 62 Sasanian glass fragments from various sites in southern and central Iraq. Ellipses approximate 95% confidence limits for each group. Asterisk (\*) indicates values are for reduced compositions.*

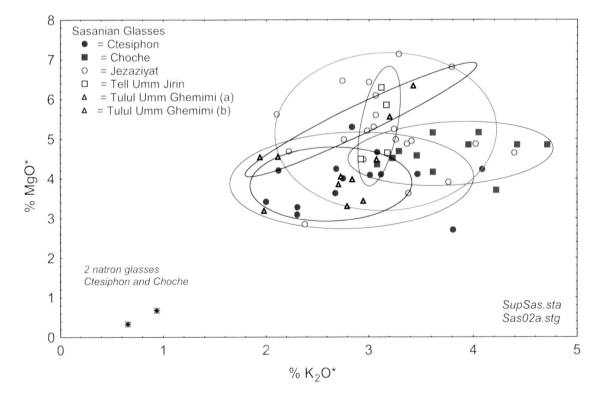

*Fig. 2. MgO\* vs. K₂O\* plot for 64 Sasanian fragments.*

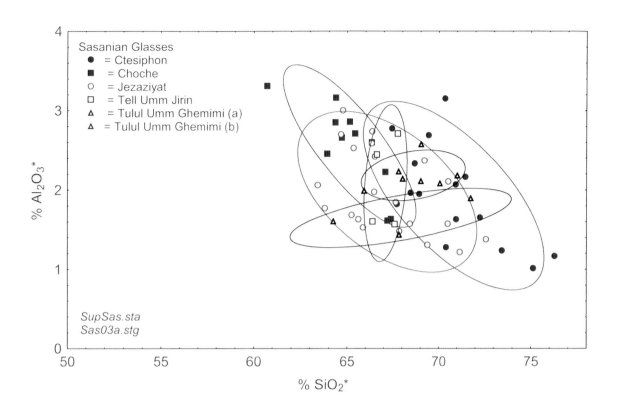

Fig. 3. Al$_2$O$_3$* vs. SiO$_2$* plot for 62 Sasanian fragments.

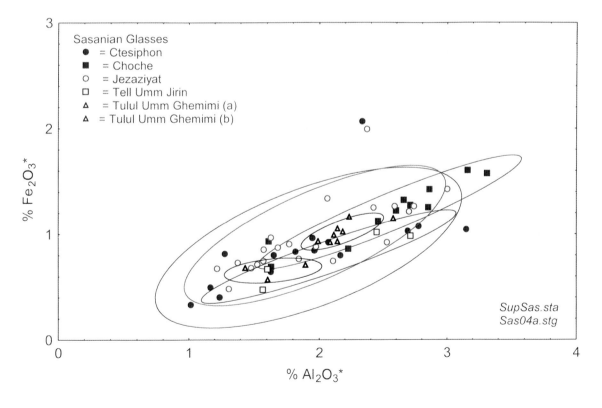

Fig. 4. Fe$_2$O$_3$* vs. Al$_2$O$_3$* plot for 62 Sasanian fragments. Data fit the equation
% Fe$_2$O$_3$* = 0.1 + 0.401 (% Al$_2$O$_3$*).

sulted from several sources. Some of those that would have affected the glasses discussed here are: differences among the ashes of desert plants growing in different localities, contamination of the ashes with soil, differences in the ways batch materials were measured out, differences in extents of hydration, possibly the point-to-point inhomogeneity within large tank melts (which could not, in any event, have been well mixed), refractory corrosion, recycling, or simple day-to-day differences in how glassmakers worked. It is wise to keep in mind, too, that such differences could have occurred over short intervals—just a week or so—and that different melting operations need not have been separated by long distances. The workshops may have been located right across an alley from one another. A review of all such sources of variability, and evaluations of their relative importance, would make an excellent topic for some future conference or workshop.

When dealing with analytical data, it is tempting to draw as much detailed information from them as possible—and we will yield to that temptation in the discussion that follows. However, another type of practical information can also be gleaned from these data, and we will return to that below.

By comparing the samples from the five archeological sites, it can be seen that those from the two controlled excavations, Ctesiphon and Choche, are similar but nonetheless clearly distinguishable from each other. (The soda levels differ markedly, and the potash and alumina levels overlap only in part.) The samples within each of these two groups also show differences, a reminder that although the fragments were found at the same site, this does not mean that they were necessarily made in the same place at the same time. When comparing glasses from different sites, it is important to find agreement on all four plots before concluding that the glasses could in some way be closely related; agreement on only one or two plots could be only fortuitous.

Part of the challenge of working with data of this sort—and this is not unique to Sasanian and Islamic glasses—is to separate out meaningful "subgroups." This is often more difficult than one would like it to be. For example, when examining a single bivariate plot, such as any of those shown here, one usually finds groups that appear to be different from one another. When one proceeds to the graph for the next pair of oxides, similar subgroups often emerge. However, although it is sometimes possible to track a single subgroup of samples through all four of the graphs, it all too often happens that the subgroups in the different plots contain *different* samples. This can be disconcerting when one is searching for compositional patterns, but that is the nature of statistical variability.

Like the glass from the two controlled excavations, the surface finds from the three surveyed sites are similar but distinguishable from one another, even though there are instances in which clusters of samples overlap on all four graphs. In short, the following incidental observations can be noted:

The glasses from Ctesiphon and Choche are clearly distinguishable from each other, even though there is overlapping on some graphs.

The glasses from Ctesiphon resemble a subgroup of eight glasses ("b" on the graphs) from Tulul Umm Ghemimi.

The glasses from Choche partly overlap the Jezaziyat and Tell Umm Jirin glasses.

The glasses from Jezaziyat and Tell Umm Jirin, along with a subgroup of three glasses from Tulul Umm Ghemimi ("a" on the graphs), are quite similar.

The glasses from Jezaziyat are quite variable in their compositions.

The two subgroups of glasses from Tulul Umm Ghemimi do not serve to separate the glasses found at the two different locations there (EP-64 and EP-65).

As usual, the iron and alumina appear to be strongly correlated. The data fit the equation

$$\% \ Fe_2O_3^* = 0.1 + 0.401(\% \ Al_2O_3^*)$$

The overall picture concerning manganese is not entirely clear. For our purposes here, levels of less than ~0.1% MnO have been assumed to be impurities. Using that as a guideline, 32 of the 69 plant-ash soda glasses analyzed contain additive levels of manganese. That amounts to 46 percent of the glasses. About half of the glasses from Ctesiphon contain manganese, but none of the glasses from Choche does. About two-thirds of the Jezaziyat glasses contain additive levels of manganese, all of the Tell Umm Jirin glasses do, but only a single glass from Tulul Umm Ghemimi does.

It is noteworthy that the two nuggets of cullet analyzed from Jezaziyat contain additive levels of manganese, so it could have been added to the original glass melt; but the nuggets of cullet from Tulul Umm Ghemimi do not contain manganese. Looking elsewhere, the Beth She'arim slab (Brill 1999, v. 1, p. 58, and v. 2, p. 81) and the large pieces of cullet from Tyre (*ibid.*, v. 1, p. 100, and v. 2, p. 202) and the Serçe Limanı shipwreck (*ibid.*, v. 1, pp. 89–92, and v. 2, pp. 178–187)—all of which, we believe, came directly from original tank melts—do contain additive levels of manganese, while some of the nuggets of cullet from Jalame (*ibid.*, v. 1, pp. 54–57, and v. 2, pp. 71–78) and elsewhere contain only trace impurities of manganese. The remains of glass from the tank melt at Bet Eliezer (*ibid.*, v. 1, pp. 58–59, and v. 2, p. 83; Freestone

and Gorin-Rosen 1999, pp. 105–108) do not contain manganese. It appears, therefore, that manganese was sometimes introduced at the time the original batches were melted and sometimes it was not.

Sample no. 1291, found at Jezaziyat, is an eroded piece of a black mineral. Its major chemical components are silica, iron, and aluminum. An X-ray diffraction pattern, obtained by Erika Stapleton of Corning Incorporated, established that it is a piece of the mineral sekaninaite, which has the formula $2(Fe, Mg)O.2Al_2O_3.5SiO_2$. Physically, this material closely resembles the bulk form of pyrolusite, a naturally occurring form of manganese dioxide $(MnO_2)$. We suspect that pyrolusite may have been used in ancient times for decolorizing glass, or to keep batches from turning amber during melting. Therefore, when this piece of mineral was picked up at the site, we thought it might be pyrolusite. Because we do not know what other use sekaninaite may have had at an ancient industrial site, we wonder if someone else might have made the same mistake centuries ago.

While visiting Jezaziyat in 1967, the author noticed that there were occasional desert plants growing in the area. One of these was sampled and later ashed and analyzed (Brill 1999, v. 1, p. 213, and v. 2, p. 482). The chemical analysis yielded a $Na_2O/K_2O$ ratio of 5.14 and a $CaO/MgO$ ratio of 1.73. These values are close enough to the corresponding values for the Jezaziyat glass (4.69 and 1.45) to suggest that similar plants could have been used to make the glasses found at Jezaziyat.

During his visit to Tell Umm Jirin, the author came across a cairn that had apparently been set up as a marker in the desert. It had been built by loosely piling large chunks of a peculiar material to a height of a little over a meter. Some of the chunks were roughly slab-shaped. They had an ocher color and looked like a porous aggregate of small, irregularly rounded lumps or nodules of hardened material. In some places, the nodules had broken open, revealing that they were actually hollow protrusions. Overall, the material was coherent, as if fused together by heat. Neither the author nor his driver had ever seen anything like this before. Later, several experienced archeologists were also at a loss to explain what the material was.

One of the larger pieces was selected and exported for laboratory examination. When it was sawed open, the material was found to be frothy throughout, and several occluded areas of green glass were exposed. Occasional pockets of whitish material were also found. The glass appeared to account for about 15–20 percent of the bulk volume. A chemical analysis of the frothy surface material is shown in Table 4 (no. 1290). An X-ray diffraction pattern showed that a major portion of the material was strongly crystalline and consisted of diopside $(CaO.MgO.2SiO_2)$. Three other crystalline phases were also identified. These were: cristobalite and quartz (both forms of $SiO_2$), and calcite $(CaCO_3)$. A chemical analysis of one of the glassy regions showed that it resembles the glass found at the site. X-ray diffraction identified wollastonite $(CaO.SiO_2)$ as a devitrification product, or reaction intermediate, in the glass.

Although the cairn had evidently been constructed in modern times, it is probable that the chunks of material themselves were ancient, and they may have been contemporaneous with the glassmaking activities associated with Tell Umm Jirin. Because both diopside and cristobalite are known to be devitrification products of soda-lime glasses, and because both might be expected to form as intermediate reaction products during glass-melting processes, we believe that the material is the remains of an ancient frit or of partially reacted glass batch. (A frit is a material produced deliberately by heating a glass batch at a moderate temperature to expel gaseous reaction products.) Presumably the quartz would then have been unreacted batch material, and the calcite a weathering product. If this identification is accurate, these chunks represent one of the very few examples of such material that have ever come to our attention. There are two possible alternatives, but they do not fit the evidence as well. Laboratory experiments in which desert plants were ashed have shown that plants with high soda contents often fuse to a hardened, frothy mass. Therefore, it is conceivable that the peculiar material found at Tell Umm Jirin is the weathered remains of ancient plant ashes from which the alkali had been leached out over the centuries. The other possibility is that the material is waste from a brick kiln, but our experience has been that over-fired bricks have an entirely different appearance than these chunks of material. For one thing, over-fired bricks tend to be vitrified on the outside, not on the inside.

The Sasanian glasses have also been compared with 180 samples of Islamic glasses representing 24 chemical compositional types. These glasses came from nine different archeological sites or groups of fragments decorated by certain techniques (Brill 2001). The same four graphs were used. The data for the Sasanian and Islamic glasses overlap to the extent that both types are clearly plant-ash soda glasses. This is consistent with the belief that the plant-ash soda composition—probably also utilizing pebbles as a source of silica—was in continuous use through the 11 or so centuries spanning the two periods. However, there was only one instance in which any of the Islamic and Sasanian groups (perhaps they should be called "sub-

groups") agreed closely with one another on more than one plot. It is evident, then, that chemical variability introduced by factors such as those listed above allows for the separation of glasses made in different places or at different times, even though they were made from similar batch materials.

The one instance uncovered of overlapping between Sasanian and Islamic glasses involved the glasses from Ctesiphon—along with a group of eight fragments from Tulul Umm Ghemimi. They were found to be chemically similar to some Islamic glasses from Takht-i-Sulaiman and to some from Siraf. They agree in their $Na_2O^*$, $CaO^*$, $K_2O^*$, and $MgO^*$ contents. (The $Al_2O_3^*$ was borderline.) Nevertheless, the agreement is not such that we would conclude that it must have been due to anything other than chance. Statistically, that sort of thing can be expected to happen occasionally.

A principal components analysis (PCA) was used to compare the overall mean composition of the 62 Sasanian glasses with the mean compositions of the 24 groups of Islamic glasses. Using all seven of the oxides of the reduced compositions, it was found that the $SiO_2^*$, $Na_2O^*$, $CaO^*$, and $MgO^*$ accounted for 86 percent of the total variability of the data. The mean compositions of the 62 Sasanian archeological glasses most closely resembled certain glasses from Caesarea and Qasr al-Hayr, as well as some luster- and scratch-decorated glasses. The Sasanian glasses were quite different from all of the other Islamic glasses. The closest matches for a group of four cut and faceted Sasanian vessels (which are discussed below) were some different Islamic glasses from Qasr al-Hayr, some glasses from Nishapur, and—curiously—some glasses excavated in Afghanistan. However, the latter are likely to have been imported from Iran.

There is another type of useful information contained in these data. Assuming that the glasses analyzed here were all made in a region corresponding to present-day central-southern Iraq, the data can be used to evaluate what extent of compositional variability can be expected within glasses made in a region of that size, over a period of a few centuries, employing a more or less unchanging glassmaking tradition. As noted above, that variability appeared to be somewhat greater than we had anticipated—particularly in the soda and lime contents.

Table 8 shows estimates of that variability in terms of the relative deviations for each of the seven major and minor oxides used for calculating the reduced compositions. The relative deviations are the standard deviations expressed as percentages of the mean values.

The same table compares the relative deviations for the five groups of Sasanian glasses with correspond-ing values calculated for groups of Hellenistic and Roman natron-based glasses (Brill 1999, v. 1, pp. 51–81, and v. 2, pp. 61–149), Byzantine mosaics (*ibid.*, v. 1, pp. 85–101, and v. 2, pp. 161–205), and medieval Islamic glasses (*ibid.*, v. 1, pp. 105–111, and v. 2, pp. 215–237), as well as for three groups of glasses believed to have been made in individual factories over limited periods of time. It should be noted especially that all of the analyses used for these calculations were performed by a single laboratory, running replicate analyses, following identical (or very similar) procedures, using the same reference glasses. Therefore, the precision of the analytical methods should be well within the actual variability in the glass compositions.

It can be seen that, in general, the relative deviations of the glasses made in single factories are lower than those for the larger groups of glasses that are related, but that were made in different factories and/or at different times. We refer to the glasses from the individual factories—those having the lower relative deviations—as being "coherent groups." If, eventually, this sort of reasoning is to become useful, it would have to include many more data, and it would need refinement. Nevertheless, it appears, on the basis of the data cited, that the glasses from Choche and Tell Umm Jirin are the only Sasanian glasses from these five archeological sites that come close to being coherent within themselves.

As a group, the four cut glasses are "about as coherent" as those from individual factories: Jalame, the colorless vessel fragments from Nishapur (Brill 1995), and the Serçe Limanı glasses.

*Objects from the Museum's Collection*

The samples analyzed included glass from three vessels in the Museum's collection. All of these are deep-cut or faceted vessels, typical of familiar types of Sasanian glass. The analyses of these objects are reported in Table 1 and are plotted in Figures 5–8. The graphs show the same pairs of oxides as those plotted for the archeological samples, and the scales are identical, making it convenient to compare the Museum's cut objects and the archeological fragments. Such graphical comparisons show, as expected, that the cut objects were also based on the plant-ash soda tradition. However, the points for the Museum's objects tend to fall either outside, or only marginally inside, the fields for the archeological fragments.

There are two instances in which there is close agreement between samples of vessels from the Museum's collection and the archeological fragments. No. 3074, a facet-cut, pear-shaped bottle in the Museum's collection, is a very close match on all four graphs for no. 1272, a heavily weathered and eroded fragment of

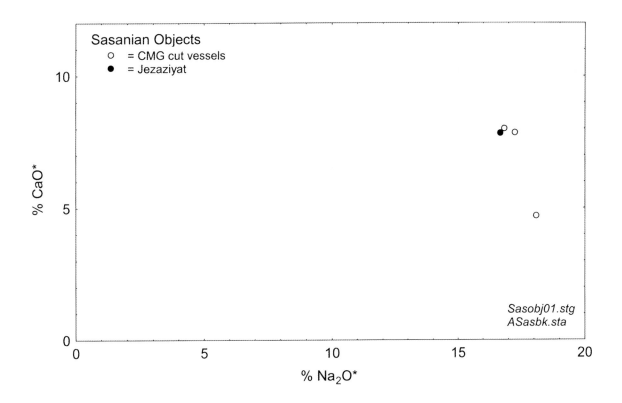

*Fig. 5. CaO\* vs. Na₂O\* plot for four Sasanian cut glass objects.*

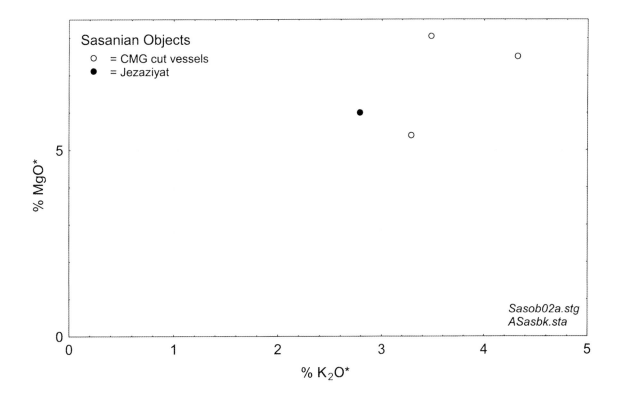

*Fig. 6. MgO\* vs. K₂O\* plot for four Sasanian cut glasses.*

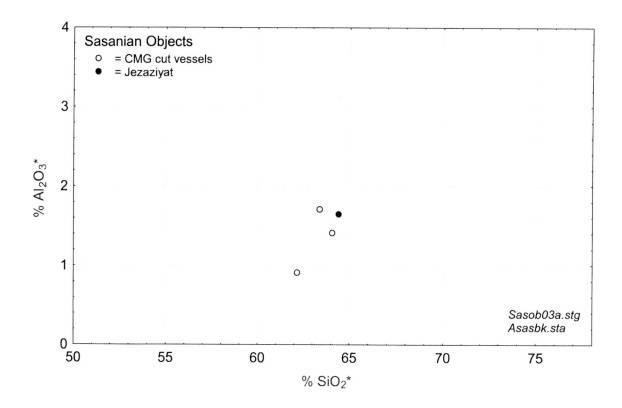

*Fig. 7. Al₂O₃\* vs. SiO₂\* plot for four Sasanian cut glasses.*

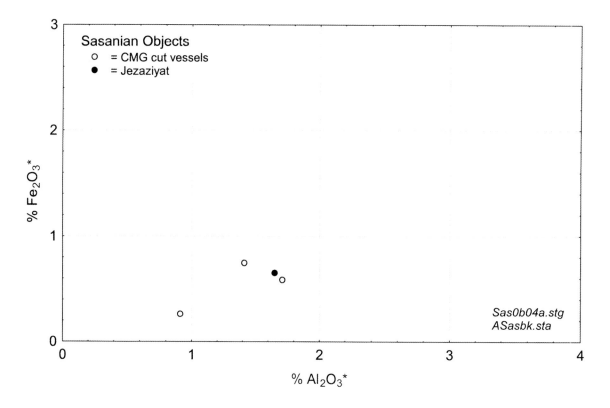

*Fig. 8. Fe₂O₃\* vs. Al₂O₃\* plot for four Sasanian cut glasses. Data fit the equation*
*% Fe₂O₃\* = -0.62 + 0.44 (% Al₂O₃\*).*

a facet-cut vessel of some sort found at Jezaziyat. No. 1272 was the only faceted piece; the author happened to come across during that quick surface survey. Along with nos. 1271 and 1274—two pieces of heavily eroded and solarized utilitarian wares from Jezaziyat—the four pieces constitute a rather convincing compositional group. (To that same group can be added a fifth glass: a sample removed from a deep-cut dish, said to be Sasanian, that was on the market a number of years ago.) But as closely as they resemble one another, these glasses lie only marginally within the "central-southern Iraq" compositional field as a whole. It therefore poses something of a mystery: Why was a fragment of what is unmistakably a piece of a facet-cut vessel (no. 1272) found at Jezaziyat to begin with, given that its composition is somewhat different from that of the majority of the other fragments analyzed from the same location? Because they are all surface finds, these four glasses may not be related to the other fragments and glassworking debris found at the site. They may instead have been cullet brought in for recycling, or they may just have been lost or broken in transit across the site.

There is another instance of chemical agreement between a vessel in the collection and three archeological fragments. The vessel is no. 3087, a greenish Islamic bowl that had been sagged in a fire. The three fragments were among those collected at Jezaziyat. Two of the fragments are apparently from rather ordinary wares (nos. 1276 and 1277), but the third (no. 1279) is a vessel base bearing part of a distinctive eight-lobed molded pattern. These four glasses form their own tight chemical group, but they, too, lie only marginally within the "central-southern Iraq" field. They are marked by somewhat lower lime contents than that type as a whole. Possibly, they are intrusions. Therefore, the presence of that molded base at Jezaziyat should not necessarily be taken as proof that the eight-lobed molded motif is characteristic of Sasanian glass.

It could be argued that the lack of wider agreement between the analyses of these five cut or faceted Sasanian vessels and the analyses of more than 60 archeological fragments suggests that the typical Sasanian cut or faceted vessels were made somewhere other than the region of central-southern Iraq, where these particular archeological glasses are presumed to have been made. In that connection, however, it should be noted that Negro Ponzi Mancini published fragments of a typical Sasanian faceted hemispherical bowl excavated at Choche (Negro Ponzi Mancini 1984). Unfortunately, that fragment was not included in the pieces sampled for analysis.

The analyses of the three Sasanian cut vessels were also compared with analyses of the same 24 groups of Islamic glasses as were discussed above. The comparisons were made by inspections of the same four bivariate graphs used earlier. Although there was much overlapping on single graphs, no examples of really close agreement were uncovered that held up on all four graphs. In general, where there was good agreement on the $CaO^*$ vs. $Na_2O^*$ plots, there was not good agreement on the $MgO^*$ vs. $K_2O^*$ plots—and vice versa. The nearest case of a match for the cut vessels was the mean composition of some glasses from Qasr al-Hayr in northern Syria (Brill 1999, v. 1, p. 88, and v. 2, pp. 171–172).

Overall, then, we conclude that the particular Sasanian cut glasses that we analyzed do not bear a close enough chemical resemblance to any of the particular groups of Islamic glasses considered to allow us to infer that they came from closely related glassmaking locations. (Our analyses of some additional cut Sasanian vessels from Qizil will be discussed elsewhere in the future.)

*A Closing Remark*

Following his brief 1967 survey visits to the three glass-related sites, the author attempted to initiate plans for a proper excavation of one or more of these small tells. However, for various reasons, these attempts were unsuccessful. It is probable that valuable information about Sasanian glassmaking remains to be uncovered beneath these tells. In recent correspondence, Professor Wright indicated that he had passed by Tulul Umm Ghemimi in 2004, and it appeared that the site may by now have been much disturbed. But the present condition of the other two surveyed sites, Jezaziyat and Tell Umm Jirin, is unknown to the author, and it is uncertain what effects recent events may have had on them. Nevertheless, we hope that it will someday be possible to excavate them or, at least, to investigate them with the attention that small industrial sites deserve.

*Acknowledgments*

The author thanks Robert McC. Adams and Henry T. Wright for having called his attention many years ago to the three sites mentioned in the text, and also for helpful comments they have made more recently in correspondence. He thanks Jens Kröger and Maria-maddalena Negro Ponzi for supplying samples for analysis, as well as David Whitehouse for helpful conversations regarding Sasanian glass. As she has done so many times in the past, Shana Wilson patiently assisted the author in plotting graphs, running statistical computations, and preparing tables.

# Sample Descriptions

## Obects in the Collection

1296    Hemispherical cup, deep-cut, leaving prominent bosses; 6th–7th century. Colorless, very heavily weathered. CMG 61.1.11.

3074    Pear-shaped bottle, facet-cut; 4th–6th century. Colorless, pitted and iridescent. CMG 62.1.4.

3086    Goblet, facet-cut, forming hexagonal patterns. Colorless, very heavily weathered. CMG 79.1.59; J. Strauss no. S2479.

3087    Bowl, relief-cut, cracked and partly sagged from a fire. Islamic, possibly Egyptian. Green, heavily iridescent. CMG 66.1.266; J. Strauss no. S1680.

## Ctesiphon
Sasanian–Islamic
(J. Kröger, Museum für Islamische Kunst, Berlin)

5351    Bowl; 3rd–7th century. Colorless, heavily weathered. The Metropolitan Museum of Art 32.150.230.

5352    Bottle; Parthian, Grave I. Aqua, moderately weathered.

5353    Large bowl; Sasanian, west(?) church. Colorless, heavily weathered.

5354    Bottle; 3rd–4th century. Pale aqua, heavily weathered.

5355    Vessel; Sasanian. Colorless, moderately weathered.

5356    Vessel; Sasanian. Pinkish, moderately weathered.

5357    Thick-walled vessel(?); Sasanian. Green, with scum.

5358    Bowl; Sasanian. Olive-amber, heavily weathered.

5359    Large bowl; Sasanian, west church. Dark blue, heavily weathered.

5360    Thin-walled vessel; early Islamic(?). Aqua, lightly weathered.

5361    Window glass or vessel; Islamic. Pale green, heavily weathered.

5362    Vessel; Islamic. Colorless, heavily weathered.

5363    Thick-walled vessel; Islamic. Colorless, moderately weathered.

5364    Thick-walled vessel rim. Pale green, heavily weathered, with bright red paintlike substance on concave surface. (1931–1932 excavations.)

5365    As above, the red substance.

5366    Thick plaque or mosaic blank. Opaque red, very heavily weathered.

5367    Thick plaque or mosaic blank. Opaque yellow, heavily weathered.

## Choche
3rd–early 5th century
(M. Negro Ponzi, Istituto di Archeologia, Turin)

1241    Vessel wall, cut. Aqua, moderately weathered. NP-V793.

1242    Vessel wall. Aqua, moderately weathered. NP-V2430.

1243    Vessel foot. Aqua, moderately weathered. NP-B1.

1244    Vessel base. Green, lightly weathered. NP-B4.

1245    Vial base. Green, heavily weathered. NP-B6.

1246    Vial base. Green, pitted. NP-C398.

1247    Vessel base. Dark green, heavily weathered. NP-V272.

1248    Goblet stem. Green, moderate enamellike weathering. NP-407.

1249    Stem. Green, heavily weathered. NP-B3.

1250   Stem. Green, heavily weathered. NP-B7.

1251   Stem. Green, heavily weathered. NP-1003.

1252   Vessel, facet-cut. Colorless, heavily weathered. NP-N2148.

## Jezaziyat
2nd–6th century
(Collected by RHB at suggestion of Robert McC. Adams)
*Note: All samples were heavily weathered and eroded.*

1266   Bottle base. Greenish olive, vertical molded ribs and pontil mark.

1267   Vial(?) base. Light green.

1268   Vessel base. Green.

1269   Vessel base. Green.

1270   Vessel wall. Green.

1271   Goblet base with hollow stem. Colorless.

1272   Vessel wall and part of base, facet-cut. Two complete hexagonal facets are preserved, measuring about 2.0 cm across corners. Colorless, but slightly solarized (?), very heavily eroded.

1273   Vessel base with vertical ribbing. Colorless.

1274   Dish, base and wall. Colorless.

1275   Vessel base with pontil mark. Colorless.

1276   Tumbler base. Colorless.

1277   Dish rim. Colorless.

1278   Vessel base with pontil mark. Colorless.

1279   Vessel base, molded pattern on bottom, probably showing an "8-lobed rosette." Colorless.

1280   Dish wall. Colorless.

1281   Vessel base. Green.

1282   Vessel base. Aqua with dark green applied base-ring. Sample consists of aqua glass only.

1283   Vessel wall. Bluish aqua.

1284   Bottle base with traces of vertical-molded ribs. Greenish aqua.

1285   Goblet with solid stem. Bluish aqua.

1286   Nugget of cullet. Bluish aqua.

1287   Nugget of cullet. Colorless.

1288   Vessel wall. Transparent dark blue, some surface erosion.

1289   Composite of about 50 Jezaziyat fragments crushed together. Reference glass JZ, greenish powder.

1291   Lump of black mineral found with glass at Jezaziyat site.

## Tell Umm Jirin
5th–6th century
(Collected by RHB at suggestion of Robert McC. Adams)
*Note: All samples were heavily weathered and eroded.*

1260   Vessel base with pontil mark. Dark green.

1261   Vessel base. Bluish aqua.

1262   Vessel base with high kick. Bluish aqua.

1263   Vessel base, flatter profile than above. Dark green.

1264   Vessel base. Colorless.

1290   Chunk of hard, porous, ocher-colored material from cairn at Tell Umm Jirin. Approximate dimensions = 24 cm x 14 cm x 5 cm.

1295   Glassy phase inside chunk of material described under 1290. Slightly turbid green glass, continuous with frothy material.

## Tulul Umm Ghemimi
2nd–6th century
(H. T. Wright)

These samples came from surface finds collected at three locations (EP-63, EP-64, and EP-65) that are collectively called Tulul Umm Ghemimi. The samples were provided by H. T. Wright. The site was

visited by RHB in May 1967, at which time numerous similar pieces of cullet and vessel fragments were collected.

*Note: All samples were weathered and eroded.*

7628    Nugget of pale green cullet. (EP-64.)

7629    As above. (EP-64.)

7630    As above. (EP-64.)

7631    As above. (EP-64.)

7632    As above, bluish green, with many small stones. (EP-64.)

7633    Rim fragment. Pale aqua. (EP-65.)

7634    Rim fragment. Pale aqua. (EP-65.)

7635    Wall fragment. Pale aqua. (EP-65.)

7636    Base fragment with shallow kick. Pale aqua. (EP-65.)

7637    Base fragment with shallow kick. Aqua. (EP-65.)

7638    Base(?) fragment of small vessel with hollow rim. Pale aqua. (EP-65.)

7639    Twisted spiral handle. Pale aqua. (EP-65.)

# TABLES

## Table 1

### OBJECTS IN THE COLLECTION

### (n=4)

| | 1296 | 3074 | 3086 | 3087 (Islamic) |
|---|---|---|---|---|
| $SiO_2$ d | | 63.48 | | |
| $SiO_2$ a | 61.36 | | 62.64 | 70.92 |
| $Na_2O$ | 16.62 | 17.1 | 17.88 | 14.4 |
| $CaO$ | 7.90 | 7.78 | 4.65 | 4.35 |
| $K_2O$ | 4.27 | 3.26 | 3.44 | 2.76 |
| $MgO$ | 7.41 | 5.34 | 7.95 | 4.28 |
| $Al_2O_3$ | 0.90 | 1.4 | 1.69 | 1.75 |
| $Fe_2O_3$ | 0.26 | 0.74 | 0.58 | 0.70 |
| $TiO_2$ | | 0.15 | | |
| $Sb_2O_5$ | 0.09 | | 0.06 | 0.03 |
| $MnO$ | 0.23 | 0.29 | 0.53 | 0.35 |
| $CuO$ | | 0.001 | | |
| $CoO$ | | | | |
| $SnO_2$ | | 0.001 | | |
| $Ag_2O$ | | 0.0005 | | |
| $PbO$ | 0.02 | 0.001 | 0.01 | 0.03 |
| $BaO$ | | 0.01 | | |
| $SrO$ | | 0.08 | | |
| $Li_2O$ | | 0.005 | | |
| $Rb_2O$ | | 0.001 | | |
| $B_2O_3$ | | 0.05 | | |
| $V_2O_5$ | | 0.001 | | |
| $Cr_2O_3$ | | 0.005 | | |
| $NiO$ | | 0.001 | | |
| $ZnO$ | | 0.05 | | |
| $ZrO_2$ | | | | |
| $P_2O_5$ | 0.02 | 0.25 | 0.01 | 0.16 |
| Sum | 98.72 | 99.10 | 98.83 | 99.16 |
| $SiO_2$* | 62.16 | 64.06 | 63.38 | 71.52 |
| $Na_2O$* | 16.84 | 17.25 | 18.09 | 14.52 |
| $CaO$* | 8.00 | 7.85 | 4.71 | 4.39 |
| $K_2O$* | 4.33 | 3.29 | 3.48 | 2.78 |
| $MgO$* | 7.51 | 5.39 | 8.04 | 4.32 |
| $Al_2O_3$* | 0.91 | 1.41 | 1.71 | 1.76 |
| $Fe_2O_3$* | 0.26 | 0.75 | 0.59 | 0.71 |
| T* | 100.00 | 100.00 | 100.00 | 100.00 |

Sum is sum of $SiO_2$ through $Fe_2O_3$.

# Table 2

## CTESIPHON

## (n=16)

| | 5351 | 5352 | 5353 | 5354 | 5355 | 5356 | 5357 | 5358 |
|---|---|---|---|---|---|---|---|---|
| $SiO_2$ d | 67.30 | 69.98 | 70.44 | 68.58 | 73.00 | 67.95 | 69.90 | 67.09 |
| $Na_2O$ | 13.7 | 13.1 | 12.3 | 12.6 | 10.9 | 13.3 | 12.8 | 14.7 |
| $CaO$ | 8.56 | 5.95 | 6.56 | 7.87 | 7.14 | 7.13 | 6.01 | 8.45 |
| $K_2O$ | 3.10 | 4.06 | 3.06 | 3.45 | 2.74 | 2.82 | 3.78 | 1.99 |
| $MgO$ | 4.08 | 4.21 | 4.63 | 4.09 | 3.98 | 5.26 | 2.69 | 3.40 |
| $Al_2O_3$ | 1.81 | 1.27 | 1.62 | 1.94 | 1.23 | 1.95 | 3.13 | 2.76 |
| $Fe_2O_3$ | 0.83 | 0.81 | 0.64 | 0.96 | 0.40 | 0.84 | 1.04 | 1.07 |
| $TiO_2$ | 0.15 | 0.1 | 0.1 | 0.1 | 0.05 | 0.1 | 0.1 | 0.1 |
| $Sb_2O_5$ | | | | | | | | |
| $MnO$ | 0.05 | 0.04 | 0.28 | 0.04 | 0.34 | 0.33 | 0.04 | 0.05 |
| $Cu_2O$ | | | | | | | | |
| $CuO$ | 0.01 | 0.005 | 0.005 | 0.001 | 0.001 | 0.001 | 0.001 | 0.001 |
| $CoO$ | | | | | | | | |
| $SnO_2$ | 0.003 | 0.001 | | | | | | |
| $Ag_2O$ | 0.003 | 0.0005 | 0.001 | 0.0005 | 0.0005 | 0.0005 | 0.0005 | 0.0005 |
| $PbO$ | 0.003 | 0.001 | 0.03 | 0.001 | 0.001 | 0.02 | 0.001 | 0.003 |
| $BaO$ | 0.01 | 0.03 | 0.03 | 0.01 | 0.03 | 0.03 | 0.05 | 0.03 |
| $SrO$ | 0.1 | 0.05 | 0.05 | 0.05 | 0.03 | 0.05 | 0.05 | 0.08 |
| $Li_2O$ | 0.003 | 0.001 | 0.003 | 0.002 | 0.003 | 0.004 | 0.001 | 0.003 |
| $B_2O_3$ | 0.02 | 0.02 | 0.02 | 0.02 | 0.02 | 0.02 | 0.02 | 0.02 |
| $V_2O_5$ | 0.001 | 0.001 | 0.001 | 0.001 | | 0.001 | 0.001 | 0.001 |
| $Cr_2O_3$ | 0.005 | 0.005 | 0.005 | 0.005 | | 0.005 | 0.005 | 0.005 |
| $NiO$ | 0.005 | 0.005 | 0.005 | 0.005 | | 0.005 | 0.005 | 0.005 |
| $ZnO$ | 0.023 | 0.024 | 0.019 | 0.016 | 0.014 | 0.016 | 0.09 | 0.024 |
| $ZrO_2$ | 0.005 | | 0.005 | 0.005 | 0.005 | 0.005 | 0.005 | 0.005 |
| $Bi_2O_3$ | | | | | | | | |
| $P_2O_5$ | 0.23 | 0.34 | 0.20 | 0.25 | 0.12 | 0.16 | 0.28 | 0.21 |
| Sum | 99.379 | 99.3765 | 99.246 | 99.4935 | 99.3855 | 99.2525 | 99.3505 | 99.4625 |
| $SiO_2$* d | 67.72 | 70.42 | 70.97 | 68.93 | 73.45 | 68.46 | 70.36 | 67.46 |
| $Na_2O$* | 13.79 | 13.18 | 12.39 | 12.66 | 10.97 | 13.40 | 12.88 | 14.78 |
| $CaO$* | 8.61 | 5.99 | 6.61 | 7.91 | 7.18 | 7.18 | 6.05 | 8.50 |
| $K_2O$* | 3.12 | 4.09 | 3.08 | 3.47 | 2.76 | 2.84 | 3.80 | 2.00 |
| $MgO$* | 4.11 | 4.24 | 4.67 | 4.11 | 4.00 | 5.30 | 2.71 | 3.42 |
| $Al_2O_3$* | 1.82 | 1.28 | 1.63 | 1.95 | 1.24 | 1.96 | 3.15 | 2.77 |
| $Fe_2O_3$* | 0.84 | 0.82 | 0.64 | 0.96 | 0.40 | 0.85 | 1.05 | 1.08 |
| T* | 100.00 | 100.00 | 100.00 | 100.00 | 100.00 | 100.00 | 100.00 | 100.00 |

Sum is sum of $SiO_2$ through $Fe_2O_3$.

|  | 5359 | 5360 | 5361 | 5362 | 5363 | 5364 | 5366 | 5367 |
|---|---|---|---|---|---|---|---|---|
| $SiO_2$ d | 67.12 | 77.45 | 71.19 | 75.10 | 74.79 | 70.63 | 65.32 | 54.47 |
| $Na_2O$ | 12.0 | 9.90 | 11.7 | 10.9 | 10.5 | 11.5 | 12.4 | 8.37 |
| $CaO$ | 8.13 | 8.08 | 6.37 | 4.58 | 6.64 | 7.38 | 7.76 | 6.85 |
| $K_2O$ | 2.62 | 0.66 | 2.65 | 2.09 | 2.09 | 3.00 | 2.17 | 1.76 |
| $MgO$ | 3.55 | 0.33 | 4.18 | 4.14 | 4.19 | 4.07 | 2.91 | 2.50 |
| $Al_2O_3$ | 2.28 | 2.73 | 1.63 | 1.15 | 1.01 | 2.06 | 2.53 | 1.65 |
| $Fe_2O_3$ | 2.02 | 0.47 | 0.79 | 0.49 | 0.33 | 0.92 | 0.97 | 0.61 |
| $TiO_2$ | 0.1 | 0.08 | 0.08 | 0.05 | 0.03 | 0.1 | 0.1 | 0.1 |
| $Sb_2O_5$ |  |  |  |  |  |  | 0.01 |  |
| $MnO$ | 0.68 | 0.02 | 1.01 | 1.24 | 0.27 | 0.04 | 0.04 | 0.03 |
| $Cu_2O$ |  |  |  |  |  |  | 4.04 |  |
| $CuO$ | 0.23 | 0.001 | 0.02 | 0.001 | 0.001 | 0.001 |  | 0.002 |
| $CoO$ | 0.15 |  |  |  |  |  |  |  |
| $SnO_2$ | 0.02 |  |  |  |  |  | 0.71 | 2.48 |
| $Ag_2O$ | 0.0005 | 0.0005 | 0.0005 | 0.0005 | 0.0005 | 0.0005 | 0.005 | 0.02 |
| $PbO$ | 0.06 | 0.003 | 0.005 | 0.001 | 0.001 | 0.002 | 0.64 | 20.8 |
| $BaO$ | 0.05 | 0.05 | 0.05 | 0.05 | 0.02 | 0.02 | 0.02 | 0.01 |
| $SrO$ | 0.1 | 0.05 | 0.05 | 0.05 | 0.03 | 0.05 | 0.03 | 0.03 |
| $Li_2O$ | 0.003 | 0.001 | 0.003 | 0.003 | 0.003 | 0.003 | 0.001 | 0.001 |
| $B_2O_3$ | 0.03 | 0.01 | 0.02 | 0.02 | 0.01 | 0.01 | 0.02 | 0.02 |
| $V_2O_5$ | 0.001 |  | 0.005 | 0.005 |  | 0.001 | 0.001 | 0.001 |
| $Cr_2O_3$ | 0.005 |  | 0.005 |  |  | 0.005 | 0.01 | 0.005 |
| $NiO$ | 0.005 |  | 0.005 | 0.005 |  | 0.005 | 0.008 | 0.005 |
| $ZnO$ | 0.54 | 0.017 | 0.027 | 0.012 | 0.004 | 0.005 | 0.017 | 0.007 |
| $ZrO_2$ | 0.005 | 0.005 | 0.005 | 0.005 | 0.005 | 0.005 | 0.005 | 0.005 |
| $Bi_2O_3$ |  |  |  |  |  |  |  | 0.003 |
| $P_2O_5$ | 0.30 | 0.14 | 0.20 | 0.11 | 0.08 | 0.19 | 0.28 | 0.27 |
| Sum | 97.7205 | 99.617 | 98.5145 | 98.4475 | 99.5455 | 99.5625 | 94.063 | 76.211 |
| $SiO_2$* d | 68.69 | 77.74 | 72.27 | 76.28 | 75.13 | 70.94 | 69.45 | 71.47 |
| $Na_2O$* | 12.28 | 9.94 | 11.88 | 11.07 | 10.55 | 11.55 | 13.18 | 10.98 |
| $CaO$* | 8.32 | 8.11 | 6.47 | 4.65 | 6.67 | 7.41 | 8.25 | 8.99 |
| $K_2O$* | 2.68 | 0.66 | 2.69 | 2.12 | 2.10 | 3.01 | 2.31 | 2.31 |
| $MgO$* | 3.63 | 0.33 | 4.24 | 4.21 | 4.21 | 4.09 | 3.09 | 3.28 |
| $Al_2O_3$* | 2.33 | 2.74 | 1.65 | 1.17 | 1.01 | 2.07 | 2.69 | 2.17 |
| $Fe_2O_3$* | 2.07 | 0.47 | 0.80 | 0.50 | 0.33 | 0.92 | 1.03 | 0.80 |
| T* | 100.00 | 100.00 | 100.00 | 100.00 | 100.00 | 100.00 | 100.00 | 100.00 |

Sum is sum of $SiO_2$ through $Fe_2O_3$.

# Table 3

## CHOCHE

### (n=12)

| | 1241 | 1242 | 1243 | 1244 | 1249 | 1250 | 1245 | 1246 | 1247 | 1248 | 1251 | 1252 |
|---|---|---|---|---|---|---|---|---|---|---|---|---|
| $SiO_2$ d | 64.14 | 67.00 | 65.19 | 66.11 | 66.90 | 64.18 | 67.21 | 63.72 | 60.52 | 64.95 | 64.51 | 68.57 |
| $Na_2O$ | 15.6 | 15.4 | 16.3 | 16.0 | 16.1 | 15.3 | 15.4 | 15.8 | 16.9 | 15.3 | 16.5 | 15.8 |
| $CaO$ | 7.03 | 6.00 | 6.73 | 5.98 | 5.72 | 7.42 | 5.24 | 7.40 | 8.12 | 7.20 | 6.97 | 9.05 |
| $K_2O$ | 3.94 | 3.60 | 3.07 | 3.60 | 4.21 | 3.45 | 4.70 | 4.04 | 4.41 | 3.28 | 3.22 | 0.93 |
| $MgO$ | 4.84 | 5.14 | 4.34 | 4.15 | 3.70 | 4.56 | 4.84 | 5.15 | 4.84 | 4.67 | 4.50 | 0.66 |
| $Al_2O_3$ | 2.84 | 1.61 | 2.70 | 2.59 | 2.22 | 3.15 | 1.63 | 2.45 | 3.30 | 2.85 | 2.65 | 3.27 |
| $Fe_2O_3$ | 1.25 | 0.93 | 1.27 | 1.22 | 0.86 | 1.60 | 0.69 | 1.12 | 1.57 | 1.42 | 1.32 | 0.43 |
| $TiO_2$ | 0.2 | 0.18 | 0.25 | 0.2 | 0.15 | 0.18 | 0.15 | 0.15 | 0.15 | 0.18 | 0.18 | 0.1 |
| $Sb_2O_5$ | | | | | | | | | | | | |
| $MnO$ | 0.036 | 0.03 | 0.036 | 0.033 | 0.032 | 0.044 | 0.025 | 0.036 | 0.042 | 0.04 | 0.037 | 1.01 |
| $CuO$ | | | | | 0.001 | 0.001 | | | 0.001 | 0.001 | 0.001 | 0.001 |
| $CoO$ | | | | | | | | | | | | |
| $SnO_2$ | | 0.001 | | | | | | | | | | |
| $Ag_2O$ | | | | | 0.0005 | 0.0005 | | | 0.001 | 0.003 | 0.0005 | 0.0005 |
| $PbO$ | | 0.001 | 0.001 | 0.001 | 0.001 | 0.001 | | | 0.001 | 0.001 | 0.001 | 0.002 |
| $BaO$ | 0.03 | 0.01 | 0.01 | 0.01 | 0.03 | 0.03 | 0.01 | 0.03 | 0.05 | 0.03 | 0.03 | 0.1 |
| $SrO$ | 0.05 | 0.05 | 0.05 | 0.05 | 0.03 | 0.03 | 0.05 | 0.05 | 0.05 | 0.03 | 0.03 | 0.05 |
| $Li_2O$ | 0.001 | 0.001 | 0.001 | 0.001 | 0.001 | 0.001 | 0.001 | 0.001 | 0.001 | 0.001 | 0.001 | 0.001 |
| $B_2O_3$ | 0.02 | 0.02 | 0.02 | 0.02 | 0.02 | 0.02 | 0.02 | 0.02 | 0.02 | 0.02 | 0.02 | 0.02 |
| $V_2O_5$ | 0.005 | 0.001 | 0.005 | 0.005 | 0.005 | 0.005 | 0.005 | 0.005 | 0.005 | 0.005 | 0.005 | 0.001 |
| $Cr_2O_3$ | 0.005 | 0.005 | 0.005 | 0.005 | 0.005 | 0.01 | 0.005 | 0.005 | 0.005 | 0.008 | 0.01 | 0.001 |
| $NiO$ | 0.005 | 0.005 | 0.005 | 0.005 | 0.005 | 0.005 | 0.005 | 0.005 | 0.005 | 0.005 | 0.005 | 0.001 |
| $ZnO$ | 0.008 | 0.008 | 0.008 | 0.008 | | | 0.007 | 0.008 | | | | |
| $ZrO_2$ | 0.005 | 0.01 | 0.01 | 0.01 | 0.01 | 0.01 | 0.01 | 0.01 | 0.005 | 0.01 | 0.01 | 0.005 |
| $P_2O_5$ | | | | | | | | | | | | |
| Sum | 99.635 | 99.678 | 99.599 | 99.652 | 99.7095 | 99.6625 | 99.712 | 99.68 | 99.664 | 99.666 | 99.6695 | 98.7075 |
| $SiO_2$* d | 64.37 | 67.21 | 65.45 | 66.34 | 67.09 | 64.40 | 67.41 | 63.92 | 60.73 | 65.16 | 64.72 | 69.47 |
| $Na_2O$* | 15.66 | 15.45 | 16.37 | 16.06 | 16.15 | 15.35 | 15.44 | 15.85 | 16.96 | 15.35 | 16.55 | 16.01 |
| $CaO$* | 7.06 | 6.02 | 6.76 | 6.00 | 5.74 | 7.45 | 5.26 | 7.42 | 8.15 | 7.22 | 6.99 | 9.17 |
| $K_2O$* | 3.95 | 3.61 | 3.08 | 3.61 | 4.22 | 3.46 | 4.71 | 4.05 | 4.42 | 3.29 | 3.23 | 0.94 |
| $MgO$* | 4.86 | 5.16 | 4.36 | 4.16 | 3.71 | 4.58 | 4.85 | 5.17 | 4.86 | 4.69 | 4.51 | 0.67 |
| $Al_2O_3$* | 2.85 | 1.62 | 2.71 | 2.60 | 2.23 | 3.16 | 1.63 | 2.46 | 3.31 | 2.86 | 2.66 | 3.31 |
| $Fe_2O_3$* | 1.25 | 0.93 | 1.28 | 1.22 | 0.86 | 1.61 | 0.69 | 1.12 | 1.58 | 1.42 | 1.32 | 0.44 |
| T* | 100.00 | 100.00 | 100.00 | 100.00 | 100.00 | 100.00 | 100.00 | 100.00 | 100.00 | 100.00 | 100.00 | 100.00 |

Sum is sum of $SiO_2$ through $Fe_2O_3$.

# Table 4

## TELL UMM JIRIN

### (n=5 glasses)

|  | 1260 | 1261 | 1264 | 1262 | 1263 | 1290 |
|---|---|---|---|---|---|---|
| $SiO_2$ d | 59.53 | 66.73 | 66.72 | 65.34 | 65.34 | major |
| $Na_2O$ | 16.2 | 14.2 | 15.8 | 16.0 | 14.9 | 1.47 |
| $CaO$ | 10.0 | 6.60 | 4.86 | 5.96 | 6.76 | 19.5 |
| $K_2O$ | 2.75 | 2.88 | 3.08 | 3.12 | 3.12 | 1.99 |
| $MgO$ | 4.27 | 4.42 | 6.21 | 5.76 | 4.56 | 6.80 |
| $Al_2O_3$ | 4.21 | 2.67 | 1.55 | 1.58 | 2.40 | 8.17 |
| $Fe_2O_3$ | 1.46 | 0.97 | 0.47 | 0.66 | 1.00 | 4.37 |
| $TiO_2$ | 0.24 | 0.16 | 0.09 | 0.12 | 0.15 | 0.55 |
| $Sb_2O_5$ |  |  |  |  |  |  |
| $MnO$ | 0.75 | 0.77 | 0.99 | 1.28 | 1.59 | 0.12 |
| $CuO$ | 0.04 | 0.01 | 0.001 | 0.01 | 0.005 | 0.014 |
| $CoO$ | 0.001 |  |  |  |  |  |
| $SnO_2$ |  |  |  |  |  |  |
| $Ag_2O$ | 0.001 | 0.001 | 0.001 | 0.0005 | 0.0005 | 0.001 |
| $PbO$ | 0.01 | 0.13 | 0.001 | 0.004 | 0.008 |  |
| $BaO$ | 0.02 | 0.03 | 0.03 | 0.1 | 0.1 | 0.08 |
| $SrO$ | 0.06 | 0.05 | 0.03 | 0.03 | 0.03 | 0.20 |
| $Li_2O$ | 0.001 | 0.001 | 0.001 | 0.001 | 0.001 | 0.001 |
| $Rb_2O$ |  |  |  |  |  | 0.005 |
| $B_2O_3$ | 0.01 | 0.02 | 0.01 | 0.02 | 0.02 | 0.02 |
| $V_2O_5$ | 0.005 | 0.005 | 0.005 | 0.001 | 0.001 | 0.01 |
| $Cr_2O_3$ | 0.005 | 0.005 | 0.001 | 0.005 | 0.005 | 0.01 |
| $NiO$ | 0.005 | 0.005 | 0.001 | 0.001 | 0.005 | 0.01 |
| $ZnO$ | 0.016 | 0.02 | 0.001 |  |  | 0.012 |
| $ZrO_2$ |  | 0.005 | 0.005 | 0.005 | 0.005 | 0.005 |
| $Bi_2O_3$ |  |  |  |  |  |  |
| $P_2O_5$ | 0.42 | 0.32 | 0.14 |  |  | 1.23 |
| $As_2O_5$ |  |  |  |  |  |  |
| Sum | 98.416 | 98.468 | 98.693 | 98.4225 | 98.0795 | 42.30 |
| $SiO_2$* d | 60.48 | 67.77 | 67.61 | 66.39 | 66.62 |  |
| $Na_2O$* | 16.46 | 14.42 | 16.01 | 16.26 | 15.19 |  |
| $CaO$* | 10.16 | 6.70 | 4.92 | 6.06 | 6.89 |  |
| $K_2O$* | 2.79 | 2.92 | 3.12 | 3.17 | 3.18 |  |
| $MgO$* | 4.34 | 4.49 | 6.29 | 5.85 | 4.65 |  |
| $Al_2O_3$* | 4.28 | 2.71 | 1.57 | 1.61 | 2.45 |  |
| $Fe_2O_3$* | 1.48 | 0.99 | 0.48 | 0.67 | 1.02 |  |
| T* | 100.00 | 100.00 | 100.00 | 100.00 | 100.00 |  |

Sum is sum of $SiO_2$ through $Fe_2O_3$.

83

# Table 5

## Jezaziyat

## (n=20 glasses)

| | 1266 | 1267 | 1269 | 1281 | 1282 | 1283 | 1271 | 1272 | 1274 | 1275 | 1276 |
|---|---|---|---|---|---|---|---|---|---|---|---|
| SiO$_2$ d | 66.13 | 66.16 | 64.45 | 66.30 | 64.54 | 65.06 | 63.05 | 63.37 | 65.16 | 67.07 | 71.65 |
| Na$_2$O | 17.3 | 16.2 | 16.4 | 15.5 | 14.9 | 15.8 | 16.4 | 16.4 | 16.8 | 15.0 | 12.9 |
| CaO | 5.43 | 5.70 | 6.04 | 6.77 | 6.77 | 5.73 | 8.28 | 7.76 | 7.90 | 6.35 | 4.43 |
| K$_2$O | 3.37 | 3.75 | 4.01 | 3.04 | 4.38 | 3.78 | 3.39 | 2.73 | 2.21 | 2.96 | 2.73 |
| MgO | 3.62 | 3.90 | 4.86 | 5.29 | 4.63 | 6.79 | 4.92 | 6.42 | 4.65 | 5.16 | 4.92 |
| Al$_2$O$_3$ | 2.58 | 2.73 | 2.69 | 1.97 | 2.99 | 1.68 | 2.05 | 1.76 | 1.62 | 1.83 | 1.36 |
| Fe$_2$O$_3$ | 1.26 | 1.26 | 1.21 | 0.88 | 1.42 | 0.87 | 1.33 | 0.90 | 0.96 | 0.76 | 0.72 |
| TiO$_2$ | 0.13 | 0.15 | 0.2 | 0.1 | 0.2 | 0.13 | 0.15 | 0.1 | 0.13 | 0.1 | 0.1 |
| Sb$_2$O$_5$ | | | | | | | | | | | |
| MnO | 0.068 | 0.048 | 0.048 | 0.068 | 0.058 | 0.055 | 0.33 | 0.44 | 0.47 | 0.69 | 1.07 |
| CuO | 0.003 | 0.001 | 0.001 | 0.001 | 0.001 | 0.001 | 0.001 | 0.001 | 0.001 | 0.001 | 0.05 |
| CoO | | | | | | | | | | | |
| SnO$_2$ | | | | | | | | | | | |
| Ag$_2$O | 0.0005 | 0.0005 | 0.0005 | 0.0005 | 0.0005 | 0.0005 | 0.0005 | 0.0005 | 0.0005 | 0.0005 | 0.0005 |
| PbO | 0.003 | 0.001 | | | | | | | | | |
| BaO | 0.005 | 0.005 | 0.002 | 0.001 | 0.002 | 0.001 | 0.002 | 0.005 | 0.005 | 0.007 | 0.01 |
| SrO | 0.03 | 0.05 | 0.05 | 0.05 | 0.05 | 0.05 | 0.05 | 0.08 | 0.05 | 0.05 | 0.03 |
| Li$_2$O | 0.001 | 0.001 | 0.001 | 0.004 | 0.001 | 0.004 | 0.002 | 0.005 | 0.002 | 0.003 | 0.002 |
| Rb$_2$O | | | | | | | | | | | |
| B$_2$O$_3$ | 0.03 | 0.02 | 0.01 | 0.01 | 0.02 | 0.01 | 0.02 | 0.01 | 0.02 | 0.01 | 0.01 |
| V$_2$O$_5$ | 0.005 | 0.005 | 0.005 | | 0.005 | | 0.005 | 0.005 | 0.005 | | |
| Cr$_2$O$_3$ | 0.005 | 0.005 | 0.005 | 0.005 | 0.005 | 0.005 | 0.005 | | 0.005 | | |
| NiO | 0.005 | 0.006 | 0.006 | | 0.006 | 0.005 | 0.006 | 0.005 | 0.005 | | |
| ZnO | 0.0041 | 0.0037 | 0.0047 | 0.0028 | 0.0078 | 0.0044 | 0.0044 | 0.0044 | 0.0041 | 0.0034 | 0.0037 |
| ZrO$_2$ | 0.018 | 0.005 | 0.005 | 0.005 | 0.01 | 0.02 | 0.005 | 0.005 | 0.005 | 0.005 | 0.01 |
| P$_2$O$_5$ | | | | | | | | | | | |
| Sum | 99.6924 | 99.6988 | 99.6618 | 99.7527 | 99.6337 | 99.7141 | 99.4191 | 99.3391 | 99.2974 | 99.1301 | 98.7138 |
| SiO$_2$* d | 66.34 | 66.36 | 64.67 | 66.47 | 64.78 | 65.25 | 63.42 | 63.79 | 65.62 | 67.66 | 72.59 |
| Na$_2$O* | 17.35 | 16.25 | 16.46 | 15.54 | 14.95 | 15.85 | 16.50 | 16.51 | 16.92 | 15.13 | 13.07 |
| CaO* | 5.45 | 5.72 | 6.06 | 6.79 | 6.79 | 5.75 | 8.33 | 7.81 | 7.96 | 6.41 | 4.49 |
| K$_2$O* | 3.38 | 3.76 | 4.02 | 3.05 | 4.40 | 3.79 | 3.41 | 2.75 | 2.23 | 2.99 | 2.77 |
| MgO* | 3.63 | 3.91 | 4.88 | 5.30 | 4.65 | 6.81 | 4.95 | 6.46 | 4.68 | 5.21 | 4.98 |
| Al$_2$O$_3$* | 2.59 | 2.74 | 2.70 | 1.97 | 3.00 | 1.68 | 2.06 | 1.77 | 1.63 | 1.85 | 1.38 |
| Fe$_2$O$_3$* | 1.26 | 1.26 | 1.21 | 0.88 | 1.43 | 0.87 | 1.34 | 0.91 | 0.97 | 0.77 | 0.73 |
| T* | 100.00 | 100.00 | 100.00 | 100.00 | 100.00 | 100.00 | 100.00 | 100.00 | 100.00 | 100.00 | 100.00 |

Sum is sum of SiO$_2$ through Fe$_2$O$_3$.

| | 1277 | 1278 | 1279 | 1280 | 1284 | 1285 | 1286 | 1287 | 1288 | 1289 (same as JZ) | 1291 |
|---|---|---|---|---|---|---|---|---|---|---|---|
| $SiO_2$ d | 70.00 | 68.93 | 69.35 | 70.70 | 65.91 | 67.83 | 65.55 | 66.93 | 68.06 | 65.16 | major |
| $Na_2O$ | 13.8 | 14.6 | 13.7 | 12.8 | 14.3 | 15.7 | 16.8 | 15.5 | 14.8 | 16.6 | 1.31 |
| $CaO$ | 4.43 | 6.67 | 4.57 | 6.29 | 6.67 | 4.23 | 4.57 | 4.78 | 6.04 | 6.27 | 0.44 |
| $K_2O$ | 3.34 | 2.93 | 3.19 | 2.09 | 3.04 | 3.04 | 3.27 | 2.96 | 2.34 | 3.25 | 4.06 |
| $MgO$ | 4.84 | 4.45 | 5.16 | 5.58 | 5.55 | 6.04 | 7.10 | 6.34 | 2.8 | 4.97 | 2.31 |
| $Al_2O_3$ | 2.09 | 1.30 | 1.55 | 1.21 | 2.40 | 1.56 | 1.52 | 1.46 | 2.33 | 2.52 | 19.7 |
| $Fe_2O_3$ | 0.74 | 0.48 | 0.84 | 0.67 | 1.24 | 0.74 | 0.71 | 0.67 | 1.96 | 0.92 | 7.14 |
| $TiO_2$ | 0.1 | 0.1 | 0.1 | 0.08 | 0.2 | 0.13 | 0.1 | 0.1 | 0.15 | 0.13 | 0.81 |
| $Sb_2O_5$ | | | | | | | | | | | |
| $MnO$ | 0.60 | 0.46 | 1.47 | 0.53 | 0.57 | 0.63 | 0.30 | 1.13 | 1.11 | 0.074 | 0.20 |
| $CuO$ | 0.001 | 0.001 | 0.002 | 0.001 | 0.001 | | 0.002 | 0.01 | 0.2 | 0.002 | |
| $CoO$ | | | | | | | | | 0.07 | | 0.088 |
| $SnO_2$ | | | | | | | | | | | 0.17 |
| $Ag_2O$ | 0.0005 | 0.0005 | 0.0005 | 0.0005 | 0.0005 | 0.0005 | 0.0005 | 0.0005 | 0.0005 | 0.0005 | 0.0005 |
| $PbO$ | | | | | | | 0.002 | 0.001 | 0.001 | | 0.005 |
| $BaO$ | 0.01 | 0.005 | 0.007 | 0.001 | 0.003 | 0.001 | 0.001 | 0.05 | 0.02 | 0.007 | 0.087 |
| $SrO$ | 0.03 | 0.03 | 0.03 | 0.03 | 0.05 | 0.05 | 0.03 | 0.03 | 0.03 | 0.04 | 0.009 |
| $Li_2O$ | 0.002 | 0.002 | 0.002 | 0.002 | 0.002 | 0.004 | 0.01 | 0.008 | 0.01 | 0.004 | |
| $Rb_2O$ | | | | | | | | | | 0.005 | |
| $B_2O_3$ | 0.01 | 0.01 | 0.01 | 0.01 | 0.02 | 0.02 | 0.02 | 0.02 | 0.03 | 0.02 | 0.01 |
| $V_2O_5$ | | | | | 0.005 | | | | | 0.002 | 0.02 |
| $Cr_2O_3$ | | | 0.005 | | 0.005 | 0.005 | | | | 0.003 | 0.0025 |
| $NiO$ | | | | | 0.005 | 0.005 | | | 0.007 | 0.004 | 0.01 |
| $ZnO$ | 0.0044 | 0.024 | 0.0053 | 0.0031 | 0.0044 | 0.0047 | 0.0041 | 0.0029 | 0.035 | 0.009 | 0.016 |
| $ZrO_2$ | 0.005 | 0.005 | 0.01 | 0.005 | 0.02 | 0.01 | 0.01 | 0.01 | 0.01 | 0.005 | 0.005 |
| $P_2O_5$ | | | | | | | | | | | 0.14 |
| Sum | 99.24 | 99.36 | 98.36 | 99.34 | 99.11 | 99.14 | 99.52 | 98.64 | 98.33 | 99.69 | 34.96 |
| $SiO_2$* d | 70.54 | 69.37 | 70.51 | 71.17 | 66.50 | 68.42 | 65.87 | 67.85 | 69.21 | 65.36 | |
| $Na_2O$* | 13.91 | 14.69 | 13.93 | 12.89 | 14.43 | 15.84 | 16.88 | 15.71 | 15.05 | 16.65 | |
| $CaO$* | 4.46 | 6.71 | 4.65 | 6.33 | 6.73 | 4.27 | 4.59 | 4.85 | 6.14 | 6.29 | |
| $K_2O$* | 3.37 | 2.95 | 3.24 | 2.10 | 3.07 | 3.07 | 3.29 | 3.00 | 2.38 | 3.26 | |
| $MgO$* | 4.88 | 4.48 | 5.25 | 5.62 | 5.60 | 6.09 | 7.13 | 6.43 | 2.85 | 4.99 | |
| $Al_2O_3$* | 2.11 | 1.31 | 1.58 | 1.22 | 2.42 | 1.57 | 1.53 | 1.48 | 2.37 | 2.53 | |
| $Fe_2O_3$* | 0.75 | 0.48 | 0.85 | 0.67 | 1.25 | 0.75 | 0.71 | 0.68 | 1.99 | 0.92 | |
| T* | 100.00 | 100.00 | 100.00 | 100.00 | 100.00 | 100.00 | 100.00 | 100.00 | 100.00 | 100.00 | |

Sum is sum of $SiO_2$ through $Fe_2O_3$.

85

# Table 6
## Tulul Umm Ghemimi
## (n=12)

| | 7628 | 7629 | 7630 | 7631 | 7632 | 7633 | 7634 | 7635 | 7636 | 7637 | 7638 | 7639 |
|---|---|---|---|---|---|---|---|---|---|---|---|---|
| $SiO_2$ d | 67.67 | 67.57 | 65.56 | 78.33 | 71.48 | 70.61 | 68.60 | 68.32 | 63.95 | 67.42 | 67.63 | 69.61 |
| $SiO_2$ a | | | | | | | | | | | | |
| $Na_2O$ | 14.1 | 15.8 | 14.4 | 10.0 | 13.1 | 11.9 | 13.5 | 13.1 | 16.5 | 13.7 | 14.7 | 12.5 |
| CaO | 7.73 | 5.40 | 9.06 | 4.13 | 5.80 | 7.64 | 7.85 | 8.73 | 7.20 | 8.17 | 7.57 | 7.81 |
| $K_2O$ | 2.83 | 3.19 | 3.06 | 1.75 | 2.11 | 2.78 | 2.93 | 1.96 | 3.41 | 2.72 | 2.70 | 1.93 |
| MgO | 3.96 | 5.54 | 4.46 | 3.61 | 4.53 | 3.29 | 3.42 | 3.16 | 6.31 | 4.03 | 3.84 | 4.51 |
| $Al_2O_3$ | 2.13 | 1.43 | 1.98 | 1.32 | 1.89 | 2.17 | 2.10 | 2.55 | 1.60 | 2.22 | 2.13 | 2.07 |
| $Fe_2O_3$ | 1.05 | 0.68 | 0.93 | 0.53 | 0.71 | 1.02 | 0.99 | 1.14 | 0.57 | 1.16 | 0.93 | 0.92 |
| $TiO_2$ | 0.11 | 0.059 | 0.10 | 0.056 | 0.089 | 0.12 | 0.12 | 0.16 | 0.068 | 0.12 | 0.098 | 0.12 |
| $Sb_2O_5$ | | | | | | | | | | | | |
| MnO | 0.038 | 0.038 | 0.036 | 0.025 | 0.035 | 0.033 | 0.034 | 0.45 | 0.041 | 0.047 | 0.036 | 0.036 |
| CuO | 0.013 | 0.005 | 0.005 | 0.02 | 0.002 | 0.005 | 0.002 | 0.002 | 0.002 | 0.002 | 0.002 | 0.001 |
| CoO | | | | | | | | | | | | |
| $SnO_2$ | 0.001 | | | | | | | | | | | 0.17 |
| $Ag_2O$ | 0.0005 | 0.0005 | 0.0005 | 0.001 | 0.0005 | 0.0005 | 0.0005 | 0.0005 | 0.0005 | 0.0005 | 0.0005 | 0.0005 |
| PbO | 0.01 | 0.005 | 0.005 | 0.001 | 0.001 | 0.001 | 0.001 | 0.001 | 0.001 | | 0.001 | 0.001 |
| BaO | 0.011 | 0.007 | 0.010 | 0.006 | 0.008 | 0.011 | 0.010 | 0.014 | 0.008 | 0.011 | 0.009 | 0.001 |
| SrO | 0.037 | 0.050 | 0.044 | 0.043 | 0.051 | 0.032 | 0.031 | 0.032 | 0.057 | 0.039 | 0.037 | 0.045 |
| $Li_2O$ | | | | | | | | | | | | |
| $Rb_2O$ | | | | | | | | | | | | |
| $B_2O_3$ | 0.01 | 0.01 | 0.01 | 0.005 | 0.01 | 0.01 | 0.01 | 0.01 | 0.01 | 0.01 | 0.01 | 0.02 |
| $V_2O_5$ | 0.0025 | 0.005 | 0.0025 | 0.0025 | 0.005 | 0.005 | 0.0025 | 0.0025 | | 0.005 | 0.005 | 0.0025 |
| $Cr_2O_3$ | 0.005 | 0.01 | 0.005 | 0.01 | 0.01 | 0.005 | 0.01 | 0.005 | 0.005 | 0.005 | 0.005 | 0.005 |
| NiO | 0.005 | 0.005 | 0.005 | 0.005 | 0.005 | 0.005 | 0.005 | 0.005 | 0.005 | 0.005 | 0.005 | 0.005 |
| ZnO | 0.011 | 0.008 | 0.008 | 0.004 | 0.007 | 0.012 | 0.010 | 0.011 | 0.009 | 0.008 | 0.009 | 0.010 |
| $ZrO_2$ | 0.005 | 0.005 | 0.005 | 0.005 | 0.005 | 0.005 | 0.005 | 0.005 | 0.005 | 0.005 | 0.005 | 0.005 |
| $Bi_2O_3$ | | | | | | | | | | | | |
| $P_2O_5$ | 0.27 | 0.18 | 0.31 | 0.15 | 0.15 | 0.35 | 0.37 | 0.34 | 0.25 | 0.32 | 0.28 | 0.23 |
| $As_2O_5$ | | | | | | | | | | | | |
| Sum | 99.471 | 99.6125 | 99.454 | 99.6665 | 99.6215 | 99.4055 | 99.389 | 98.962 | 99.5385 | 99.4225 | 99.4975 | 99.348 |
| $SiO_2$ a* | 68.03 | 67.84 | 65.92 | 78.59 | 71.75 | 71.03 | 69.02 | 69.04 | 64.24 | 67.81 | 67.97 | 70.06 |
| $Na_2O$* | 14.17 | 15.86 | 14.48 | 10.03 | 13.15 | 11.97 | 13.58 | 13.24 | 16.58 | 13.78 | 14.77 | 12.58 |
| CaO* | 7.77 | 5.42 | 9.11 | 4.14 | 5.82 | 7.69 | 7.90 | 8.82 | 7.23 | 8.22 | 7.61 | 7.86 |
| $K_2O$* | 2.85 | 3.20 | 3.08 | 1.76 | 2.12 | 2.80 | 2.95 | 1.98 | 3.43 | 2.74 | 2.71 | 1.94 |
| MgO* | 3.98 | 5.56 | 4.48 | 3.62 | 4.55 | 3.31 | 3.44 | 3.19 | 6.34 | 4.05 | 3.86 | 4.54 |
| $Al_2O_3$* | 2.14 | 1.44 | 1.99 | 1.32 | 1.90 | 2.18 | 2.11 | 2.58 | 1.61 | 2.23 | 2.14 | 2.08 |
| $Fe_2O_3$* | 1.06 | 0.68 | 0.94 | 0.53 | 0.71 | 1.03 | 1.00 | 1.15 | 0.57 | 1.17 | 0.93 | 0.93 |
| T* | 100.00 | 100.00 | 100.00 | 100.00 | 100.00 | 100.00 | 100.00 | 100.00 | 100.00 | 100.00 | 100.00 | 100.00 |

Sum is sum of $SiO_2$ through $Fe_2O_3$.

# Table 7

## MEAN COMPOSITIONS OF SASANIAN GLASSES

### Ctesiphon
### (n=15)

|  | 90% CL | mean | 90% CL | std. dev. | % RD |
|---|---|---|---|---|---|
| $SiO_2$* d | 66.65 | **70.80** | 74.95 | 2.51 | 3.55 |
| $Na_2O$* | 10.45 | **12.37** | 14.29 | 1.17 | 9.42 |
| $CaO$* | 5.34 | **7.25** | 9.17 | 1.16 | 16.0 |
| $K_2O$* | 1.83 | **2.83** | 3.82 | 0.60 | 21.3 |
| $MgO$* | 2.93 | **3.95** | 4.98 | 0.62 | 15.7 |
| $Al_2O_3$* | 0.93 | **1.93** | 2.93 | 0.61 | 31.5 |
| $Fe_2O_3$* | 0.23 | **0.87** | 1.51 | 0.39 | 44.5 |

### Choche
### (n=11)

|  | 90% CL | mean | 90% CL | std. dev. | % RD |
|---|---|---|---|---|---|
| $SiO_2$* d | 62.14 | **65.16** | 68.19 | 1.84 | 2.82 |
| $Na_2O$* | 15.08 | **15.93** | 16.78 | 0.51 | 3.23 |
| $CaO$* | 5.36 | **6.73** | 8.11 | 0.83 | 12.4 |
| $K_2O$* | 2.96 | **3.79** | 4.62 | 0.50 | 13.3 |
| $MgO$* | 3.95 | **4.63** | 5.31 | 0.41 | 8.92 |
| $Al_2O_3$* | 1.69 | **2.55** | 3.42 | 0.52 | 20.5 |
| $Fe_2O_3$* | 0.76 | **1.21** | 1.66 | 0.27 | 22.7 |

### Jezaziyat
### (n=21)

|  | 90% CL | mean | 90% CL | std. dev. | % RD |
|---|---|---|---|---|---|
| $SiO_2$* d | 63.12 | **67.22** | 71.31 | 2.48 | 3.69 |
| $Na_2O$* | 13.40 | **15.46** | 17.52 | 1.25 | 8.07 |
| $CaO$* | 4.11 | **6.03** | 7.95 | 1.16 | 19.3 |
| $K_2O$* | 2.25 | **3.16** | 4.06 | 0.55 | 17.3 |
| $MgO$* | 3.50 | **5.18** | 6.86 | 1.02 | 19.6 |
| $Al_2O_3$* | 1.12 | **1.98** | 2.83 | 0.52 | 26.2 |
| $Fe_2O_3$* | 0.43 | **0.99** | 1.54 | 0.34 | 34.3 |

### Tell Umm Jirin
### (n=5)

|  | 90% CL | mean | 90% CL | std. dev. | % RD |
|---|---|---|---|---|---|
| $SiO_2$* d | 61.32 | **65.77** | 70.23 | 2.70 | 4.10 |
| $Na_2O$* | 14.42 | **15.67** | 16.92 | 0.76 | 4.84 |
| $CaO$* | 4.06 | **6.95** | 9.83 | 1.75 | 25.2 |
| $K_2O$* | 2.79 | **3.04** | 3.29 | 0.15 | 5.03 |
| $MgO$* | 3.82 | **5.12** | 6.43 | 0.79 | 15.5 |
| $Al_2O_3$* | 0.89 | **2.52** | 4.15 | 0.99 | 39.1 |
| $Fe_2O_3$* | 0.36 | **0.93** | 1.49 | 0.34 | 37.1 |

### Tulul Umm Ghemimi
### (n=12)

|  | 90% CL | mean | 90% CL | std. dev. | % RD |
|---|---|---|---|---|---|
| $SiO_2$* d | 65.05 | **68.43** | 71.81 | 2.05 | 2.99 |
| $Na_2O$* | 11.87 | **14.02** | 16.16 | 1.30 | 9.28 |
| $CaO$* | 5.84 | **7.59** | 9.34 | 1.06 | 14.0 |
| $K_2O$* | 1.93 | **2.71** | 3.49 | 0.47 | 17.4 |
| $MgO$* | 2.79 | **4.30** | 5.81 | 0.91 | 21.3 |
| $Al_2O_3$* | 1.55 | **2.04** | 2.52 | 0.29 | 14.4 |
| $Fe_2O_3$* | 0.62 | **0.92** | 1.23 | 0.18 | 19.9 |

### Four Sasanian Cut Glasses
### (n=4)[†]

|  | 90% CL | mean | 90% CL | std. dev. | % RD |
|---|---|---|---|---|---|
| $SiO_2$* d | 61.86 | **63.50** | 65.13 | 0.99 | 1.56 |
| $Na_2O$* | 16.17 | **17.22** | 18.26 | 0.63 | 3.68 |
| $CaO$* | 4.46 | **7.10** | 9.73 | 1.60 | 22.5 |
| $K_2O$* | 2.42 | **3.47** | 4.53 | 0.64 | 18.4 |
| $MgO$* | 4.68 | **6.73** | 8.79 | 1.25 | 18.5 |
| $Al_2O_3$* | 0.82 | **1.42** | 2.02 | 0.36 | 25.5 |
| $Fe_2O_3$* | 0.22 | **0.56** | 0.91 | 0.21 | 37.3 |

† CMG 1272, 1296, 3074, 3086.

# Table 8

## Mean Compositions of Various Glasses

### Sasanian
### Plant Ash
### (n=62 glasses from 5 sites)

|  | mean | std. dev. | % RD |
|---|---|---|---|
| $SiO_2$*d | 67.93 | 2.95 | 4.35 |
| $Na_2O$* | 14.54 | 1.78 | 12.2 |
| CaO* | 6.73 | 1.25 | 18.5 |
| $K_2O$* | 3.10 | 0.64 | 20.6 |
| MgO* | 4.64 | 0.97 | 20.9 |
| $Al_2O_3$* | 2.08 | 0.56 | 26.9 |
| $Fe_2O_3$* | 0.97 | 0.34 | 34.8 |

### Four Sasanian Cut Glasses
### Plant Ash
### (n=6)[†]

|  | mean | std. dev. | % RD |
|---|---|---|---|
| $SiO_2$*d | 63.50 | 0.99 | 1.56 |
| $Na_2O$* | 17.22 | 0.63 | 3.68 |
| CaO* | 7.10 | 1.60 | 22.5 |
| $K_2O$* | 3.47 | 0.64 | 18.4 |
| MgO* | 6.73 | 1.25 | 18.5 |
| $Al_2O_3$* | 1.42 | 0.36 | 25.5 |
| $Fe_2O_3$* | 0.56 | 0.21 | 37.3 |

† CMG 1272, 1296, 3074, 3086.

### Islamic
### Plant Ash
### (n=180 glasses, 20 sites or types)

|  | mean | std. dev. | % RD |
|---|---|---|---|
| $SiO_2$*d | 67.42 | 4.22 | 6.26 |
| $Na_2O$* | 15.09 | 3.06 | 20.3 |
| CaO* | 7.27 | 1.76 | 24.2 |
| $K_2O$* | 2.97 | 0.93 | 31.3 |
| MgO* | 3.97 | 1.22 | 30.7 |
| $Al_2O_3$* | 2.29 | 1.28 | 55.9 |
| $Fe_2O_3$* | 0.99 | 0.67 | 67.7 |

### Hellenistic-Roman
### Natron

|  | mean | std. dev. | % RD |
|---|---|---|---|
| $SiO_2$*d | 70.25 | 2.38 | 3.39 |
| $Na_2O$* | 17.63 | 1.85 | 10.5 |
| CaO* | 7.40 | 1.35 | 18.2 |
| $K_2O$* | 0.71 | 0.19 | 26.7 |
| MgO* | 0.72 | 0.24 | 33.4 |
| $Al_2O_3$* | 2.36 | 0.44 | 18.5 |
| $Fe_2O_3$* | 0.93 | 0.47 | 50.4 |

### Byzantine Mosaics
### Natron
### (n=162 glasses from 16 sites)

|  | mean | std. dev. | % RD |
|---|---|---|---|
| $SiO_2$*d | 69.12 | 2.65 | 3.84 |
| $Na_2O$* | 17.49 | 2.85 | 16.3 |
| CaO* | 7.60 | 1.64 | 21.6 |
| $K_2O$* | 1.11 | 0.67 | 60.1 |
| MgO* | 1.09 | 0.69 | 63.2 |
| $Al_2O_3$* | 2.26 | 0.55 | 24.4 |
| $Fe_2O_3$* | 1.32 | 0.85 | 64.6 |

### Individual Factories

|  | Nishapur Plant Ash (17 colorless) | Serçe Limanı Plant Ash (85) | Jalame Natron (52) |
|---|---|---|---|
|  | % RD | % RD | % RD |
| $SiO_2$*d | 1.92 | 1.54 | 1.8 |
| $Na_2O$* | 8.25 | 6.73 | 5.7 |
| CaO* | 6.37 | 10.1 | 7.7 |
| $K_2O$* | 13.2 | 11.0 | 17.6 |
| MgO* | 12.4 | 11.8 | 20.8 |
| $Al_2O_3$* | 13.4 | 14.0 | 5.7 |
| $Fe_2O_3$* | 29.1 | 31.5 | 22.6 |

# Bibliography

Most works are cited by author(s) and date (e.g., An 1991). Exhibition catalogs are cited by name and date (e.g., *Gläser der Antike* 1974). Catalogs (including sale catalogs) of well-known private collections are cited by owner's name and date (e.g., *Constable-Maxwell Collection* 1979). Other sale catalogs are cited by their short title and date (e.g., *Antiquities* 1985). Entries beginning with a cardinal or ordinal number, expressed either as a numeral or spelled out, will be found after the alphabetical entries, arranged numerically.

The following abbreviations are used:

## A. Names of Publications

| | |
|---|---|
| *AnnAIHV* | *Annales de l'Association Internationale pour l'Histoire du Verre* |
| *JGS* | *Journal of Glass Studies* |

## B. Other

| | |
|---|---|
| c., cc. | column, columns |
| ed., eds. | editor, edited by, editors |
| edn. | edition |
| no., nos. | number, numbers |
| n.p. | not paginated |
| n.s. | new series |
| p., pp. | page, pages |
| pl., pls. | plate, plates |
| pt. | part |
| publ. | published |
| s.l. | *sine loco* (place not stated) |
| tr. | translated |
| v., vv. | volume, volumes |

Adams 1965
R. McC. Adams, *Land behind Baghdad*, Chicago: University of Chicago Press, 1965.

An 1986
An Jiayao, "A Glass Bowl Found in the Tomb of Li Xian of the Northern Zhou Period—The Discovery of and Research on Sasanian Glassware," *Kaogu*, 1986, pt. 2, pp. 173–181 (in Chinese).

An 1991
An Jiayao, "The Early Glass of China," in *Scientific Research in Early Chinese Glass*, ed. R. H. Brill and J. H. Martin, Corning: The Corning Museum of Glass, 1991, pp. 5–19.

*Ancient and Islamic Glass* 1986
*Ancient and Islamic Glass, Ancient Jewellery and Silver, Middle Eastern, Egyptian, Greek, Etruscan and Roman Antiquities*, sale catalog, London: Sotheby's, July 14, 1986.

*Ancient Glass* 1986
*Ancient Glass, Ancient Jewellery, Middle Eastern, Egyptian, Greek,* *Etruscan and Roman Antiquities, also Art Reference Books*, sale catalog, London: Sotheby's, December 8 and 9, 1986.

*Ancient Glass* 2001
M. Akiyo and others, *Ancient Glass = Kodaī garasu*, Shiga, Japan: Miho Museum, 2001.

*Antiquities* 1975a
*Egyptian, Middle Eastern, Greek, Etruscan and Roman Antiquities, Islamic Pottery and Metalwork, Indian Art*, sale catalog, London: Sotheby & Co., July 14, 1975.

*Antiquities* 1975b
*Greek, Roman, Egyptian, Western Asiatic, Islamic Antiquities & Works of Art, Including Ancient and Islamic Glass from the Collection of Ray Winfield Smith*, sale catalog, New York: Sotheby Parke Bernet, May 2, 1975.

*Antiquities* 1983
*Egyptian, Middle Eastern, Greek, Etruscan, Celtic, Anglo-Saxon, and Roman Antiquities, Ancient Glass and Art Reference Books*, sale catalog, London: Sotheby's, December 12 and 13, 1983.

*Antiquities* 1984a
*Catalogue of Egyptian, Middle Eastern, Greek, Etruscan, Roman, Celtic, Byzantine, Frankish, Anglo-Saxon and Viking Antiquities, also Art Reference Books*, sale catalog, London: Sotheby's, July 9 and 10, 1984.

*Antiquities* 1984b
*Egyptian, Middle Eastern, Greek, Etruscan, Celtic and Roman Antiquities, Ancient Glass and Art Reference Books*, sale catalog, London: Sotheby's, December 10 and 11, 1984.

*Antiquities* 1985
*Ancient Glass, Egyptian, Middle Eastern, Greek, Etruscan and Roman Antiquities*, sale catalog, London: Sotheby's, December 9, 1985.

*Antiquities* 1986
*Egyptian, Middle Eastern, Greek, Etruscan and Roman Antiquities, also Ancient Glass and Art Reference Books*, sale catalog, London: Sotheby's, May 19, 1986.

*Antiquities* 1988a
*Ancient Glass, Ancient Jewellery, Middle Eastern, Egyptian, and Greek, Etruscan and Roman Antiquities*, sale catalog, London: Sotheby's, December 12, 1988.

*Antiquities* 1988b
*Egyptian, Greek, Etruscan, Roman and Western Asiatic Antiquities and Islamic Works of Art*, sale catalog, New York: Sotheby's, December 2, 1988.

*Antiquities* 1989
*Egyptian and Middle Eastern Antiquities, Ancient Jewellery, Greek, Etruscan and Roman Antiquities, South Italian Greek Pottery Vases, Roman Mosaics, Ancient Glass and Art Reference Books*, sale catalog, London: Sotheby's, July 10 and 11, 1989.

*Antiquities* 1996
*Antiquities*, sale catalog, London: Sotheby's, December 10, 1996.

*Antiquities* 1997
*Antiquities and Islamic Art*, sale catalog, New York: Sotheby's, December 17, 1997.

*Antiquities* 2000a

Antiquities, sale catalog, London: Bonhams, October 3, 2000.

*Antiquities* 2000b

Antiquities and Islamic Works of Art, sale catalog, New York: Sotheby's, June 14, 2000.

*Antiquities* 2001

Antiquities, sale catalog, London: Bonhams & Brooks, November 8, 2001.

*Antiquities and Islamic Art* 1998

Antiquities and Islamic Art, sale catalog, New York: Sotheby's, December 17, 1998.

*Antiquities and Islamic Works of Art* 2000

Antiquities and Islamic Works of Art, sale catalog, New York: Sotheby's, December 8, 2000.

Balog 1974

P. Balog, "Sasanian and Early Islamic Ornamental Glass Vessel-Stamps," in *Near Eastern Numismatics, Iconography, Epigraphy and History: Studies in Honor of George C. Miles*, ed. D. K. Kouymjian, Beirut: American University of Beirut, 1974, pp. 131–140.

Barag 1985

D. Barag, *Catalogue of Western Asiatic Glass in the British Museum*, v. 1, London: British Museum Publications Ltd. in association with Magnes Press, Hebrew University, Jerusalem, 1985.

Beech 1992

G. T. Beech, "The Eleanor of Aquitaine Vase: Its Origins and History to the Early Twelfth Century," *Ars Orientalis*, v. 22, 1992, pp. 69–79.

Beech 1993

G. T. Beech, "The Eleanor of Aquitaine Vase, William IX of Aquitaine, and Muslim Spain," *Gesta*, v. 32, 1993, pp. 3–10.

Beech 2002

G. T. Beech, "The Eleanor of Aquitaine Vase," in *Eleanor of Aquitaine: Lord and Lady*, ed. J. C. Parsons and B. Wheeler, New York: Palgrave Macmillan, 2002, pp. 369–376.

Bier 1986

L. Bier, *Sarvistan: A Study in Early Iranian Architecture*, The College Art Association Monographs on the Fine Arts, no. 41, University Park, Pennsylvania: Pennsylvania State University Press for the association, 1986.

*Billups Collection* 1962

A Decade of Glass Collecting: Selections from the Melvin Billups Collection, Corning, New York: The Corning Museum of Glass, 1962.

Blair 1973

D. Blair, *A History of Glass in Japan*, New York: Kodansha International USA Ltd., 1973.

Boon 1977

G. C. Boon, "Gold-in-Glass Beads from the Ancient World," *Britannia*, v. 8, 1977, pp. 193–207.

Booth-Clibborn 2001

E. Booth-Clibborn, originator, *The Splendour of Iran*, v. 1, *Ancient Times*, London: Booth-Clibborn Editions, 2001.

Boucharlat and Lecomte 1987

R. Boucharlat and O. Lecomte, *Fouilles de Tureng Tepe sous la direction de Jean Deshayes†*, v. 1, *Les Périodes sassanides et islamiques*, Paris: Editions Recherche sur les Civilisations, 1987.

Brewerton 1991

A. Brewerton, review of R. J. Charleston, *Masterpieces of Glass: A World History from The Corning Museum of Glass*, expanded edn., 1990, in *Crafts* (London), no. 112, September/October 1991, pp. 57–58.

Brill 1968

R. H. Brill, "The Scientific Investigation of Ancient Glasses," *Proceedings of the VIIIth International Congress on Glass, London*, Sheffield: The Society of Glass Technology, 1968, pp. 47–68.

Brill 1970

R. H. Brill, "The Chemical Interpretation of the Texts," in A. L. Oppenheim and others, *Glass and Glassmaking in Ancient Mesopotamia*, Corning: The Corning Museum of Glass, 1970, pp. 105–128.

Brill 1972

R. H. Brill, "Some Chemical Observations on the Cuneiform Glassmaking Texts," *AnnAIHV*, v. 5, Prague, 1970 (Liège, 1972), pp. 329–335.

Brill 1991

R. H. Brill, "Scientific Investigations of Some Glasses from Sedeinga," *JGS*, v. 33, 1991, pp. 11–28.

Brill 1995

R. H. Brill, "Appendix 3. Chemical Analyses of Some Glass Fragments from Nishapur in The Corning Museum of Glass," in Jens Kröger, *Nishapur: Glass of the Early Islamic Period*, New York: The Metropolitan Museum of Art, 1995, pp. 211–233.

Brill 1999

R. H. Brill, *Chemical Analyses of Early Glasses*, v. 1, *Catalogue of Samples*, and v. 2, *Tables of Analyses*, Corning: The Corning Museum of Glass, 1999.

Brill 2001

R. H. Brill, "Some Thoughts on the Chemistry and Technology of Islamic Glass," in S. Carboni and D. Whitehouse, *Glass of the Sultans*, New York: The Metropolitan Museum of Art in association with The Corning Museum of Glass, Benaki Museum, and Yale University Press, 2001, pp. 25–45.

Brill and Shirahata 1997

R. H. Brill and H. Shirahata, "Laboratory Analyses of Some Glasses and Metals from Tell Brak," in D. Oates, J. Oates, and H. McDonald, *Excavations at Tell Brak*, v. 1, *The Mitanni and Old Babylonian Periods*, Cambridge, England: McDonald Institute for Archaeological Research, 1997, pp. 89–94; see also pp. 99–100, passim, fig. 124, and frontispiece.

*Brilliant Vessels* 2001

T. Mori, *Brilliant Vessels of Ancient Near East—Glass, Metal and Lustre Pottery*, Seto City: Aichi Prefecture Museum of Ceramics, 2001.

Brisch and others 1971

K. Brisch and others, *Museum für Islamische Kunst, Berlin: Katalog 1971*, Berlin: Staatliche Museen Preussischer Kulturbesitz, 1971.

Brisch and others 1980

K. Brisch and others, *Museum für Islamische Kunst, Berlin. Staatliche Museen Preussischer Kulturbesitz*, Kunst der Welt in

den Berliner Museen, Stuttgart and Zurich: Belser AG für Verlagsgeschäfte & Co. KG, 1980.

Carboni and others 2001

S. Carboni and others, "*Ars Vitraria*: Glass in The Metropolitan Museum of Art," *The Metropolitan Museum of Art Bulletin*, v. 59, no. 1, Summer 2001, pp. 1–68.

Charleston 1980

R. J. Charleston, *Masterpieces of Glass: A World History from The Corning Museum of Glass*, New York: Harry N. Abrams Inc., 1980.

Charleston 1990

R. J. Charleston, with contributions by D. B. Whitehouse and S. K. Frantz, *Masterpieces of Glass: A World History from The Corning Museum of Glass*, expanded edn., New York: Harry N. Abrams Inc., 1990.

*China: Dawn* 2004

J. C. Y. Watt and others, *China: Dawn of a Golden Age, 200–750 AD*, New York, New Haven, and London: The Metropolitan Museum of Art and Yale University Press, 2004.

Clairmont 1963

C. W. Clairmont, *The Glass Vessels*, The Excavations at Dura-Europos Conducted by Yale University and the French Academy of Inscriptions and Letters, Final Report, v. 4, pt. 5, New Haven, Connecticut: Dura-Europos Publications, 1963.

*Cohn Collection* 1980

A. von Saldern, *Glass 500 B.C. to A.D. 1900: The Hans Cohn Collection, Los Angeles, Cal.*, Mainz am Rhein: Verlag Philipp von Zabern, 1980.

*Constable-Maxwell Collection* 1979

*The Constable-Maxwell Collection of Ancient Glass*, sale catalog, London: Sotheby Parke Bernet, June 4 and 5, 1979.

Č'xatarašvili 1978

M. N.-A. Č'xatarašvili, *Minis čurčeli šua saukunetá Sakartveloši* (The glassware of medieval Georgia), Tbilisi: Metziereba, 1978 (in Georgian, with Russian and English summaries).

*Davids Samling: Islamisk Kunst* 1975

C. L. Davids Fond og Samling, *Davids Samling, Islamisk Kunst = The David Collection, Islamic Art*, Copenhagen: the collection, 1975.

Dolez 1988

A. Dolez, *Glass Animals: 3,500 Years of Artistry and Design*, New York: Harry N. Abrams Inc., 1988.

Dusenbery 1971

E. B. Dusenbery, "Ancient Glass in the Collections of Wheaton College," *JGS*, v. 13, 1971, pp. 9–33.

Eisen 1927

G. A. Eisen, assisted by F. Kouchakji, *Glass: Its Origin, History, Chronology, Technic and Classification to the Sixteenth Century*, New York: William Edwin Rudge, 1927.

Erdmann 1950–1

K. Erdmann, "Zur Datierung der Berliner Pegasus-Schale," *Archäologischer Anzeiger*, vv. 65–66, 1950–1951 (publ. 1952), cc. 115–132.

Erdmann 1953

K. Erdmann, "Noch einmal zur Datierung der Berliner Pegasus-Schale," *Archäologischer Anzeiger*, v. 68, 1953, cc. 135–142.

Erdmann 1961

K. Erdmann, "Neuerworbene Gläser der Islamischen Abteilung 1958–1961," *Berliner Museen*, n.s., v. 11, no. 2, 1961, pp. 31–41.

Erdmann 1969

K. Erdmann, *Die Kunst Irans zur Zeit der Sasaniden*, 2nd edn., Berlin: F. Kupferberg, 1969.

*Eredità dell'Islam* 1993

G. Curatola, ed., *Eredità dell'Islam: Arte Islamica in Italia*, Cinisello Balsamo, Milan: Silvana Editoriale, 1993.

Fehérvári 1976

G. Fehérvári, *Islamic Metalwork of the Eighth to the Fifteenth Century in the Keir Collection*, London: Faber and Faber Ltd., 1976.

Fehérvári and others 1996

G. Fehérvári and others, *Art of the Eastern World*, London: Hadji Baba Ancient Art, 1996.

*Fine Antiquities* 1982

*Fine Egyptian, Classical and Near Eastern Antiquities, Islamic Works of Art, and Oriental Miniatures and Manuscripts*, sale catalog, New York: Sotheby's, December 2 and 3, 1982.

Folsach 2001

K. von Folsach, *Art from the World of Islam in the David Collection*, Copenhagen: the collection, 2001.

Freestone and Gorin-Rosen 1999

I. C. Freestone and Y. Gorin-Rosen, "The Great Glass Slab at Bet She'arim, Israel: An Early Islamic Glassmaking Experiment?," *JGS*, v. 41, 1999, pp. 105–116.

Frye 1973

R. N. Frye, *Sasanian Remains from Qasr-i Abu Nasr: Seals, Sealings, and Coins*, Cambridge, Massachusetts: Harvard University Press, 1973.

Frye 1983

R. N. Frye, "The Political History of Iran under the Sasanians," in *The Cambridge History of Iran*, v. 3, pt. 1, *The Seleucid, Parthian and Sasanian Periods*, ed. E. Yarshater, Cambridge, etc.: Cambridge University Press, 1983, pp. 116–180.

Fukai 1960

S. Fukai, "A Persian Treasure in the Shosoin Repository," *Japan Quarterly*, v. 7, no. 2, April–June 1960, pp. 169–176.

Fukai 1968

S. Fukai, "On a Glass Bowl with Decoration of Doubled Circular Facets Excavated in Gilan," *Memoirs of the Institute of Oriental Culture*, no. 45, March 1968, pp. 309–327.

Fukai 1973

S. Fukai, *Perushia no Garasu*, Kyoto: Tankosha, 1973.

Fukai 1977

S. Fukai, *Persian Glass*, New York, Tokyo, and Kyoto: Weatherhill/Tankosha, 1977.

Ghirshman 1956

R. Ghirshman, *Bîchâpour II: Les Mosaïques sassanides*, Série Archéologique, v. 7, Paris: Musée du Louvre, Département des Antiquités Orientales, 1956.

*Gläser der Antike* 1974

A. von Saldern and others, *Gläser der Antike, Sammlung Erwin Oppenländer*, Hamburg: Museum für Kunst und Gewerbe, and Cologne: Römisch-Germanisches Museum, 1974.

*Glass from the Ancient World* 1957

[R. W. Smith], *Glass from the Ancient World: The Ray Winfield Smith Collection*, Corning: The Corning Museum of Glass, 1957.

*Glass of the Sultans* 2001

    S. Carboni and D. Whitehouse, with contributions by R. H. Brill and W. Gudenrath, *Glass of the Sultans*, New York: The Metropolitan Museum of Art in association with The Corning Museum of Glass, Benaki Museum, and Yale University Press, 2001.

*Glasses of Antiquity* 2002

    C. A. Marinescu and S. E. Cox, *Glasses of Antiquity*, New York: Fortuna Fine Arts Ltd., 2002.

*Glassmakers of Herat* 1979

    *The Glassmakers of Herat*, 30-minute color sound film, produced for The Corning Museum of Glass by Elliott Erwitt, 1979.

*Guide to the Collections* 2001

    Anon., *The Corning Museum of Glass: A Guide to the Collections*, Corning: the museum, 2001.

Hansman and Stronach 1970

    J. Hansman and D. Stronach, "Excavations at Shahr-i Qumis, 1967," *Journal of the Royal Asiatic Society*, 1970, pp. 29–62.

Harada and others 1965

    Y. Harada and others, *Shōsōin no garasu = Glass Objects in the Shōsōin*, Tokyo: Nihon Keizai Shimbun Sha, 1965.

Harper 1974

    P. O. Harper, "Sasanian Medallion Bowls with Human Busts," in *Near Eastern Numismatics, Iconography, Epigraphy and History: Studies in Honor of George C. Miles*, ed. D. K. Kouymjian, Beirut: American University of Beirut, 1974, pp. 61–80.

Hasson 1979

    R. Hasson, *Early Islamic Glass*, Jerusalem: L. A. Mayer Memorial Institute for Islamic Art, 1979.

*Hentrich Collection* 1974

    A. von Saldern, *Glassammlung Hentrich: Antike und Islam*, Kataloge des Kunstmuseums Düsseldorf, v. 1, pt. 3, Düsseldorf: the museum, 1974.

Huff 1995

    D. Huff, "Eine sasanidische Glasbläserwerkstatt auf dem Takht-i Suleiman (Iran)," in *Beiträge zur Kulturgeschichte Vorderasiens*, ed. U. Finkbeiner, R. Dittmann, and H. Hauptman, Mainz: Verlag Philipp von Zabern, 1995, pp. 259–266.

*Islamic Art* 1995

    *Islamic Art and Indian Miniatures*, sale catalog, London: Christie's, April 25, 1995.

*Islamic Art* 2004

    *Islamic Art and Manuscripts, Including Property from the Theodore Sehmer and Heidi Vollmoeller Collections and Including the Clive of India Treasure*, sale catalog, London: Christie's South Kensington, April 28, 2004.

*Islamic Works of Art* 1980

    *Islamic Works of Art and Ancient & Islamic Glass*, sale catalog, London: Sotheby's, April 21 and 22, 1980.

Jenkins 1986

    M. Jenkins, "Islamic Glass: A Brief History," *The Metropolitan Museum of Art Bulletin*, n.s., v. 44, no. 2, Fall 1986, pp. 3–56.

Joo 2003

    Y. H. Joo, "A Study on the Korean Glass-Made Sarira Vessel," *Bulletin of the Ancient Orient Museum*, v. 23, 2003, pp. 167–200 (in Korean).

*Kofler-Truniger Collection* 1985

    *Ancient Glass: Formerly the Kofler-Truniger Collection*, sale catalog, London: Christie's, March 5 and 6, 1985.

Kröger 1984

    J. Kröger, *Glas* (*Islamische Kunst: Loseblattkatalog unpublizierter Werke aus deutschen Museen*, v. 1, *Berlin, Staatliche Museen Preussischer Kulturbesitz Museum für Islamische Kunst*), Mainz am Rhein: Verlag Philipp von Zabern, 1984.

Kröger 1993

    J. Kröger, "Décor en stuc," in *Splendeur des Sassanides: L'Empire perse entre Rome et la Chine (224–642)*, Brussels: Musées Royaux d'Art et d'Histoire and Crédit Communal, 1993, pp. 63–65.

Kröger 1998

    J. Kröger, "From Ctesiphon to Nishapur: Studies in Sasanian and Islamic Glass," in *The Art and Archaeology of Ancient Persia: New Light on the Parthian and Sasanian Empires*, ed. V. S. Curtis, R. Hillenbrand, and J. M. Rogers, London: I. B. Tauris, 1998, pp. 133–140.

Kröger forthcoming

    J. Kröger, *Parthisches, sasanidisches und islamisches Glas: Die Glasfunde von Ktesiphon (Iraq) nach den Ausgrabungen der Ktesiphon-Expedition 1928–29 und 1931–2*, forthcoming.

Kühnel and Wachsmut 1933

    E. Kühnel and F. Wachsmut, *Die Ausgrabungen der zweiten Ktesiphon-expedition 1931–32*, Berlin: Islamische Kunstabteilung der Staatlichen Museen, 1933.

Laing 1991

    E. J. Laing, "A Report on Western Asian Glassware in the Far East," *Bulletin of the Asia Institute*, n.s., v. 5, 1991, pp. 109–121.

Lamm 1929–30

    C. J. Lamm, *Mittelalterliche Gläser und Steinschnittarbeiten aus dem Nahen Osten*, 2 vv., Forschungen zur Islamischen Kunst, v. 5, Berlin: Verlag Dietrich Reimer/Ernst Vohsen, 1929–1930.

Lamm 1931

    C. J. Lamm, "Les Verres trouvés à Suse," *Syria*, v. 12, 1931, pp. 358–367.

Lamm 1939

    C. J. Lamm, "Glass and Hard Stone Vessels," in *A Survey of Persian Art from Prehistoric Times to the Present*, ed. A. U. Pope, London and New York: Oxford University Press, v. 3, 1939, pp. 2592–2606.

Langdon and Harden 1934

    S. Langdon and D. B. Harden, "Pottery and Glass from Kish: Excavations at Kish and Barghuthiat," *Iraq*, v. 1, 1934, pp. 124–136.

Leclant 1973

    J. Leclant, "Glass from the Meroitic Necropolis of Sedeinga (Sudanese Nubia)," *JGS*, v. 15, 1973, pp. 52–68.

Lecomte 1993

    O. Lecomte, "Ed-Dur, les occupations des 3$^e$ et 4$^e$ s. ap. J.-C.: Contexte des trouvailles et matériel diagnostique," in *Materialien zur Archäologie der Seleukiden- und Partherzeit im südlichen Babylonien und im Golfgebiet*, ed. U. Finkbeiner, Tübingen: Ernst Wasmuth Verlag, 1993, pp. 195–217.

Lee 1993

    I.-S. Lee, *Han'gukūi kodai yuri = Ancient Glass in Korea*, Seoul, Korea: Tōsō Ch'ulpan Ch'angmun Hanglas, 1993 (in Korean).

Leth 1970

A. Leth, *Davids Samling, Islamisk Kunst = The David Collection, Islamic Art*, Copenhagen: the collection, 1970.

Leth 1975

A. Leth, *Davids Samling, Islamisk Kunst = The David Collection, Islamic Art*, Copenhagen: the collection, 1975.

Marshak 1998

B. I. Marshak, "The Decoration of Some Late Sasanian Silver Vessels and Its Subject-Matter," in *The Art and Archaeology of Ancient Persia: New Light on the Parthian and Sasanian Empires*, ed. V. S. Curtis, R. Hillenbrand, and J. M. Rogers, London: I. B. Tauris, 1998, pp. 84–92.

*Masterpieces of Glass* 1968

D. B. Harden and others, *Masterpieces of Glass*, London: Trustees of The British Museum, 1968.

Masuda 1960a

S. Masuda, "Glass Objects from the Alburz Mountains, Iran," *Museum* [National Museum, Tokyo], no. 108, March 1960, pp. 25–28.

Masuda 1960b

S. Masuda, "Glassware of the Sassanid Age," *Museum* [National Museum, Tokyo], no. 110, May 1960, pp. 24–26.

Meyer 1996

C. Meyer, "Sasanian and Islamic Glass from Nippur, Iraq," *AnnAIHV*, v. 13, Pays Bas, 1995 (Lochem, 1996), pp. 247–255.

*Monks and Merchants* 2001

A. L. Juliano and J. A. Lerner, *Monks and Merchants: Silk Road Treasures from Northwest China, Gansu and Ningxia, 4th–7th Century*, New York: Harry N. Abrams Inc., with the Asia Society, 2001.

Morton 1985

A. H. Morton, *A Catalogue of Early Islamic Glass Stamps in The British Museum*, London: British Museum Publications, 1985.

Negro Ponzi 1968–9

M. Negro Ponzi, "Sasanian Glassware from Tell Mahuz (North Mesopotamia)," *Mesopotamia*, vv. 3–4, 1968–1969, pp. 293–384.

Negro Ponzi 1972

M. Negro Ponzi, "Glassware from Abu Skhair," *Mesopotamia*, v. 7, 1972, pp. 215–237.

Negro Ponzi 1987

M. Negro Ponzi, "Late Sasanian Glassware from Tell Baruda," *Mesopotamia*, v. 22, 1987, pp. 265–275.

Negro Ponzi 2002

M. Negro Ponzi, "The Glassware from Seleucia (Central Iraq)," *Parthica*, v. 4, 2002, pp. 63–156.

Negro Ponzi Mancini 1984

M. Negro Ponzi Mancini, "Glassware from Choche (Central Mesopotamia)," in *Arabie orientale, Mésopotamie et Iran méridionale de l'âge du fer au début de la période islamique*, ed. R. Boucharlat and J.-F. Salles, Mémoire no. 37, Paris: Editions Recherche sur les Civilisations, 1984, pp. 33–40.

Nenna 1999

M.-D. Nenna, "Glassware," in *Bahrain: The Civilisation of the Two Seas*, Paris and Ghent: Institut du Monde Arabe and Snoeck-Ducaju & Zoon, 1999, pp. 181–191.

Oliver 1980

A. Oliver Jr., *Ancient Glass in the Carnegie Museum of Natural History, Pittsburgh*, Pittsburgh: Carnegie Institute, 1980.

*Persian Glass* 1972

P. Perrot, *A Tribute to Persia: Persian Glass*, Corning: The Corning Museum of Glass, 1972.

Pinder-Wilson 1963

R. Pinder-Wilson, "Cut-Glass Vessels from Persia and Mesopotamia," *British Museum Quarterly*, v. 27, no. 2, 1963, pp. 33–39.

Pope 1938

A. U. Pope, ed., *A Survey of Persian Art from Prehistoric Times to the Present*, London and New York: Oxford University Press, v. 1, 1938.

Price and Worrell 2003

J. Price and S. Worrell, "Roman, Sasanian, and Islamic Glass from Kush, Ras al-Khaimah, United Arab Emirates: A Preliminary Survey," *AnnAIHV*, v. 15, New York and Corning, 2001 (Nottingham, 2003), pp. 153–157.

Puttrich-Reignard 1934

O. Puttrich-Reignard, *Die Glasfunde von Ktesiphon*, Ph.D. diss., Christian-Alberts Universität, Kiel, 1934.

Reuther 1929

O. Reuther, "The German Excavations at Ctesiphon," *Antiquity*, v. 3, December 1929, pp. 434–451.

Reuther 1938

O. Reuther, "Sāsānian Architecture. A. History," in *A Survey of Persian Art from Prehistoric Times to the Present*, ed. A. U. Pope, London and New York: Oxford University Press, v. 1, 1938, pp. 493–578.

*Royal Hunter* 1978

P. O. Harper, *The Royal Hunter: Art of the Sasanian Empire*, New York: The Asia Society in association with John Weatherhill Inc., 1978.

Saldern 1963

A. von Saldern, "Achaemenid and Sasanian Cut Glass," *Ars Orientalis*, v. 5, 1963, pp. 7–16.

Saldern 1967

A. von Saldern, "The So-Called Byzantine Glass in the Treasury of San Marco," *Annales du 4ᵉ Congrès des Journées Internationales du Verre*, Ravenna and Venice (publ. in Liège), 1967, pp. 124–132.

Saldern 1968

A. von Saldern, "Sassanidische und islamische Gläser in Düsseldorf und Hamburg," *Jahrbuch der Hamburger Kunstsammlungen*, v. 13, 1968, pp. 33–62.

Saldern 1995

A. von Saldern, *Glas—Antike bis Jugendstil: Die Sammlung im Museum für Kunst und Gewerbe Hamburg*, Stuttgart: Arnoldsche, 1995.

*Sasanian Silver* 1967

*Sasanian Silver: Late Antique and Early Mediaeval Arts of Luxury from Iran, Aug.–Sept. 1967*, Ann Arbor: The University of Michigan Museum of Art, 1967.

Sayre 1963

E. V. Sayre, "The Intentional Use of Antimony and Manganese in Ancient Glasses," *Advances in Glass Technology, Part 2*, New York: Plenum Press, 1963, pp. 263–282.

Sayre 1964

E. V. Sayre, *Some Ancient Glass Specimens with Compositions of Particular Archeological Significance*, BNL 879 (T-354), Brookhaven, New York: Brookhaven National Laboratory, 1964.

Sayre and Smith 1961

E. V. Sayre and R. W. Smith, "Compositional Categories

of Ancient Glass," *Science*, v. 133, no. 3467, June 9, 1961, pp. 1824–1826.

Silk Road 1988
*Shiruku Rōdo dai bunmei ten*, v. 2, *Shiruku rōdo, oashisu to sōgen no michi = The Grand Exhibition of Silk Road Civilizations*, v. 2, *The Oasis and Steppe Routes*, Nara: Nara Kenritsu Bijutsukan, 1988.

Simpson 1996
StJ. Simpson, "From Tekrit to Jaghjagh. Sasanian Sites, Settlement Patterns and Material Culture in Northern Mesopotamia," in *Continuity and Change in Northern Mesopotamia from the Hellenistic to the Early Islamic Period*, ed. K. Bartl and S. R. Hauser, Berlin: Dietrich Reimer Verlag, 1996, pp. 87–126.

Smith 1957
R. W. Smith, "New Finds of Ancient Glass in North Africa," *Ars Orientalis*, v. 2, 1957, pp. 91–117.

Smith 1963
R. W. Smith, "Archaeological Evaluation of Analyses of Ancient Glass," *Advances in Glass Technology, Part 2*, New York: Plenum Press, 1963, pp. 283–290.

Smith 1964
R. W. Smith, "History Revealed in Ancient Glass," *National Geographic*, v. 126, no. 3, September 1964, pp. 346–369.

Sono and Fukai 1968
T. Sono and S. Fukai, *Dailaman III. The Excavations at Hassani Mahale and Ghalekuti, 1964*, Tokyo: Institute of Oriental Culture, University of Tokyo, 1968.

Spaer 2001
M. Spaer, *Ancient Glass in the Israel Museum: Beads and Other Small Objects*, Jerusalem: the museum, 2001.

Splendeur des Sassanides 1993
*Splendeur des Sassanides: L'Empire perse entre Rome et la Chine (224–642)*, Brussels: Musées Royaux d'Art et d'Histoire and Crédit Communal, 1993.

Stein 1936
M. A. Stein, "An Archaeological Tour in Ancient Persis," *Iraq*, v. 3, 1936, pp. 112–225.

Stern 1977
E. M. Stern, *Ancient Glass at the Fondation Custodia (Collection Frits Lugt), Paris*, Archaeologica Traiectina, v. 12, Groningen: Wolters-Noordhof, 1977.

Stern 1995
E. M. Stern, *The Toledo Museum of Art. Roman Mold-Blown Glass: The First through Sixth Centuries*, Rome: "L'Erma" di Bretschneider in association with the museum, 1995.

Taniichi 1987
T. Taniichi, *Catalogue of Ancient Glass*, v. 4, *Catalogue of Near Eastern Glass in the Okayama Orient Museum*, Okayama: the museum, 1987.

Tesoro del Delfin 2002
L. Arbeteta Mira, *El Tesoro del Delfín*, Madrid: Museo Nacional del Prado, 2002.

Treasures from Corning 1992
D. Whitehouse and others, *Treasures from The Corning Museum of Glass*, Yokohama: Yokohama Museum of Art, 1992.

Treasures from Korea 1984
R. Goepper and R. Whitfield, *Treasures from Korea: Art through 5000 Years*, London: British Museum Publications, 1984.

Treasures of the Orient 1979
Anon., *Oriento no Bijutsu = Treasures of the Orient*, Tokyo: Idemitsu Bijutsukan, 1979 (in Japanese).

Trois millénaires d'art verrier 1958
*Trois millénaires d'art verrier à travers les collections publiques et privées de Belgique*, Liège: Musée Curtius, 1958.

Van Ess and Pedde 1992
M. Van Ess and F. Pedde, *Uruk Kleinfunde*, v. 2, *Metall und Asphalt, Farbreste, Fritte/Fayence, Glas, Holz, Knochen/Elfenbein, Leder, Muschel/Perlmutt/Schnecke, Schilf, Textilien*, Uruk-Warka Endberichte, v. 7, Mainz: Philipp von Zabern, 1992.

Vanden Berghe 1993
L. Vanden Berghe, "Historique de la découverte et de la recherche," in *Splendeur des Sassanides: L'Empire perse entre Rome et la Chine (224–642)*, Brussels: Musées Royaux d'Art et d'Histoire and Crédit Communal, 1993, pp. 13–18.

Vanderheyde 1994
C. Vanderheyde, "Réflexions sur l'iconographie du sémourve et sa diffusion dans l'art byzantin," *Revue des Archéologues et Historiens d'Art de Louvain*, v. 27, 1994, pp. 35–40.

Verres antiques et de l'Islam 1985
*Verres antiques et de l'Islam. Ancienne collection de Monsieur D.*, sale catalog, Paris: Guy Loudmer, June 3 and 4, 1985.

Weinberg 1988
G. D. Weinberg, ed., *Excavations at Jalame, Site of a Glass Factory in Late Roman Palestine*, Columbia, Missouri: University of Missouri Press, 1988.

Whitcomb 1985
D. S. Whitcomb, *Before the Roses and the Nightingales. Excavations at Qasr-i Abu Nasr, Old Shiraz*, New York: The Metropolitan Museum of Art, 1985.

Whitcomb 1995
D. Whitcomb, "Two Glass Medallions: Sasanian Influence in Early Islamic Aqaba," *Iranica Antiqua = Festschrift K. Schippmann II*, v. 30, 1995, pp. 191–206.

Whitehouse 1997
D. Whitehouse, *Roman Glass in The Corning Museum of Glass*, v. 1, Corning: the museum, 1997.

Whitehouse 1998
D. Whitehouse, *Excavations at ed-Dur (Umm al-Qaiwain, United Arab Emirates)*, v. 1, *The Glass Vessels*, Leuven: Peeters, 1998.

Whitehouse 2001
D. Whitehouse, *Roman Glass in The Corning Museum of Glass*, v. 2, Corning: the museum, 2001.

Whitehouse 2003
D. Whitehouse, *Roman Glass in The Corning Museum of Glass*, v. 3, Corning: the museum, 2003.

Wolf Collection 2001
E. M. Stern, *Roman, Byzantine, and Early Medieval Glass, 10 BCE–700 CE. Ernesto Wolf Collection*, Ostfildern-Ruit, Germany: Hatje Cantz Publishers, and New York: Distributed Art Publishers, 2001.

Wolkenberg Collection 1991
*The Alfred Wolkenberg Collection of Ancient Glass and Related Antiquities*, sale catalog, London: Christie, Manson & Woods Ltd., July 9, 1991.

Wright 1981
H. T. Wright, "The Southern Margins of Sumer: Archae-

ological Survey of the Area of Eridu and Ur," in R. McC. Adams, *Heartland of Cities: Surveys of Ancient Settlement and Land Use on the Central Floodplain of the Euphrates*, Chicago and London: University of Chicago Press, 1981, pp. 295–345.

*Yémen* 1997

Institut du Monde Arabe, *Yémen: Au pays de la reine de Saba'*, Paris: Flammarion, 1997.

Yoshimizu 1992

T. Yoshimizu, ed., *The Survey of Glass in the World*, Tokyo: Kyuyodo Art Publishing, 1992 (in Japanese).

Zerwick 1980

C. Zerwick, *A Short History of Glass*, New York: Harry N. Abrams Inc. in association with The Corning Museum of Glass, 1980.

Zerwick 1990

C. Zerwick, *A Short History of Glass*, 2nd edn., New York: Harry N. Abrams Inc. in association with The Corning Museum of Glass, 1990.

*2000 Jahre persisches Glas* 1963

K. Erdmann, *2000 Jahre persisches Glas*, Braunschweig: Stadtisch Museum, 1963.

*3000 Jahre Glaskunst* 1981

M. Kunz and others, *3000 Jahre Glaskunst: Von der Antike bis zum Jugendstil*, Lucerne: Kunstmuseum, 1981.

*7000 Jahre persische Kunst* 2001

*7000 Jahre persische Kunst. Meisterwerke aus dem Iranischen Nationalmuseum in Teheran*, Milan: Skira, 2001.

*7000 Years of Iranian Art* 1964

Anon., *7000 Years of Iranian Art*, Washington, D.C.: Smithsonian Institution, 1964.

# CONCORDANCES

**1. Accession Numbers**

| | |
|---|---|
| 55.1.46 | **37** |
| 55.1.47 | **42** |
| 56.1.1 | **3** |
| 59.1.174 | **38** |
| 59.1.175 | **40** |
| 59.1.176 | **41** |
| 59.1.178 | **39** |
| 59.1.179 | **22** |
| 59.1.180 | **21** |
| 59.1.181 | **24** |
| 59.1.182 | **25** |
| 59.1.183 | **26** |
| 59.1.184 | **19** |
| 59.1.185 | **23** |
| 59.1.186 | **20** |
| 59.1.187 | **35** |
| 59.1.188 | **18** |
| 59.1.189 | **29** |
| 59.1.190 | **27** |
| 59.1.191 | **33** |
| 59.1.192 | **28** |
| 59.1.193 | **32** |
| 59.1.194 | **31** |
| 59.1.195 | **30** |
| 59.1.272 | **43** |
| 59.1.435 | **64** |
| 59.1.488 | **67** |
| 59.1.580 | **62** |
| 60.1.3 | **46** |
| 61.1.11 | **51** |
| 61.1.12 | **49** |

| | |
|---|---|
| 62.1.4 | **65** |
| 62.1.9 | **63** |
| 62.1.28 | **13** |
| 62.1.53-27 | **55** |
| 63.1.4 | **57** |
| 63.1.10 | **7** |
| 63.1.21 | **60** |
| 64.1.31 | **1** |
| 65.1.28 | **45** |
| 66.1.6 | **61** |
| 66.1.19 | **66** |
| 66.1.22 | **5** |
| 66.1.23 | **4** |
| 66.1.254 | **15** |
| 68.1.28 | **36** |
| 68.1.44 | **59** |
| 70.1.6 | **16** |
| 72.1.21 | **50** |
| 73.1.8 | **73** |
| 76.1.93A | **68** |
| 76.1.93B | **69** |
| 76.1.93C | **70** |
| 76.1.93D | **71** |
| 76.1.94 | **72** |
| 76.1.131 | **34** |
| 76.1.134 | **44** |
| 79.1.56 | **53** |
| 79.1.58 | **54** |
| 79.1.59 | **56** |
| 79.1.64 | **52** |
| 79.1.66 | **17** |
| 79.1.95 | **12** |
| 79.1.219 | **48** |

| | |
|---|---|
| 79.1.221 | **14** |
| 79.1.240 | **8** |
| 79.1.241 | **47** |
| 79.1.250 | **11** |
| 79.1.254 | **6** |
| 79.1.269 | **10** |
| 79.1.272 | **9** |
| 2003.1.4 | **58** |
| 2005.1.1 | **2** |

**2. Smith Collection**

| | |
|---|---|
| 203 | **72** |
| 230-9 | **70** |
| 230-12 | **68** |
| 230-18 | **71** |
| 388 | **5** |
| 893 | **21** |
| 1001 | **19** |
| 1002 | **39** |
| 1013 | **31** |
| 1050 | **67** |
| 1179 | **64** |
| 1184 | **20** |
| 1185 | **35** |
| 1187 | **25** |
| 1188 | **40** |
| 1192 | **44** |
| 1269-a | **41** |
| 1269-b | **29** |
| 1269-c | **18** |
| 1299 | **22** |
| 1305 | **30** |

| | |
|---|---|
| 1307 | **32** |
| 1313 | **38** |
| 1358 | **24** |
| 1371 | **43** |
| 1379-1 | **26** |
| 1379-2 | **33** |
| 1379-3 | **28** |
| 1379-4 | **27** |
| 1394 | **4** |
| 1430 | **23** |
| 1543 | **51** |
| Unknown | **34** |
| Unknown | **49** |
| Unknown | **66** |
| Unknown | **69** |
| Unknown | **73** |

**3. Strauss Collection**

| | |
|---|---|
| S2149 | **48** |
| S2226 | **14** |
| S2411 | **53** |
| S2430 | **12** |
| S2471 | **8** |
| S2472 | **54** |
| S2475 | **47** |
| S2479 | **56** |
| S2560 | **52** |
| S2600 | **11** |
| S2608 | **17** |
| S2610 | **6** |
| S2744 | **10** |
| S2788A | **9** |

# INDEX

The index contains the names of persons (other than authors cited in the Bibliography), places, and things. Collections in museums and other institutions are listed by city; private collections are listed by name. Names of regions and countries are listed only when more precise information is not available. Names of shapes and techniques are listed only when they are discussed. Numerals in boldface indicate catalog numbers.

Abu Skhair, Iraq, 10, 20
Ad Diwaniyah, Iraq, 61, 66
Adams, Robert McC., 65, 66, 75
Afghanistan, 72
Amlash, Iran, 10, 25, 42, 53
An Nasiriyah, Iraq, 61, 67
Ankan (Japanese emperor), 11, 43
appliqué(s), 5, 7, 10, 11, 12, 30, 31, 32, 33, 34, 35, 36, 37, 38, 39, 40
Arabian Peninsula, 9
Arabic inscription. *See* inscription, Arabic
Ardashir I (Sasanian king), 9
Asia, Central, 9, 11
Azerbaijan region, Iran, 57
Babylon, 11, 19, 43
Baghdad, Iraq, 10, 11, 25, 66; Iraq Museum, 25
Bahrain, 22
Balog, Paul, 30, 31
Banbhore, Pakistan, 18
Barchuk, China, 45
Bardhan, Gail, 8
bas-relief, 16
Bat-Ha, Iraq, 67
bead(s), 11, 12, 58, 59
beaker(s), 10, 23, 27, 29, 34, 42, 50, 51, 53; bell beaker, 10
beard, 37
Beijing, China. Hua Fang, tomb of, 11, 25
Beirut, Lebanon. Institut Français d'Archéologie, 32
bell beaker. *See* beaker(s)
Berkowitz, Carl, and Derek Content, **34**, **44**, **68–72**
Berlin, Germany. Museum für Islamische Kunst, 25, 30, 37, 57, 65
Bet Eli'ezer, Israel, 70
Beth She'arim, Israel, 70
Bibliothèque Nationale. *See* Paris, France
bird(s), 30, 35, 36
Bishapur, Iran, 15
bottle(s), 10, 17, 18, 19, 20, 38, 54, 55, 56
bowl(s), 9, 11, 12, 22, 23, 25, 26, 27, 30, 34, 41, 42, 45, 46, 47, 48, 49, 57
Brill, Robert H., 7, 8, 29, 50, 61
British Museum. *See* London, England
Bronze Age, 10
Bunn, Warren M., II, 8
al-Buraq, 31

bust, 41
Caesarea, Israel, 72
caftan, 16
Cairo, Egypt, 30, 51
Carnegie Museum of Natural History. *See* Pittsburgh, Pennsylvania
Caucasus, 9, 11; northern, 16
Central Asia. *See* Asia, Central
Chicago, Illinois; Field Museum of Natural History, 37; Oriental Institute Museum, 38, 40, 66; Oriental Institute of the University of Chicago, 66
Choche, Iraq, 11, 22, 23, 42, 65, 66, 67, 70, 72, 75. *See also* Ctesiphon
Chuncheng, China. Liu Zong, tomb of, 11, 43
Cincinnati, Ohio. Cincinnati Art Museum, 41
Cohn Collection, 23, 38
coin(s), 9, 11, 18, 22; Sasanian, 9; Shapur II, 11, 22
Constantinople, 10
Content, Derek. *See* Berkowitz, Carl, and Derek Content
Copenhagen, Denmark. David Collection, 43, 56
Corning, New York. Corning Incorporated, 65, 71; The Corning Museum of Glass (also Corning; the Museum), 7, 8, 10, 11, 15, 25, 26, 27, 30, 33, 37, 43, 57, 65, 72; Rakow Research Library, 8; The Studio, 8
cross, equal-arm, 42
Ctesiphon, 9, 10, 11, 15, 23, 42, 57, 65, 66, 67, 70, 72. *See also* Choche
cup(s), 2, 9, 11, 23, 24, 42, 43, 44, 45, 46
Dailaman (region), Iran, 9, 11, 25, 26, 59
David Collection. *See* Copenhagen, Denmark
dish, 9, 33, 41; silver-gilt, 16
Diyala River Plain, Iraq, 65, 66
dropper flask, 19
Dura-Europos, Syria, 20, 41
Düsseldorf, Germany. Kunstmuseum Düsseldorf, 18, 25, 26, 43
ed-Dur, United Arab Emirates, 11, 23, 25
Egypt, 9, 29
Eleanor of Aquitaine Vase, 41
Erdmann, Kurt, 30
Euphrates (river), 67
facet-cut glass, 41, 42
falconer, 33
Far East, 11, 45
Fasa, Iran, 38, 40
Fenn, Philip M., 65
Field Museum of Natural History. *See* Chicago, Illinois
figure (human), 20; female, 59
flask, 19
flute, 27, 49
forgery, 60
Foroughi Collection, 43
Fortune, Andrew M., 8
Frankish, 10

# DRAWINGS

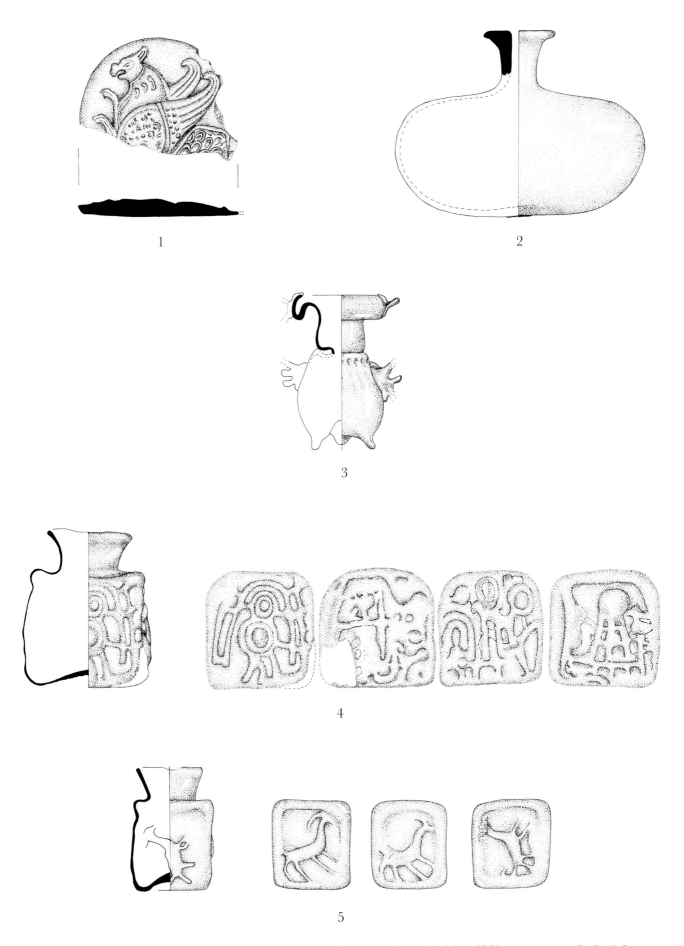

*Plaque formed by pressing (**1**), blown vessel without decoration (**2**), and vessels with mold-blown ornament (**3–5**) (1:2).*

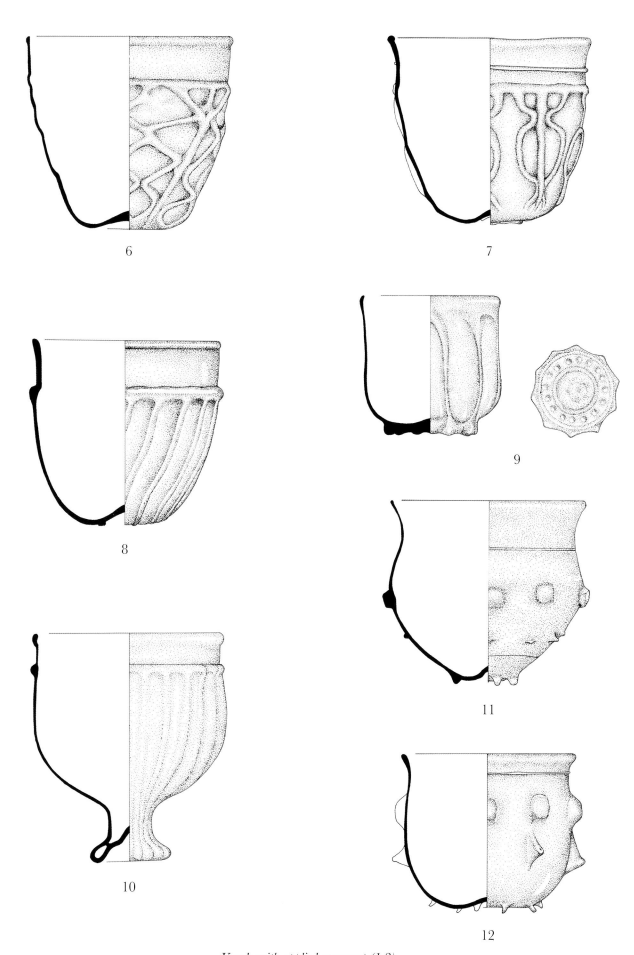

*Vessels with applied ornament (1:2).*

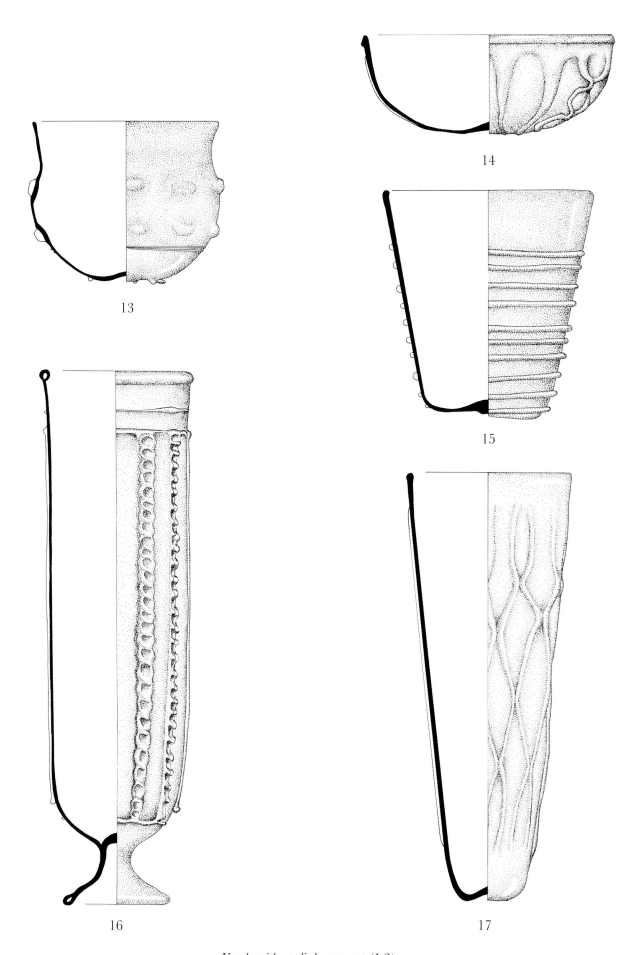

*Vessels with applied ornament (1:2).*

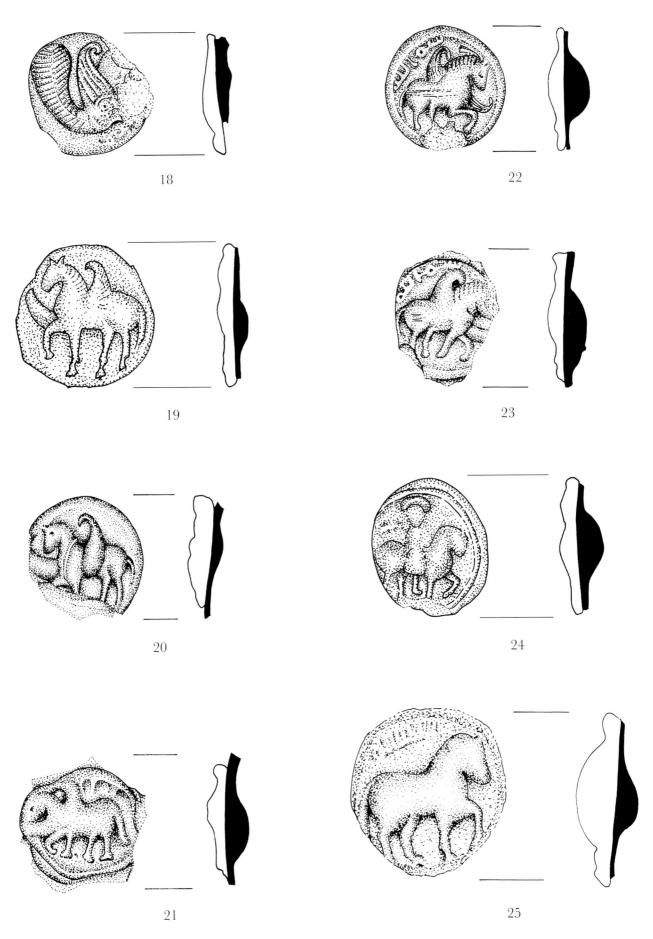

18

22

19

23

20

24

21

25

*Appliqués (1:1).*

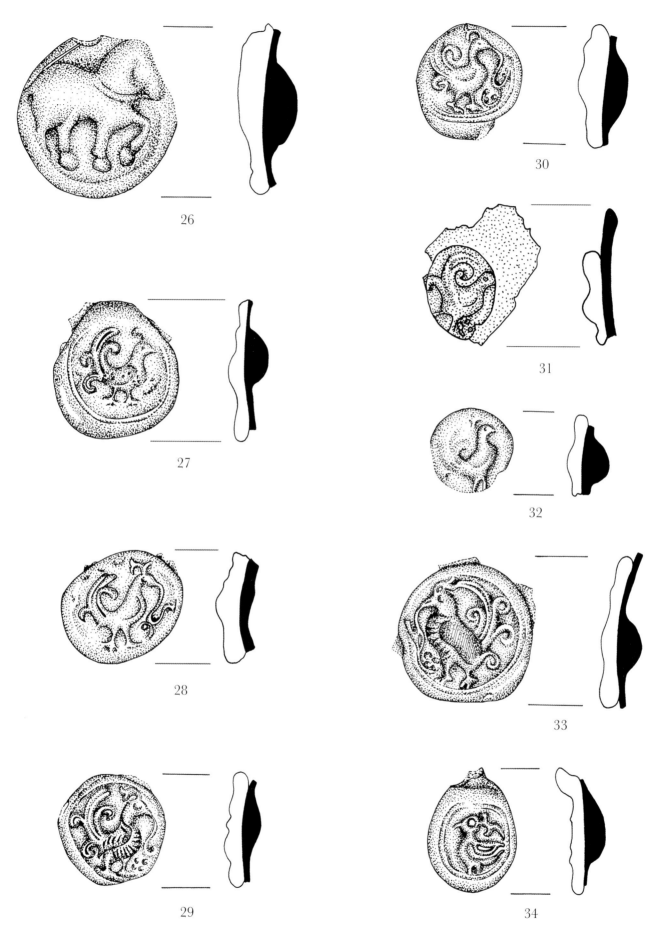

*Appliqués (1:1).*

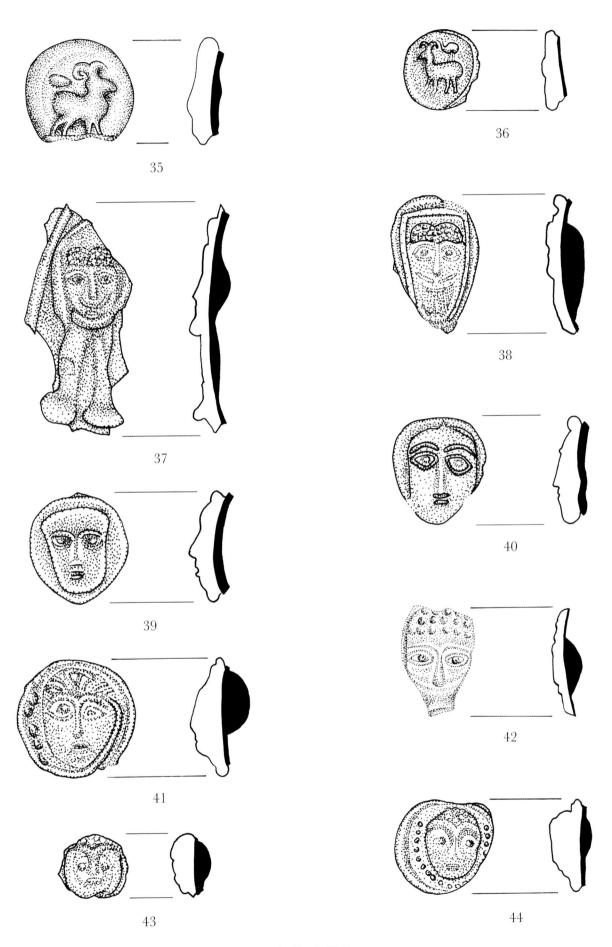

*Appliqués (1:1).*

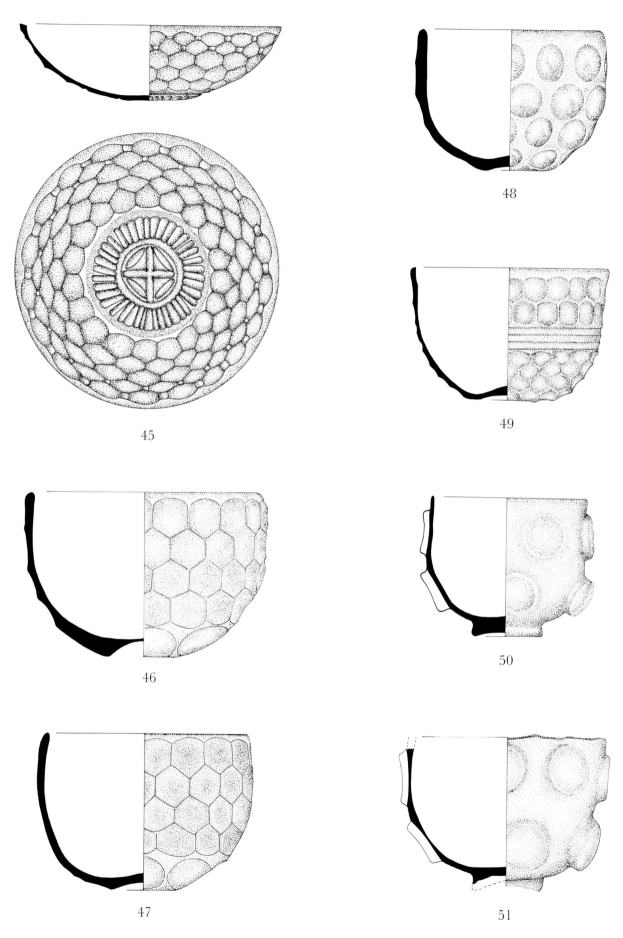

45

46

47

48

49

50

51

*Vessels with facet-cut ornament (1:2).*

52

53

54

55

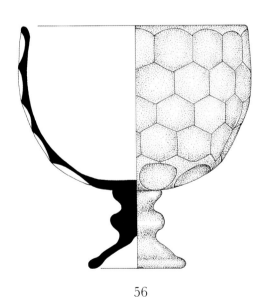

56

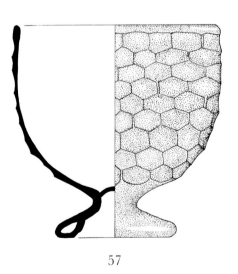

57

*Vessels with facet-cut ornament (1:2).*

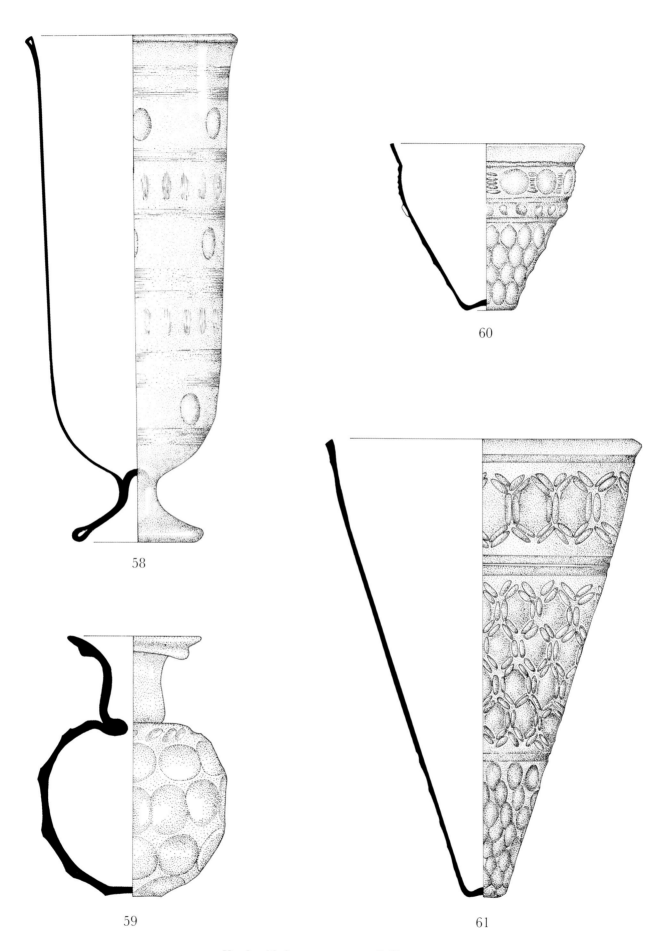

58

60

59

61

*Vessels with facet-cut ornament (1:2).*

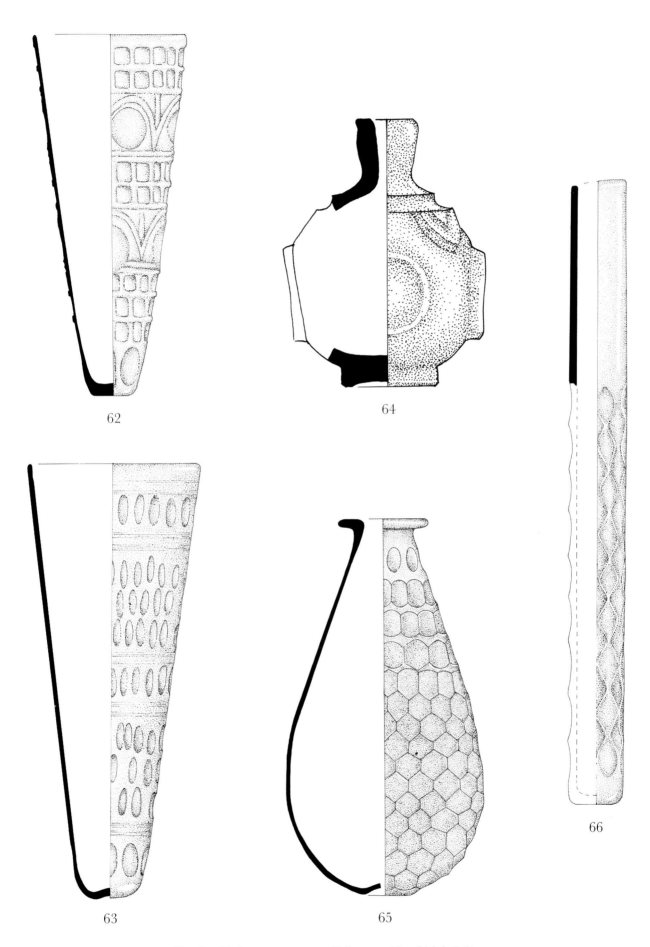

*Vessels with facet-cut ornament (1:2 except **64**, which is 1:1).*

111

*Vessel with facet-cut ornament (**67**) and beads (**68–72**) (1:1).*